Paint Shop Pro X for Photographers

Paint Shop Pro X for Photographers

Ken McMahon and Robin Nichols

AMSTERDAM • BOSTON • HEIDELBERG • LONDON • NEW YORK • OXFORD
PARIS • SAN DIEGO • SAN FRANCISCO • SINGAPORE • SYDNEY • TOKYO

Focal Press is an imprint of Elsevier

Focal Press is an imprint of Elsevier
Linacre House, Jordan Hill, Oxford OX2 8DP, UK
The Boulevard, Langford Lane, Kidlington, Oxford OX5 1GB, UK
84 Theobald's Road, London WC1X 8RR, UK
Radarweg 29, PO Box 211, 1000 AE Amsterdam, The Netherlands
30 Corporate Drive, Suite 400, Burlington, MA 01803, USA
525 B Street, Suite 1900, San Diego, CA 92101-4495, USA

First edition 2006

Copyright © 2006, Ken McMahon and Robin Nichols. Published by Elsevier 2006. All rights reserved

The right of Ken McMahon and Robin Nichols to be identified as the authors of this work has been asserted in accordance with the Copyright, Designs and Patents Act 1988

No part of this publication may be reproduced, stored in a retrieval system or transmitted in any form or by any means electronic, mechanical, photocopying, recording or otherwise without the prior written permission of the publisher

Permissions may be sought directly from Elsevier's Science & Technology Rights Department in Oxford, UK: phone (+44) (0) 1865 843830; fax (+44) (0) 1865 853333; email: permissions@elsevier.com. Alternatively you can submit your request online by visiting the Elsevier web site at http://elsevier.com/locate/permissions, and selecting Obtaining permission to use Elsevier material

British Library Cataloguing in Publication Data
A catalogue record for this book is available from the British Library

Library of Congress Cataloging-in-Publication Data
A catalog record for this book is available from the Library of Congress

ISBN–13: 978-0-240-52016-2
ISBN–10: 0-240-52016-5

For information on all Focal Press publications visit our website at:
www.focalpress.com

Printed and bound in Italy

06 07 08 09 10 10 9 8 7 6 5 4 3 2 1

Working together to grow
libraries in developing countries

www.elsevier.com | www.bookaid.org | www.sabre.org

ELSEVIER BOOK AID International Sabre Foundation

Contents

Picture credits	ix
Foreword	xi
Introduction	xiii
Why digital?	xiii
Why Paint Shop Pro?	xiii
Why this book?	xiii
Why me?	xiv
About Paint Shop Pro X	xiv
A note from Corel	xv

1 Digital Image-making: The Basics — 1

Introduction: basic tools and functions	4
Paint Shop Pro X: advanced features	10
Features new to Paint Shop Pro X	18
Additional considerations for the digital darkroom	20
Creating pictures using film, digital cameras and scanners	24
STEP-BY-STEP PROJECTS	**26**
Exploring the Learning Center	26
Straightening an image	27
Cropping pictures	31

2 Simple Picture Manipulation: Improving Your Digital Photos — 33

One-Step Photo Fix	35
Color Balance	42
Other tools for correcting color problems	44
Hue/Saturation/Lightness	46
Other tools for correcting exposure problems	49
Using Fill Flash and Backlighting	54
Making photos (appear) sharper	56
Adding soft focus effects	59
STEP-BY-STEP PROJECTS	**61**
Technique: Sharpening photos using the High Pass Sharpen filter	61

3 Simple Picture Manipulation: Moving Past the Basics — 65

Removing scratches and blemishes from scans	67
Controlling digital noise	70
Retouching using the Clone Brush	74
Creating black and white pictures	79
Tinting black and white photos	82
Creating color overlay effects	86
Using the Warp tools	88
Scripting	89
STEP-BY-STEP PROJECTS	91
Technique: repairing damaged photos	91
Technique: flood fill coloring effects	93
Technique: hand-coloring black and white photos	95

4 Controlling Change: Using Selections — 101

Understanding selections: adding creative power	103
What else can you do with selections?	104
Using the geometric selection tools	106
Alpha channels and masks	109
STEP-BY-STEP PROJECTS	111
Technique: creating an artificial point of focus	111
Technique: fixing an overexposed sky	112
Technique: object cut-out	115

5 Combining Images: Working with Layers and Layer Masks — 117

Understanding layers	119
Combining pictures	122
Advanced Layout tools	127
Using Adjustment layers	129
Creating Layer Blend Mode effects	131
Using Mask Layers	133
STEP-BY-STEP PROJECTS	137
Technique: creating a photomontage	137
Technique: layer deformations – creating the perfect shadow	140

6 Using Text: Understanding Vector Graphics — 145

How text and vectors work — 147
Adding basic text — 147
Special text effects — 151
Vectors: learning the basics — 155
Working with the Pen tool — 157
STEP-BY-STEP PROJECTS — 160
 Technique: creating a greetings card — 160
 Technique: pasting text inside an image for effect — 162
 Technique: combining text and photos to make a calendar — 164

7 Manipulating Images: Creating Special Effects — 169

Using the Materials palette — 171
Working with Brush tools — 174
About Deformation tools — 180
Applying filter effects — 183
Adding lighting effects — 190
STEP-BY-STEP PROJECTS — 193
 Technique: creating a panorama — 193
 Technique: creating realistic depth effects using displacement maps — 197
 Technique: having fun with the Picture Tube — 201
 Technique: adding edge and framing effects — 204
 Technique: how to add an edge or frame to a picture — 206
 Technique: using the Color Replacer tool — 208

8 Print Preparation — 211

Image resolution — 213
Resampling — 216
Choosing an inkjet printer — 217
Printing with Paint Shop Pro — 219
Color management — 222
STEP-BY-STEP PROJECTS — 228
 Technique: printing multiple photos with Print Layout — 228

9 Working with the Web: Optimizing and Uploading Images — 231

How the Web displays images — 233
Web file formats — 235
Special Internet graphics — 243
Animation Shop — 246
Output — 252
STEP-BY-STEP PROJECTS — 253
 Technique: creating a rollover navbar — 253
 Technique: uploading web files to a web server — 257

10 Corel Photo Album 6: Organizing Your Pictures — 259

What Corel Photo Album 6 does	262
Finding your way around	262
Keywords	266
Finding photos	268
Archiving photos	269
Panoramas	270
Printing with Print Layout	272
Enhance	273
Create	274
Share	275
Corel Photo Album 6 Full Version	276
Batch Processing	276
Video CD	277
STEP-BY-STEP PROJECTS	279
Technique: creating a web gallery	279

Appendix 1: Jargon Buster — 283

Appendix 2: Keyboard Shortcuts — 289

General	290
Paste	290
View	290
Image	291
Adjust	291
Layers	292

Index — 293

Picture Credits

Peter Eastway
Page 167

Amelia James
Pages 125, 161, 166, 168 ('July')

David Nichols
Pages 113, 114, 115

Jim Nichols
Pages 25, 72, 73, 152, 181, 182, 194, 195, 196

Robin Nichols
Pages 44, 46, 47 48, 57, 60, 78, 79, 92, 94, 104-106, 111, 119, 123, 168 ('February'), 176-178, 192, 209

Ken McMahon
Pages 10-14, 27-31, 36-39, 40, 45, 49, 50, 53-55, 75, 76, 83-85, 87, 89, 108-110, 115, 116, 127, 129, 132-134, 137-139, 159, 163, 179, 185-188, 197, 199-201, 207, 220-222, 228, 229, 234, 235, 239, 241, 243, 244, 266, 268, 271-273, 278-282

Isabelle Risner
Pages 43, 58, 61-63, 80, 208, 213, 216, 237

Corbis
Pages 2, 81, 88, 96-99, 261, 262, 264, 270, 278
Getty Images
Pages 135, 140-144, 201 (water), 215, 222 (display monitor)

Foreword

This book provides information and guidance from a photographer's perspective. Ken McMahon has done an exceptional job in creating a book and web package that is ideal for beginners and novices without insulting those who already have a solid grasp of Paint Shop Pro and are seeking quick, streamlined solutions. If you are new, this publication prevents the inevitable information overload you experience as you venture into digital photography as well as demystifying the software tricks people use to get those professional looking results and neat photo effects. If you have already mastered Shutter Speed, ISO and Aperture settings, along with how to use image editing software, you get straightforward solutions with convincing demonstrations on how Paint Shop Pro X can quickly take your digital photography to the next level.

Not only are you given insight on how to improve your digital images, you are shown how to prepare your pictures for their intended purpose. You will learn how to get great prints with Paint Shop Pro X as well as efficient online output, for example displaying pictures of merchandise on a website or emailing friends picture attachments that do not take 20, 10, or even 5 minutes to appear with their dial-up connection. Lastly you will learn how easy it is to organize, creatively share and protect your pictures using Paint Shop Pro X's free companion application, Corel Photo Album 6 Standard Edition. I am confident that this publication is ideal for you whether you are new or well versed in the world of mega pixels.

Enjoy!

Gage S. Lockhart, PSP Technical Support Specialist, Corel Software Inc.

Introduction

Why digital?

If you've picked up this book while browsing the shelves of your local bookshop (or, better still, if you've already bought it!) the chances are that you own and use a digital camera. You're far from alone. According to the research group Infotrends, in 2005 digtital camera sales in North America reached 26 million and in Western Europe, the world's largest digital camera market, nearly 30 million of us bought a new digital camera.

To those of us who have been using digital cameras for a while, this comes as no big surprise. While early digital cameras were more expensive and less capable than their conventional counterparts, as tends to happen with consumer electronics, it was only a question of time before this situation was reversed. Today you can choose from a huge variety of digital cameras that are competitively priced and outstrip film-based models in terms of features and performance.

The most obvious advantage to owning a digital camera is that you'll never again have to pay for a roll of film or to have it processed. Neither will you have to change film to cope with different lighting conditions, or because you want to take some black and white shots, or transparencies.

Before the advent of digital photography, for most photographers, the picture-making process began and ended with the pressing of the shutter release. The film was sent for processing, the snaps came back, were maybe stuck in an album and that was it. Only professionals, or those lucky enough to have their own home darkroom, were able to extend the creative process, even then it was an expensive, time-consuming, often frustrating process with limited creative possibilities.

Modern personal computers and digital image-editing software have transformed the way we make and use photographs in the 21st century. With only a modest PC and with software costing very little (if you're lucky, it might even be included in the box with your camera) you have at your fingertips creative tools and photo processing power that would have been beyond the scope of even the most lavishly equipped photo lab of a decade ago.

Why Paint Shop Pro?

Which is where Paint Shop Pro enters the picture. This inexpensive, versatile application will allow you do do just about anything with your digital pictures from correcting exposure problems and removing red-eye to making Christmas cards.

Why this book?

Paint Shop Pro is a powerful image-editing application that's packed with sophisticated tools and features that will help you get the most from your digital photos. But all this power and

sophistication comes at a price – you need to learn how to use it. This book is designed to help you do that.

In *Paint Shop Pro X for Photographers* we've tried to do much more than simply explain how Paint Shop Pro works. In each of the chapters we've taken a practical approach to demonstrating tools and techniques so that you can learn how to use the program to do the things you want with your own digital photos. At the end of each chapter you'll find a series of step-by-step projects that demonstrate many of the techniques covered.

Why me?

The book is aimed at anyone who wants to get more from their digital photos and has a basic understanding of how to use their PC. You don't even need a copy of Paint Shop Pro! If you go to www.corel.com you can download a free, fully functional, trial version which you can use for 30 days.

If you're new to Paint Shop Pro, we'd recommend you work through the book in a linear fashion as later chapters introduce more complex techniques. If you're keen to cover a topic dealt with later in the book, start by taking a look through the first two chapters, which provide an introduction to Paint Shop Pro's workspace and basic feature set.

If you're already familiar with Paint Shop Pro feel free to dip in wherever your interest takes you or where there is a gap in your knowledge. Chapter 1 covers features new to version X. Readers of the previous edition will discover a substantial amount of new and revised material in every chapter.

Digital photography is here to stay and Paint Shop Pro makes getting the best from your digital images easier than it's ever been. With *Paint Shop Pro X for Photographers* you'll be able to get the best from Paint Shop Pro – and have some fun in the process!

About Paint Shop Pro X

Paint Shop Pro X is the latest evolution in a software application that has been in continuous development for more than a decade. As an image editor, Paint Shop Pro's main purpose is to edit digital photos and it provides a wide range of tools to enable you to do this. But it goes much further than that and can be used to create and edit original artwork using vector-based graphics, type and 'natural media' painting tools.

There are, of course, other image-editing applications out there that do the same thing, but what makes Paint Shop Pro unique is that it combines power and versatility and yet sells for a fraction of the cost of similarly equipped applications. Adobe's industry-standard professional image-editing software, Photoshop, costs five times the price of Paint Shop Pro, yet Photoshop does little that can't be achieved in Paint Shop Pro.

A note from Corel

Corel® Paint Shop Pro(tm) X delivers a complete set of photo editing tools to help you create professional-looking photos fast!

By combining Ken McMahon's ideas from a photographer's viewpoint and the powerful yet easy to use features within Paint Shop Pro X, you will be able to fix brightness, color and photo imperfections; compose photos full of depth and imagination; give photos a unique and exciting look, plus, organize and share all your photos with Corel® Photo Album(tm) 6 - Standard Edition.

Corel, Ken McMahon and Focal Press have worked very closely to create a book for anyone who aspires to make good photos great and puts the power of Corel Paint Shop Pro at the finger tips of anyone who wants to create stunning photos right out of the box.

About Corel Corporation

Corel Corporation provides innovative software solutions that help millions of value-conscious businesses and consumers in over 75 countries improve their productivity. The Company is renowned for its powerful software portfolio that combines innovative photo editing and graphics creation, vector-illustration and technical-graphics applications along with office and personal productivity solutions. Corel's flagship products include the CorelDRAW® Graphics Suite, the WordPerfect® Office Suite, the Corel® Painter(tm) and Natural-Media® painting and illustration software and the Paint Shop(tm) Family of digital photography and image-editing software.

Founded in 1985, Corel is headquartered in Ottawa, Canada. For more information, please visit www.corel.com.

© 2005 Corel Corporation. All rights reserved. Corel, Paint Shop and the Corel logo are trademarks or registered trademarks of Corel Corporation and/or its subsidiaries. All other product, font and company names and logos are trademarks or registered trademarks of their respective companies.

1

Digital Image-making: The Basics

PAINT SHOP PRO X FOR PHOTOGRAPHERS

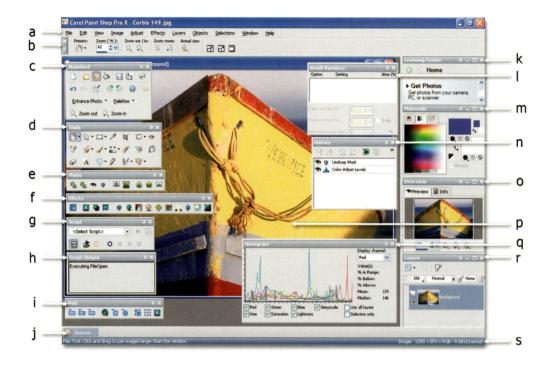

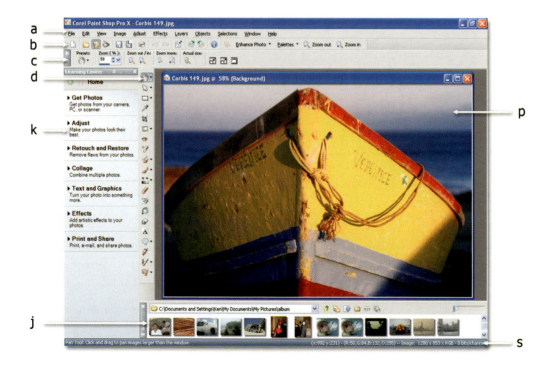

PAINT SHOP PRO X FOR PHOTOGRAPHERS

This chapter introduces Paint Shop Pro's basic and sophisticated picture editing features.

PAINT SHOP PRO FEATURES COVERED IN THIS CHAPTER

Browser palette	JPEG Optimizer
Curves	Leaning Center
Crop tool	Perspective Correction tool
Hue/Saturation/Lightness	Picture Tubes
Hue Map	Straighten tool
Image Slicer	Symmetric Shape tool
JPEG Lossless Rotation	

Figure opposite. You can customize the Paint Shop Pro interface to suit a particular workflow, whether that be for print, the Web or for illustration. The top screengrab shows most of the available toolbars and palettes. Ordinarily, you wouldn't display them all at once like this as you don't need them all the time and they clutter up the screen. The bottom screengrab shows the default workspace. Top frame: (a) Menu bar. (b) Tool Options, the operational powerhouse of every tool in Paint Shop Pro. It controls how each particular tool works: its opacity, density, tolerance to change, and so on. (c) Standard toolbar that contains some of the most frequently used commands. (d) The Tools toolbar contains all the stuff you'd need to make physical changes to a picture. These include paintbrushes, erasers, selectors and more. (e) The Photo toolbar is biased towards the photographer, with tools specifically for enhancing digital photos or scans. (f) The Effects toolbar is, as the name suggests, there for applying special actions to an image or selection within that picture. (g) The Script toolbar plays pre-recorded scripts on the currently active image. Use the Script toolbar for batch processing effects and for recording your own customized scripts. (h)The Script Output palette records everything that goes into or replays from the Scripts tool. (i) The Web toolbar is there specifically for web gurus. On it are a range of tools designed for getting the best quality and download performance from images destined for the Internet. (j) The Browser is now integrated into the workspace as a functional palette providing a quick means of accessing, organizing and opening images on your hard disk. (k) Those of you relatively new to Paint Shop Pro can use the Learning Center to quickly find your way about PSP. (l) Brush Variance adds an incredible degree of behavioral control over drawing and paint tools. (m) The Materials palette is used for selecting foreground and background colors for all the paint and drawing tools. You can also add texture and gradients to the color mix, just as if it were a painter's mixing palette. (n) The History palette allows you to step backwards and selectively delete earlier edits. (o) The Overview palette indicates, at a glance, how much the current image has been enlarged and over what section the main picture window is displaying – useful for when working at large picture magnifications. (p) This is the main picture window displaying the picture that is currently open. (q) The Histogram palette displays the spread of tones captured in the displayed picture. Clicking the checkboxes brings up individual color channel information. (r) This is the Layers palette. It displays essential information on the types of layers in a document, their order and status. (s)The Task bar displays vital information on how each selected tool works, as well as data on the image that's currently displayed in the main picture window.

DIGITAL IMAGE-MAKING

Introduction: basic tools and functions

Paint Shop Pro X marks an exciting departure from previous versions of the program. For novice users Paint Shop Pro's rather austere look and formidable array of tools, palettes and menus was a little off-putting, you might even say intimidating.

Corel has addressed this problem by redesigning the learning Center and making it a central feature of the program. The Learning Center occupies a panel to the left of the Tools toolbar and provides information and guidance on how to carry out image-editing tasks using Paint Shop Pro's tools. The Learning Center is both interactive and context-sensitive, which means that, when guiding you through an activity it will select the tools for you and, when certain tools are selected it provides information specific to those tools. The Learning Center makes it easy for first-timers to find their way around and also serves as a useful reminder for more experineced users of the functions of less-used tools. If you really don't need the Learning Center you can close the window and free up screen space for other tasks.

Another major revision is the relocation of the browser to the bottom of the screen. The browser has been redesigned and behaves like a palette, so it's easier to view thumbnail images of photos, display information about them and open them in the editing window. In it's default 'filmstrip' configuration the browser displays a single row of thumbnails but, as with the old browser you can expand it in its own window. For more on how to use the browser see page 14.

One of the strengths of the Paint Shop Pro interface is that, whether you are a novice or an experienced user, it can easily be customized to suit your personal way of working

Paint Shop Pro enables you to save and reload any palette/menu configuration through its workspace save feature ('File>Workspace>Load', + Save, + Delete). So, if you work on the Web you might save one setting for the Internet and another for print applications. Default settings can be restored via the File>Workspace>Corel Paint Shop Pro X Default.pspWorkspace command.

The menu bar

Menu bars are standard throughout the computer world, whether in word processing, photo-editing or multimedia software. Paint Shop Pro's many keyboard shortcuts are listed alongside each menu topic (where shortcuts are available). A keyboard shortcut, which we'll study in greater detail later, offers a fast way of accessing other parts of the program without the need for excessive mousing. Learning and using keyboard shortcuts will significantly increase the speed at which you can use this program.

Toolbars

The toolbars in photo-editing programs are, for many, the most important feature. Paint Shop Pro has seven of these, containing more than 70 different photo-editing features between them (not including obvious tasks like 'File Open' and 'Save As'), plus there are many more effects

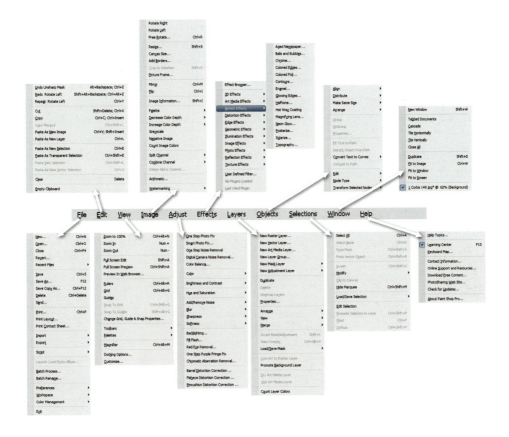

The Paint Shop Pro X menu bar contains 11 main menu options. To display the menu click on the menu heading. Each of the main menus contains tools and actions that are pertinent to that header. On the File menu, for example, you'll find commands for creating a new file (New), opening an existing file (Open), saving the file (Save) and saving the file under a different file name or format (Save As). To avoid main menus growing inordinately long, certain functions are organized into sub-menus which fly out when you hover over the appropriate main menu option. All of the effects filters are organized on the Effects menu in this way. The 15 artistic effects filters appear on the Artistic Effects sub-menu of the Effects main menu.

filters. Most tools and filters are arranged on the three main toolbars (Tools, Photo and Effects). All can be floated, or docked, according to their groupings or requirements.

Tool or filter effect?

Often, you can achieve the same end result by selecting a command from a menu, clicking a keyboard shortcut, or selecting a tool from a toolbar. A more significant distinction can be drawn between global and local editing. Global edits affect the entire image, or a selection if you've made

one. Examples of global edits are the effects filters, tonal and color adjustments, and unsharp masking. Local edits affect only those pixels touched by the tool. The Clone Brush, Dodge Brush and Eraser tool are used on localized areas of the image. You can modify the behavior of these tools by altering settings such as brush size, shape and hardness in the Tool Options palette. Global effects usually provide a dialog box with additional controls, before and after preview windows and proofing buttons which preview the effect in the main picture window.

'Standard' toolbar

This contains all the usual housekeeping style tools familiar in most software programs. These include: (create) 'New File', 'File Open', 'File Save', 'File Browse', 'TWAIN acquire' (which allows you to import a scanned picture directly), 'Print', 'Undo' and 'Redo'. The Standard toolbar also contains the Enhance Photo pull-down menu, which provides quick access to the One Step Photo Fix and other picture-improving filters. Additionally, several buttons have been added to the Standard toolbar to provide instant access to commonly used functions like rotate left and right, resize, launch Corel Photo Album 6, Zoom in and out and a Palettes pull-down menu which you can use to toggle the display of any of the palettes.

> **Tip**
>
> Small screens can become so cluttered with PSP's array of toolbars and palettes that you can't easily see the image you are working on. To free up space click the pushpin at the top of a palette or toolbar and it will autohide when not in use. Mouse over the titlebar to reactivate it.

'Tools' toolbar

The Tools palette displays 20 photo-editing tools, with more lurking beneath those marked with tiny black arrow symbols (click and hold to see what's underneath; click once and slide the cursor across to select any 'hidden' tool).

This toolbar is the Paint Shop Pro editing powerhouse. Here you'll find a tool, or sets of tools, that will enable you to do pretty much anything to a digital photo or scanned picture file, from retouching to repairing.

Tools are divided into groupings that include:

Pan + Zoom, Pick + Move, Selection + Freehand Selection + Magic Wand, Dropper + Color Replacer, Crop, Straighten + Perspective Correction, Red-Eye, Makeover, Clone brush + Scratch Remover + Object Remover, Paint Brush + Airbrush, Lighten/Darken + Dodge + Burn + Smudge + Push + Soften + Sharpen + Emboss + Saturation + Hue + Change to target + Color Replacer, Eraser, Background Eraser, Flood Fill, Picture Tube, Text tool, Preset Shape tool + Rectangle +

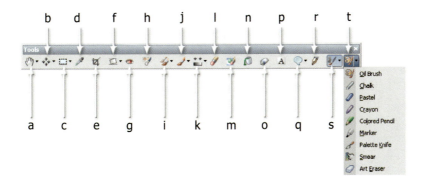

Tools include: Pan + Zoom tool (a), Pick + Move (b), Selection + Freehand Selection + Magic Wand (c), Dropper (d), Crop (e), Straighten + Perspective Correction (f), Red-Eye (g), Makeover (h), Clone Brush + Scratch Remover + Object Remover (i), Paint Brush + Airbrush (j), Lighten/Darken + Dodge + Burn + Smudge + Push + Soften + Sharpen + Emboss + Saturation Up/Down + Hue Up/Down + Change to target + Color Replacer (k), Eraser (l), Background Eraser (m), Flood Fill (n), Picture Tube (o), Text tool (p), Preset Shape tool + Rectangle + Ellipse + Symmetric Shape (q), Pen tool (r), Warp Brush + Mesh Warp (s), Oil Brush + Chalk + Pastel + Crayon + Colored Pencil + Marker + Palette Knife + Smear + Art Eraser (t).

Ellipse + Symmetric Shape, Pen tool, Warp Brush + Mesh Warp, Oil Brush + Chalk + Pastel + Crayon + Colored Pencil + Marker + Palette Knife + Smear + Art Eraser.

Though there are plenty to discover, most tools are fairly self-explanatory and can be mastered with a little practice.

Tool presets

Another powerful feature is the ability to record a favorite tool setting as a 'preset'. For example, you might have spent ages fine-tuning one particular brush look. By clicking on the Preset tab in that brush's options palette (and then 'Save') you can give it a name and save it for later use. Presets can be built up over time so that you have a customized library of user presets for different applications, like painting, web, print and layout.

'Photo' toolbar

If you deal with scanned or digital photos, this is the toolbar to get friendly with. Also on this toolbar are

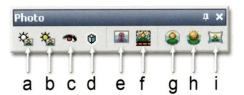

The Photo toolbar contains a number of highly useful tools including the Backlighting (a) and Fill Flash (b) filters, Red-Eye Removal tool (c), Unsharp Mask (d), Chromatic Aberration (e) and Digital Camera Noise Removal (f) filters, and three lens distortion filters: Barrel, Fisheye and Pincushion (g–i).

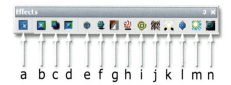

The Effects toolbar includes the Effects Browser (a), Buttonize (b), Drop Shadow (c), Inner Bevel (d), Gaussian Blur filter (e), Hot Wax (f), Brush Strokes (g), Colored Foil (h), Emboss (i), Fur (j), Lights (k), Polished Stone (l), Sunburst (m) and the Topography filter (n).

four new features. The Backlighting and Fill Flash tools help to correct exposure problems caused by problematic lighting conditions, and the Chromatic Aberration and Digital Camera Noise Removal filters help reduce colored fringing and noise problems that can occur in digital photos. See pages 17–20 for more about these new features. You can add tools for common photo enhance operations like Unsharp Mask by right-clicking the toolbar and selecting Customize from the contextual menu.

'Effects' toolbar

If you have had no experience using PSP but are curious how its effects might look when applied to a picture, click the first button on the Effects toolbar – the Browse Presets button. This loads and displays the Effects Browser, a sophisticated program that displays all of the available adjustment and effect filter presets. Click on a folder to see the entire contents, all of the artistic effects for example, or choose an individual preset from within one of the folders.

This is quite an eyeful, even for a seasoned image-maker! Double-click the effect you like the look of in the Browser and Paint Shop Pro transfers it to the photo in the work area. In this way you can preview the filter effect and save time by only trying effects that you like the look of. Other programs provide a list of effects but little clue as to how long or how effective any, or each, might be on the opened picture file.

What else is there on the Effects toolbar? 'Buttonize', 'Drop Shadow', 'Inner Bevel', 'Gaussian Blur', 'Hot Wax', 'Brush Strokes', 'Colored Foil', 'Emboss', 'Lights', 'Fur', 'Polished Stone', 'Sunburst' and 'Topography'. All are preset filter effects that can be applied to a selection, or globally, depending on application. All can be infinitely customized through the displayed options window. Customized filter sets can also be saved in the same way that customized tools can be preserved for imaging posterity.

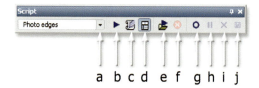

'Script' toolbar

While strictly not a tool as such, scripting offers incredible power to anyone with a bit more than the most basic of photo-editing requirements. What's scripting all about? As the name might suggest, a script is a file of instructions that produce a series of actions or

The Script toolbar has a number of features that include: Select saved scripts (a), Run selected script (b), Edit selected script (c), an interactive script playback toggle (d), Run script (e), Stop script (f), Start script recording (g), Pause script recording (h), Cancel script recording (i) and Save script recording (j).

effects – much in the same way that a play's script, when followed by a group of actors, produces actions that result in a play (hopefully!).

Paint Shop Pro ships with a small range of pre-recorded scripts but the fun really begins when you start to record your own. The Script toolbar is set up just like a video recorder. Press 'Record'; perform the actions you want on the selected picture (i.e. rotate + change contrast + save). It's that easy. Once saved, the script can be run on other pictures in the work area. It's a great way to automate, and thus perfect your working style and throughput, so important in jobs that require repetitive actions applied to multiple pictures (for example, in website design). This is an extension of the filter preset concept. Perform an action that produces a likeable result and record it so that it can be rerun on other pictures, or parts of a picture, when needed.

'Web' toolbar

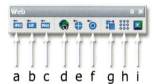

The Web toolbar contains a number of productivity-enhancing tools, including JPEG Optimizer Wizard (a), GIF File Optimizer Wizard (b), PNG File Optimizer Wizard (c), Preview in Web Browser (d), Image Slicer tool (e), Image Mapping tool (f), Offset filter (g), Seamless Tiling filter (h) and the Buttonize filter (i).

Put together specifically for web designers, this small toolbar contains an 'Image Slicer' tool, an 'Image Mapper' tool, 'JPEG', 'GIF' and 'PNG' image optimizers plus a 'Web Browser Preview' feature, 'Seamless Tiling' and a 'Buttonize' feature – most of the tools, in fact, needed to prepare images for your own website.

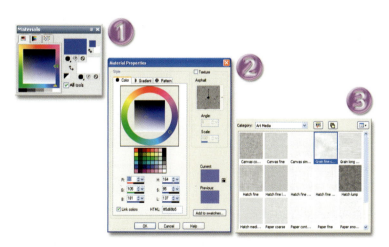

The Materials palette (1) is used for selecting foreground and background colors, gradients and patterns for all the painting and drawing tools. The Material Properties dialog (2) is used to fine-tune color selection, create gradients, and choose pattern and texture swatches (3).

Palettes

While the toolbar houses the program's main tools, it's the palette that displays all the options, in a window for each specific tool. Palettes don't have to be visible all the time and they certainly don't have to be accessed every time a tool is used. If you don't, Paint Shop Pro uses the settings from the previous time it was used. If that proves to be wrong, for whatever reason, you can reverse the process ('Edit>Undo' or keyboard shortcut 'Ctrl+Z'), open the palette and make adjustments to its controls before proceeding forward.

Paint Shop Pro X: advanced features

Tonal controls

Most of the processes mentioned in the previous section deal with single-button operations that perform a logical, but not always controllable, function. These are often good for the bulk of your photo-editing tasks, like simple color and contrast corrections. However, there'll come a time when you need to make detailed changes to a photo – this is where Paint Shop Pro's advanced tools save the day. Most are simply expanded versions of the one-button-does-all tool sets discussed previously.

One of the most versatile is the Histogram Adjustment feature, found under Adjust>

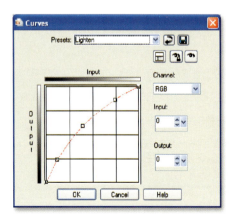

Curves offers tremendous tonal control over any digital picture.

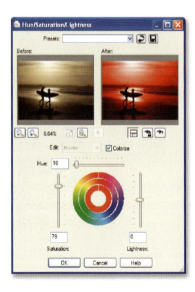

The Hue/Saturation/Lightness dialog provides an incredible range of color changing options, from black and white through to subtle color tints and dramatic colorizations.

Brightness and Contrast>Histogram Adjustment menu. With this you can set shadow and highlight values, as well as all the tones in-between (called the 'midtones'). A step up the sophistication scale is the Curves tool. Again, designed by professionals to get the maximum out of camera and scanned files, Curves is one of my favorites as it has almost limitless possibilities for tone control and creativity.

Color controls

Paint Shop Pro X provides a range of colour tools that enables you to make global changes to all of the colours in an image – for example to remove a colour cast – and to change some image colours whilst leaving others unaffected.

Tools like Color Balance, Hue/Saturation/Lightness and Hue Map require some understanding of how colour works to get the most from them, but even these sophisticated tools have something to offer the novice with features like Smart White Balance, warm/cool adjustment and a range of presets for dealing with common colour problems like colour casts caused by fluorescent lighting.

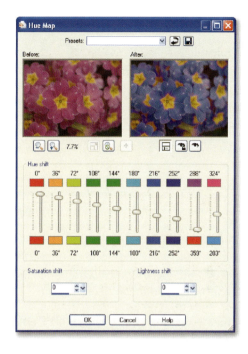

By adjusting the individual color sliders in the Hue Map dialog box you can change specific colours in an image whilst leaving others unchanged.

Tip

For lacklustre digital photos start with the One Step Photo Fix. This versatile command applies six different processes to the image: Automatic Color Balance, Automatic Contrast Enhancement, Clarify, Automatic Saturation Enhancement, Edge Preserving Smooth, and Sharpen.

Once you have got your head round the idea that all digital pictures require at least some tonal fix-ups, you'll begin to appreciate the power of selections. A selection allows you to isolate part of a picture so that you can then apply a change or filter effect to that selected area only. Paint Shop Pro not only has a wide range of selection tools but also a comprehensive range of

Not new but one of the favorites, Paint Shop Pro's Picture Tube can be used to spray images in the form of a continuous paint stream.

modifier features (under Selection Edit mode) that are so good as to shame most other photo-editing programs.

Perhaps, after tonal fix-ups and learning about selections, you'll move onto layers. Layers offer the digital image-maker incredible editing capabilities. You can add disparate picture elements to

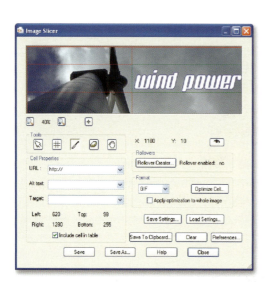

Web designers will be able to use Paint Shop Pro's many sophisticated Web Optimization tools like this Image Slicer tool.

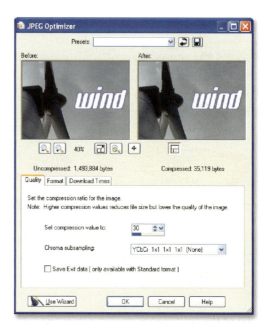

The JPEG Optimizer is designed so that you get the most from web quality and download speeds.

a 'master' picture file, move them about, change their colors and contrast, and then move them some more to make the weirdest montage effects imaginable. The reason you'd keep all these elements on layers is that you can move everything else in the frame even after it has been saved in a layered format. Once saved, in a flattened, non-layered format, you lose all editability. Layers can also be radically changed using layer masks or individual adjustment layers.

An extension of the layers concept brings us to the use of text. Paint Shop Pro has a text engine which allows you to add text, as a separate vector layer, to any document. Again, the advantage of this is that you can return to the picture at any time and edit the text layer, changing the size, font, kerning or other text-specific characteristics. Because this is done using a special vector layer (not pixel-based) there's no loss of quality. Vector text introduces us to the creation of vector shapes and art.

All digital scans and photographs are bitmap or raster files; they are made up from pixels, which explains, in some part, why a bitmapped image requires so much computing power to manipulate. An A4 photo contains more than 20 million pixels! Vector images, on the other hand, are made from mathematical calculations: dots and points on the canvas that are filled with flat or graded colors. An A4 vector illustration might only be a few hundred kilobytes at most. Besides a small file size, the beauty of vector art is that it's scalable. You can increase or

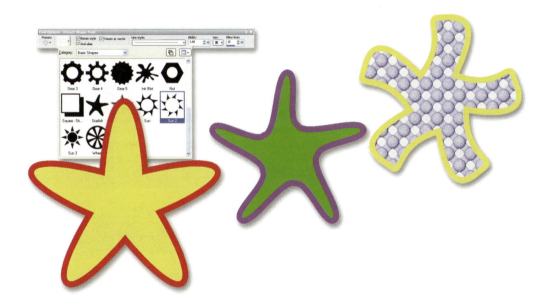

One of the advantages of vector graphics is that they can be resized with no loss in quality. Another consequence of their existence as mathematical constructs, rather than collections of dots, is that they can be easily modified. As well as changing the fill and stroke properties, the shape of these objects, created using the new Symmetric Shape tool, can be altered using Bezier handles to adjust the shape of the curve between two points.

decrease vector shapes to almost any dimensions with no discernible loss of quality. Enlarge a bitmapped file too much and it begins to look distinctly fuzzy around its edges. Vector images are created and edited using the Pen tool, one of the most sophisticated of all the tools. The Preset Shape tool and the new Rectangle, Ellipse and Symmetric Shape tools also create vector objects.

Other advanced features of Paint Shop Pro X include the use of layer and image masks, adjustment layers, gradients, the picture tube, sophisticated warping tools, a range of very cool printing aids, framing assistants, GIF and JPEG image optimizers, image mapping, and image slicing.

The Browser palette

The Browser palette helps with the task of finding and opening image files in Paint Shop Pro X. One of the difficulties with digital images is that it doesn't take long before you have so many of

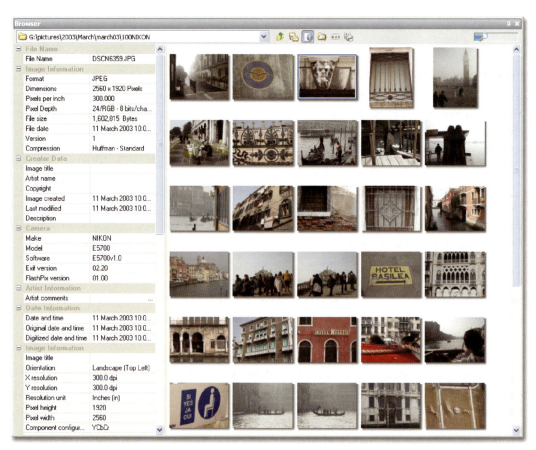

In the default layout the Browser palette is docked at the bottom of the screen, but you can undock, float and maximize it to get a better view of a folder's contents. Click the Info button on the toolbar to display EXIF and other image data that's recorded along with the image when you take a photo.

them that finding the one you want can take a lot of searching. Corel Photo Album 6 can help you organize your digital photo collection to make this task easier (see Chapter 10 – Corel Photo Album 6: Organizing your pictures) and the Browser can also help you quickly locate files, view information about them, sort them and open them for editing.

In previous versions of Paint Shop Pro the Browser has functioned as a separate application, but Paint Shop Pro X integrates it more fully so that you can find what you're looking for and get to work right away without having to waste time finding the image you want.

Using the Browser

> **TOOL USED**
> Browser

In the default workspace the Browser appears at the bottom of the screen below the main picture window. Initially, it shows the contents of the 'My Pictures' folder within 'My Documents'. You can increase the size of the Browser palette by hovering over the top edge until the cursor changes to a double bar with up and down arrows, then drag the edge of the palette upwards. Alternatively, drag the palette by its title bar and drop it anywhere in the workspace to undock it – you can then resize or maximize it like any other palette.

If you subsequently find the Browser is getting in the way and you haven't got enough room to edit, click the pushpin icon on the title bar and the palette will autohide and reappear when you mouse over it. If you prefer the default location and settings, click the Photostrip view button to redock the Browser at the bottom of the screen displaying a single strip of thumbnails.

To navigate to a folder of images on your hard drive, click the second button along on the Browser Palette's Button bar. This splits the Browser into two panes – a Windows Explorer-style pane on the left shows a hierarchical view of your PC's fixed and removable drives on the left and, when you click on a folder its contents are displayed in the pane on the right.

Initially, while PSP X catalogues the contents of a folder, it takes a short while for thumbnail images of you photos to be displayed. But on subsequent visits to the same folder the thumbnails will display much more quickly because PSP places a small cache file in the folder with all the relevant data. You can turn off this feature and set other Browser preferences by selecting File>Preferences>General Program Preferences and selecting Browser palette from the left pane.

In earlier versions of Paint Shop Pro you were stuck with tiny thumbnails, but PSP X provides a slider (it's to the right of the palette button bar with a magnifying glass icon) which allows you to increase the thumbnail size for a better view.

The button bar provides a number of other really useful features. Click the Image Information

button to replace the folder view with an Info panel. The Info panel displays image information such as the file format, image dimensions and file size, as well as EXIF data written to digital camera images along with the image pixel data. EXIF data can be quite extensive. Some of it, for example shutter speed and aperture information, metering mode, lens focal length and ISO speed, can be very useful to the digital photographer. Other EXIF data, like information from Global Positioning System (GPS) satellites, is intended for specialized applications such as scientific surveys.

You can add information, including the location where the photo was taken, the photographer's credit and a headline, to your images in the IPTC (it's an international press standard for image data) fields at the bottom of the Info panel.

The last button on the right of the Browser button bar opens the Browser Print dialog box which you can use to print a contact sheet of all the thumbnails in the current folder. The contact sheet uses the thumbnail images so it prints very quickly; the size and resolution of the

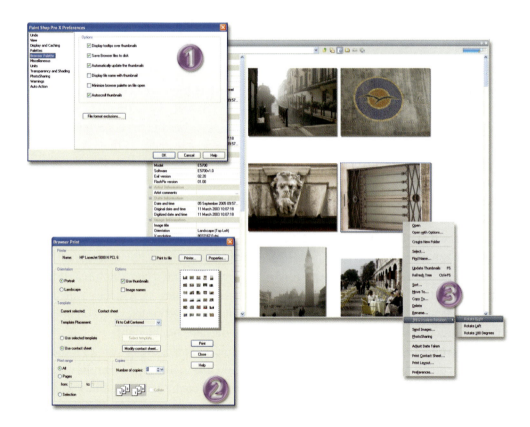

(1) Select File>Preferences>General Program Preferences to set Browser palette options like thumbnail cacheing and filename display. (2) Click the Print Contact Sheet button to display the Browser Print dialog and print a contact sheet of all the thumbnails in a folder. (3) Right-click a thumbnail and select JPEG Lossless Rotation to rotate images taken in portrait format. The Browser Palette context menu contains other useful options including 'Rename', 'Copy to' and 'Print Layout'.

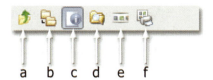

The Browser button bar provides quick access to the following functions: (A) move up one folder; (B) display folders pane; (C) display info pane; (D) Open folder in Windows Explorer; (E) Photostrip view; (F) Print contact sheet.

images are small, but that's not a problem for a contact sheet. If you want, you can choose from a number of templates, increase the thumbnail size, and even print the full resolution image rather than the thumbnail. But for multiple printing other than a quick sheet of contacts you're better of with Print Layout (see Chapter 8 – Print Preparation).

JPEG Lossless Rotation

Before we leave the Browser there's one other feature that digital photographers will find indispensible – JPEG Lossless Rotation. It doesn't have a button (perhaps we'll get one in Paint Shop Pro XI) but is accessed by right-clicking a thumbnail to display the context menu. JPEG Lossless Rotation allows you to rotate portrait format photos so that they are the right way up without any loss in image quality.

To understand why simply rotating an image would cause it to lose quality you need to know a little about how JPEG compression works. If you want to know more about this take a look at 'JPEG in depth' on page 236. In a nutshell, JPEG reduces the file size of digital images by removing information. You can remove a little, or a lot, but every time you do it the quality of your pictures deteriorates. To rotate a JPEG file some applications open the file, rotate it and then resave it – and that's where the quality loss occurs. Paint Shop Pro's JPEG Lossless Rotation cleverly rearranges the pixels in the JPEG file without ever opening and resaving it, so your rotated digital photos look every bit as good as the originals.

If JPEG Lossless Rotation is greyed out on the menu and you can't select it this means that the image is not a JPEG file. Check the suffix on the file name and you'll probably find it's a .tif, .pspimage or some other file format. You can rotate these files in the usual way, using the Rotate Right or Rotate Left buttons on the Standard toolbar, or by selecting the rotate options from the Image menu. You only need to worry about image quality when saving formats like JPEG that employ lossy compression.

Tip

If you forgot to set the date and time on your camera and your photos all have the wrong date and time (like midnight on January 1, 2000), you can correct it using the Browser. Select the affected thumbnails, right-click and choose Adjust Date Taken from the context menu.

Features new to Paint Shop Pro X

Interactive Learning Center

The interactive Learning center provides step-by-step guidance for common photo-editing and retouching tasks like rotating, cropping and straightening images as well as advice on how to use Paint Shop Pro's tools and effects to complete more involved projects. It's invaluable for beginners but is also useful for experienced users who aren't sure about a particular feature or technique.

Smart Photo Fix

Like One Step Photo Fix, the Smart Photo Fix feature provides a one-click method of 'toning-up' lacklustre images, but it also provides a degree of control over the process. Sliders provide control over tonal adjustments, saturation, sharpening and color balance, all in an easy-to-use panel with big before and after thumbnail previews.

Makeover Tools

The Blemish Fixer, Toothbrush and Suntan Brush can give your portraits an instant lift with very little effort. The Blemish Fixer can also be used for more general retouching where a more subtle effect than that which can be achieved with the Clone Brush is needed.

Red-Eye Tool

A much more straighforward tool than Paint Shop Pro's previous red-eye removal tool, just set the tool size and click on the eyes.

Object Remover

Like the Clone Brush, but easier to use, the object remover seamlessly replaces unwanted detail in a photo, such as a lamp post, tree, or other distracting background detail, with another part of the image.

One Step Purple Fringe Fix

A common problem with digital cameras, purple fringing is caused by lens abberations and the limitations of digital camera sensors. Purple fringing usually shows up as a thick purple fringe

around high contrast edges like tree branches against a bright sky. The One Step Purple Fringe fix does exactly what it says.

High Pass Sharpen

High pass sharpening is a professional sharpening technique that has some advantages over conventional unsharp masking, mainly – it's less likely to exaggerate nose and produce haloing.

Color Balance

If you don't know your additive from your subtractive primaries, then Paint Shop Pro's new Color Balance tool is the one for you. It automatically adjusts the white balance to remove color casts, then all you need to decide is whether you want to warm the colors up, or cool them down. There's also an advanced mode.

Black and White and Infra-Red Conversion Filters

These effects allow you to easily convert your images to black and white and to simulate shooting with infra-red and black and white film with colored filters for enhanced tonal reproduction.

One Step Noise Removal

Paint Shop Pro's existing Digital Camera Noise Removal provides powerful tools for cleaning up noisy images providing you have the time and know-how to use it effectively. For everyone else, there's now One Step Noise Removal.

16-bit support

You can open, edit and save 16-bit images in Paint Shop Pro X. The advantage of this is that you have more tonal and color information, so images have a higher dynamic range and are less prone to degradadation, like highlight and shadow clipping and posterization, when you make color and tonal adjustments. Some Paint Shop Pro X features require you to convert 16-bit images to 8-bit before you can use them.

Color Management

Paint Shop Pro's new color managment engine lets you work with embedded image color profiles to improve screen to print color matching

IPTC Metadata Support

Most metadata that's saved with images when you shoot them – the camera model and exposure settings for example – isn't editable. But IPTC fields are designed to allow you to record information about the photographer, the location of the scene and searchable keywords. You can now add and edit IPTC metadata in Paint Shop Pro.

Redesigned Browser Palette

The Browser is now docked in the editing workspace, but can be floated and maximized like any other palette. A zoom slider allows you to view thumbnails at different sizes and you can print a contact sheet containing the current contents of the thumbnails pane.

Redesigned Layers Palette

The Layers palette now displays a thumbnail image of the layer contents making it much easier to see how images are constructed and to identify specific elements like layer masks.

Pick Tool

The Move tool has been replaced with a new Pick tool which works like a combination of the old Deform and Object Selection tools.

File Open Pre-Processing

This feature allows you to run a script on files as they are opened. It's a time-saver if you want to automatically apply the same process to all images you open, such as the One Step Photo Fix. Or you might use it to automatically downsample 16-bit images to 8-bit, or anything else you have, or can write a script for.

Additional considerations for the digital darkroom

Digital image-making is not a cheap alternative to creating pictures with film. However, the added control and increased creativity that it brings to the photographer far outweighs its higher adoption cost.

At a basic level you'll need to buy gear to capture digital pictures, a device for storing and viewing those pictures, software (of course!) for retouching the pictures and some form of printer so that you can enjoy the fruits of your labor. (At worst, you can rely on your local photo-finishing

service to scan your film and supply commercial CDs.)

Digital cameras come in all shapes and resolutions although, to be fair, many offer remarkably similar features. The big differences lie more in the camera's resolution capabilities, the scope of its zoom lens and the capacity of its accompanying memory card. How you judge what resolution to buy is easy: look at your requirements and work backwards. For example, if you are only ever likely to use the camera for emailing and web illustration, you'd only need a 1.3 million pixel camera (or similar) as this is an ideal resolution for displaying work on a computer monitor, and that's all that's necessary for web work. A higher resolution will therefore be wasted.

A range of photo-quality inkjet papers is essential for all photo-editing enthusiasts.

If you want the highest quality from your photography, with a view to commercial printing, look for a camera with the highest resolution that your budget can afford. Other factors such as lens (glass) quality, image sensor dimensions (CCD), software processing capabilities (color and contrast), and physical handling characteristics also affect the results.

Computers are somewhat easier to understand. Buy a computer that has a fast CPU (processor or 'brain'). Because digital photos are information-heavy, they contain a lot of data so need a bit of power to shift. That said, what's almost as important is the computer's active memory or RAM (Random Access Memory). You need RAM to operate programs and you need

Digital photographers will inevitably need more than one memory card on which to store their digital camera snaps prior to loading them onto a computer for manipulating in Paint Shop Pro.

The Vosonic XS Drive Super contains a hard disk and slots for CF, SmartMedia, Memory Stick, SD, MMC and xD picture cards. Disk sizes range from 20Gb to 80Gb making it ideal for storing digital photos on the move and freeing up your memory cards. And you can also use it as an MP3 player!

Of course, no one would go far in this business without a good quality computer on which to store, view, manipulate, print or email digital pictures.

more RAM to open pictures on screen. It's not always necessary to buy the fastest processor, but it is important to load the computer with as much RAM as your (now depleted) bank balance might stomach. Also consider installing a faster graphics card (for brilliant color reproduction on screen), a second hard drive (for additional storage – digital photos take up heaps of space) and a good quality color monitor. With the latter, though costly, you get what you pay for.

Seventeen-inch monitors are now 'standard', although a 19-inch monitor will provide a significantly better viewing area for pictures, and a 21-inch monitor is the best (but considerably more expensive). It's worth paying the few extra dollars required to get a flat-screen version. This dramatically reduces annoying reflections, displays pictures more accurately and is generally easier on the eyes – an important consideration if you plan adopting this hobby full-time. A flat-screen LCD display is even better.

- ■ Software is available in a range of different types, from free giveaways to high-end products specifically designed for industrial strength commercial printmaking applications. Most perform an adequate job, although digital image-makers, with even a small amount of experience, discover that user-friendliness is as important as a program's feature list. While some are specific in their function, more are designed with a total package concept in mind, and it is into this latter category that Paint Shop Pro falls.
- ■ Desktop inkjet printers are also economical enough for anyone to buy. Having enough money to keep the ink tanks topped up is another matter. However, as a device for producing photo-realistic prints that last, in some notable examples, longer than real photo paper, this is a small price to pay, especially when compared to the advantages of immediacy, control and creativity.

Add to this the increasingly large range of digital printing services offered by commercial and professional photo labs for those who don't have the time or inclination to print at home and you have an attractive package for all requirements.

The consumer inkjet printer is fast becoming another imaging essential, as picture quality is both exceptional and long-lasting.

If you spend a lot of time making selections or creating digital art using a photo-editing program such as Paint Shop Pro, you'll find a graphics tablet essential in providing ease of use and incredible accuracy.

More accessories

Accessories for the digital image-maker are numerous and should be purchased to make your life simpler. I'd always advise digital camera users to buy a high-capacity flash memory card (512 Mb+) and third-party card reader. Extra memory allows you to shoot and store more pictures on one card. The card reader is permanently connected to make the job of downloading digital snaps quicker and more convenient (than having to connect the camera to the computer every time).

Also consider an extra removable disk, such as a CD-R, CD-RW burner or DVD-R, so that photos and other data can be stored off-computer; a range of inkjet papers to cover a variety of printing jobs, from business cards to high-quality digital photos; and of course, a fast email connection, such as cable, ISDN or ADSL, so that you can monitor and send pictures over the Internet with the minimum of fuss, delay or frustration.

Tip

Transferring files from your camera, or card reader can be a slow process, particularly if you've got lots of high resolution images on large capacity cards. When buying equipment, make sure it's equipped with the faster USB 2.0 connection, sometimes labelled as 'Hi-speed' USB

Creating pictures using film, digital cameras and scanners

There are dozens of ways to get digitized or 'digital' pictures: shoot them with a digital camera; scan them from black and white and color prints; or even scan them directly from film. You can also open them directly from your own computer hard drive (if there's anything there) and you can copy them from another computer, if connected. You can also get them from a variety of removable media (such as free CDs, DVDs, floppy and Zip disks) and, of course, you can get them from the Internet. You can even make digital pictures from scratch using Paint Shop Pro X and nothing more.

Digital cameras are now an essential part of the image-maker's toolbox. Even some of the cheaper consumer products produce image quality that's hard to pick from regular film.

Scanning has been the prevalent method of digitizing a physical photo into one that can be viewed and manipulated electronically. Two types of scanner are used for this task: regular desktop flatbed scanners that are designed to digitize flat artwork and photos, usually up to A4 in size; and film scanners. The latter are usually more expensive – and limited to scanning film only. Several different types of film scanner are available, the most common being those designed for 35 mm film – although many now ship with adaptors as included extras.

Interestingly, most desktop flatbed scanners can also scan film, although not to the quality and resolution of a dedicated film scanner. They have a small light box built into the scanner lid that provides enough illumination to scan transparent materials (like film and overhead transparencies).

If you are planning on buying a scanner to digitize an existing collection of photos, unless you have a large collection of transparencies or negatives, an inexpensive flatbed scanner will easily be up to the task with sufficient resolution to scan even small prints so that they can be reproduced up to A4 size.

For occassional scanning of slides and negatives, flatbed scanners do a reasonably good job, but the resolution is insufficient to enlarge a 35mm frame up to a reasonable size. Also, at these magnifications, shortcomings in the scanner's light source, optics and CCD sensor combined with any dust or scratches on the film can result in quite poor quality results.

Desktop scanners, whether film or flatbed, are also becoming part of the landscape, producing impressive results.

If your pre-digital photography days were largely occupied with shooting color transparency film you should consider investing in a dedicated film scanner. The sensor, optics and light source in these devices are designed specifically for scanning film and produce far superior results than a flatbed scanner which is designed primarily for scanning reflective material. Most film scanners also include, or offer as an option, a feeder tray that allows you to scan multiple slides in mounts and negative strips.

Pictures for nix

The Internet has thousands of sites and tens of thousands of web pages dedicated to giving away free pictures: web art, clip art, print art, you name it, it's there! All stuff that's useful in some context, but often useless in others. Free pictures tend to be the ones that no one else requires, the sort of stock that top image libraries have thrown out because they now have better quality pictures. Even so, some stuff is still 'OK' and, with a little help from Paint Shop Pro's tools, most can be converted into impressive multi-image artworks.

Establishing reliable picture sources is one matter, being able to open and view everything is another! Digital files come in all shapes and sizes. Some, like the JPEG file format, are readable by almost every photo-editing program you'd care to mention; others are not so hospitable.

Thankfully, Paint Shop Pro X doesn't suffer from file-opening limitations. In fact, you can use it to read and open a staggering array of file formats from a wide range of sources. Paint Shop Pro X also allows you to open and work on images saved in many proprietary camera RAW formats – so-called digital negatives that preserve all of the image data without pre-processing in the camera, so you can make the most of it in Paint Shop Pro.

STEP-BY-STEP PROJECTS

Exploring the Learning Center

Whether you're new to Paint Shop Pro, or an old hand it's worth taking a little time to explore the Learning Center and see what it has to offer. As well as taking you step-by-step through basic editing techniques, like cropping and rotating images, the Learning Center can help you with more ambitious projects like producing a photomontage and advanced editing techiques like digital camera noise removal.

STEP 1

If the Learning Center isn't on the home page, click the Home button. Topics are divided into seven categories; Get Photos, Adjust, Retouch and Restore, Collage, Text and Graphics, Effects, and Print and Share. Click on any of these to view the list of available projects. You can get back to the home page either by clicking the Home button, or the Back button at the top of the Learning Center palette, just like in a web browser.

STEP 2

Click the top option, Get Photos and on the next page click Browse. This panel gives basic instructions on how to use the Browser. You can find out more from the relevant section in the Help file which you can read by clicking the More details at the bottom.

STEP 3

Follow the instructions to open an image from your hard disk using the Browser, then click the Home button to return to the home page.

Straightening an image

STEP 1

It's often not until you get to look at your photos on screen that you realize the horizon isn't level. Deliberate tilting of the camera to create a dynamic angle is one thing, a horizon that runs downhill, whether due to a tilted camera or skewed scanning, is generally to be avoided and can easily be fixed. Use the Browser to open the offending image and click the Adjust button on the home page of the Learning Center.

STEP 2

Click the Straighten button in the Learning Center. The Straighten tool is automatically selected for you (it's the sixth tool from the top of the tool bar and looks like a tilted rectangle) and a line appears in the center of your image.

STEP 3

The panel in the Learning Center tells you exactly what you need to do to straighten the image. Move the endpoints of the line until it lines up with a horizontal or vertical line in the image – in this case the horizon.

STEP 4

Then click the Apply button, or double-click the photo to apply the straightening.

Perspective correction

STEP 1
As well as straightforward editing tasks like opening and straightening images, the Learning Center can help you with more advanced techniques. The Perspective Correction tool can be used to straighten 'converging verticals' – the tendency for tall buildings to appear to be falling backwards when you tilt the camera upwards. Start by opening the problem photo and selecting the Adjust button on the Learning Center home page.

STEP 2
Click the Advanced Adjustments button at the bottom of the panel, followed by the Perspective Correction button. The Perspective Correction tool is automatically selected and a rectangular box appears in the center of the image window.

STEP 3
Follow the instructions in the Learning Center to align the box with the edges of the building. If the building shape is irregular and you find alignment difficult, enter a number of around four to eight in the Grid Lines box in the Tool Options palette. This applies a grid to the perspective rectangle, making it easier to align it with what should be vertical features on the building.

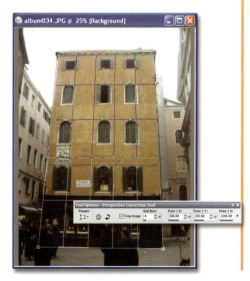

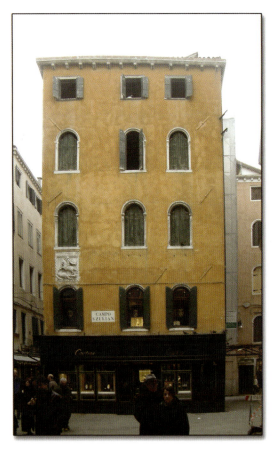

STEP 4
Click the Apply button to correct the perspective distortion, If you check the Crop Image box the edges of the photo will be cropped to remove the white space that appears as a result.

Cropping pictures

After a while you'll find you can do without the Learning Center for simple and even more advanced editing tasks. Most pictures need cropping for aesthetic reasons and there are very few pictures that can't be improved by removing some of the detail around the outside to focus attention on the central subject. You might also want to crop a picture to change its proportions for printing, for example so that it will fit a 4 x 6 inch or 5 x 7 inch frame, or a space on a web page.

Tip
Select the Crop tool, click the Presets button on the Options palette and select one of the preset crop sizes from the pull-down menu. You can save your own crop settings to this list, enabling you to quickly apply custom crop settings to any number of images.

STEP 1

Open a picture and choose the Crop tool from the Tools toolbar. The image area outside the crop rectangle is shaded. Adjust the crop area size or position.

STEP 2

Click inside the crop area and drag to reposition it. You can constrain the crop area to its existing proportions by holding down the shift key. If you're cropping for a standard sized photo frame choose a preset from the options palette.

STEP 3

When you're satisfied with the area you've chosen double-click in the crop area, or click the Apply button (the green check mark) on the Tool Options palette to crop the image. The inside section of the marquee remains while the image contents outside the crop area are discarded. Care must be taken so as not to crop off too much! If it is not right, choose 'Edit>Undo' or Ctrl+Z.

If you know the dimensions that the picture is to be cropped to, click the 'Specify Print Size' checkbox and enter the dimensions in the Width/Height and Units fields provided. The crop area automatically appears in the correct proportions for the desired crop. If you have many photos to be cropped for, say, a web gallery, this is a very productive tool. Click-drag any of the corner 'handles' or edges to expand or contract the crop dimensions while maintaining proportions.

You can also snap the Crop tool to a previously made selection in the image, its layer opaqueness or a layer's merged opaqueness. Once the cropped image is saved, the discarded area cannot be recovered. As a general rule you should click File>Save As to save a copy and make sure you have the originals safely backed up on a CD!

2

Simple Picture Manipulation: Improving Your Digital Photos

TECHNIQUES COVERED AND TOOLS USED IN THIS CHAPTER

Techniques
Adjusting color saturation
Adding soft focus effects
Controlling picture contrast
Correcting color balance
Changing image colors
Fixing exposure problems
One-button photo fix-ups
Sharpening photos

Tools
Backlighting filter
Brightness/Contrast
Channel mixer
Clarify filter
Color Balance tool
Colorize
Curves tool
Fade Correction filter
Fill Flash filter
Highlight/Midtone/Shadow
High Pass Sharpen filter
Histogram Adjustment tool
Histogram equalize
Histogram palette
Histogram stretch
Hue Map tool
Hue/Saturation/Lightness
Levels
One Step Photo Fix
Red/Green/Blue
Sharpen filter
Sharpen More filter
Soft Focus filter
Threshold tool
Unsharp Mask filter

This chapter explains how to use Paint Shop Pro's tools to improve digital photos that suffer from common problems like incorrect exposure, or are simply a bit dull and lifeless and need polishing up. Paint Shop Pro X has a selection of tools like One Step Photo Fix, Smart Photo Fix and Color Balance which do most of the work for you and make it easy to get good results with very little effort. We'll take a look at these first of all.

Later in the chapter we'll look at some of the more advanced tools for enhancing image quality like Levels, Histogram Adjustment, Unsharp Mask filter and Paint Shop Pro X's new High Pass Sharpen filter.

Previous versions of Paint Shop Pro had a wide range of automatic tools for 'fixing' below par photos including Automatic Color Balance, Automatic Contrast Enhancement and Automatic Saturation Enhancement. These have now all been incorporated into the new Smart Photo Fix feature which makes things much simpler. But before we talk about that, let's first take a look at the One Step Photo Fix feature

TOOLS USED

One Step Photo Fix Smart Photo Fix

One Step Photo Fix

As the name suggests, One Step Photo Fix applies a 'one step' correction to improve overall image quality. What One Step Photo Fix actually does is make tonal adjustments to improve image contrast, boost (or in some cases reduce) the color saturation, sharpen the image and correct the color balance.

There's nothing for you to do other than select Adjust>One Step Photo Fix and wait for a second or two for the filter to do its work. For most photos you'll see a marked improvement in image quality.

Smart Photo Fix

If the One Step Photo Fix doesn't quite do the job, or you just like to tinker, you'll get more satisfaction, and quite probably a better result, using Smart Photo Fix – it's the next option down on the Adjust menu.

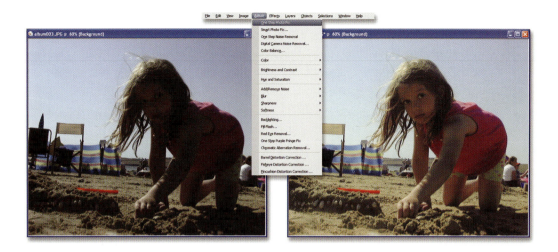

One Step Photo Fix does all the work for you – just select it from the Adjust menu, sit back and await the transformation.

Smart Photo Fix does exactly what One Step Photo Fix does, only you get access to the individual controls which determine the degree of correction applied. In other words the smart component is supplied by you.

Like most Paint Shop Pro filters, Smart Photo Fix has before and after preview thumbnails so you can see the effect your changes make before applying them. Click the maximize button at the top right of the dialog box to get the best possible view, or, if you don't have much screen space, click the Auto Proof button to see changes previewed in the image window.

Advanced options

The first thing you should do when using Smart Photo Fix is click the Advanced Options checkbox. This reveals the histogram and Color Balance tools. The histogram provides important information about the tonal range in the photo – see the 'Histogram' section later in this chapter to find out why this is important.

When you open the Smart Photo Fix dialog box it automatically analyzes the photo and sets all of the controls to where it thinks you will get the best improvement in image quality. This is exactly what happens when you use One Step Photo Fix, except in this case the settings aren't applied and you can use them as the starting point for further refinement. If at any point you feel that you've gone too far with the sliders and want to get back here, just click the Suggest Settings button. Alternatively, if you select Default from the Presets pull-down menu you can start from the original uncorrected image and make your own adjustments. When you've arrived at settings that work well for a particular kind of problem, for example underexposed photos, save the settings as a preset so that you can easily apply them to other problem images.

PAINT SHOP PRO X FOR PHOTOGRAPHERS

SIMPLE PICTURE MANIPULATION

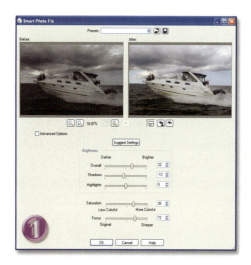
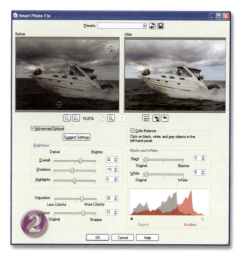
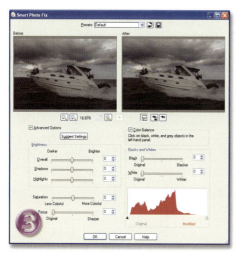
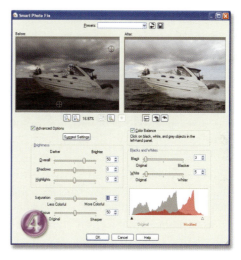

Select Adjust>Smart Photo Fix to open the Smart Photo Fix dialog box. (1) On opening, the image is automatically analyzed and suggested settings applied which you can see in the preview thumbnail on the right. No changes are actually made to the image until you click the OK button. (2) Click the Advanced Options checkbox to display the Histogram, Color Balance and Black and White controls. The histogram is a graphical display of the tonal distribution in the image and provides indispensable feedback when making tonal adjustments. (3) Click the Suggest Settings button to get back to the original situation, or select Default from the Presets pull-down menu to remove all correction and start from scratch. Incidentally, in this mode you can see the typical histogram for an underexposed photo with all the pixels on the left (shadow) side of the histogram and nothing on the right (highlight) side. (4) For this image, the suggested settings were improved upon by increasing the overall brightness, reducing the saturation, removing the shadow adjustment, and unchecking Color Balance as there is no cast. The amount of sharpening has been reduced to avoid exaggerating the noise that will become more visible as a result of the large brightness adjustment. Note the adjusted histogram (pink) which now shows a more even distribution across the tonal range from shadows to highlights.

Brightness

The Brightness panel contains three sliders: overall, shadows, and highlights which allow you to adjust the brightness individual in these areas. If the shadows in your photo are very dark you can use the Shadows slider to bring out some detail in them without making the highlights too bright. If a photo is just generally too dark use the Overall slider to brighten it throughout the range.

The best way to judge whether you're doing the right thing is to take a look at the 'after' thumbnail preview on the right and compare it with the original on the left. Sometimes, though, it can be hard to tell whether you're making things better, or worse and this is where the histogram can help.

Using the histogram

The histogram is a graph of the values of all the pixels in the image. Dark pixels have low values and light pixels have high values. Black is 0, white is 255, mid-grey is 128. So the histogram shows the distribution of pixels in the image from black to white with darker pixels on the left and light ones on the right.

The shape of the histogram depends to a certain extent on the nature of the subject, but generally speaking the histogram should show a reasonably even distribution from black to white.

Typical problems like under and overexposure have very characteristic histograms. In an underexposed image there's a predominance of dark pixels and few, if any, white ones so the histogram tends to be bunched down at the left-hand end. In overexposed photos the histogram is bunched at the right-hand end, with no black or very dark pixels.

Another problem that is easily confirmed by a quick look at the histogram is lack of contrast. Images that lack contrast look flat and dull. They lack punch due to the absence of pure black and pure white pixels. The tonal range starts at light grey and ends at dark grey, and the histogram this time is all in the middle of the range with no pixels at either end.

In the Smart Photo Fix dialog box when you make an adjustment with the Brightness sliders the histogram displays a pink overlay which shows you how the tonal distribution of pixels changes; the original histogram appears in grey. If you drag any of the sliders towards the right (brighter) direction you'll see the histogram move the same way. Dragging the Shadows and highlights sliders moves the histogram at the ends, while the Overall slider moves the whole thing, but the middle more than the edges.

The important thing to remember when making adjustments with the brightness sliders is not to let the histogram slip off either end of the chart – it should taper off just before reaching the end. If you allow pixels to drop off the end of the histogram, you are losing image detail – in the case of highlights remapping every pixel that is light grey to pure white and, in the shadows, turning darker detail pure black. This applies to all dark and light colors which are represented by grey pixels in the red, green and blue channels.

PAINT SHOP PRO X FOR PHOTOGRAPHERS

SIMPLE PICTURE MANIPULATION

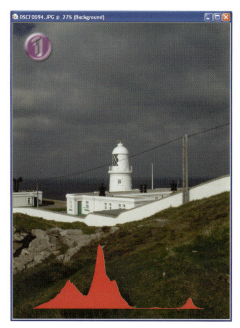
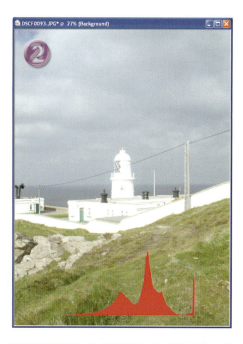
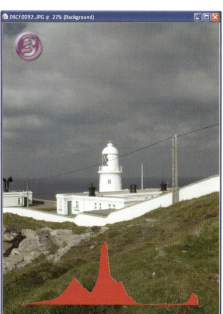
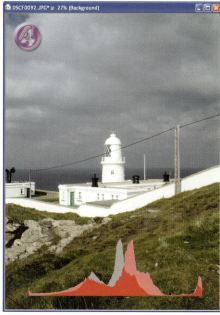

Understanding histograms will help you make the right decisions about tonal adjustments. (1) In underexposed photos the graph is bunched down the left-hand side. (2) The histogram for overexposed photos is squeezed up on the right-hand side. (3) The correct exposure shows most detail in the central area of the histogram, but the image lacks contrast. (4) Smart Photo fix improves things by 'stretching' the histogram to produce true blacks and whites, but be careful; using these settings will lose some highlight detail in the lighthouse building – note the clipped bunch of pixels on the far right of the histogram.

Blacks and Whites

To quickly fix contrast problems use the Blacks and Whites sliders. Remember, a flat image lacking in contrast has a histogram that's bunched in the middle and doesn't make it to either end of the histogram. Drag the Black slider until the black triangle under the histogram is underneath the left most edge of the graph, then do the same with the White slider, positioning the white triangle under the right-most edge. Smart Photo Fix 'stretches' the histogram, mapping the darkest grey to black and the lightest grey to white and adjusting all the tones in-between.

Saturation

The Saturation slider makes all colours more vivid when you slide it to the right and less vivid when slid towards the left. Depending on your camera settings you may find that increasing the saturation by up to 20 gives you much punchier colors, but beware of going too far.

Color Balance

To correct an overall color cast in your pictures check the Color Balance box and click on areas of the image which should be neutral in colour – i.e. pure blacks, whites and grays in the left-hand thumbnail. Smart Photo Fix places a cross-hairs target where you clicked and automatically

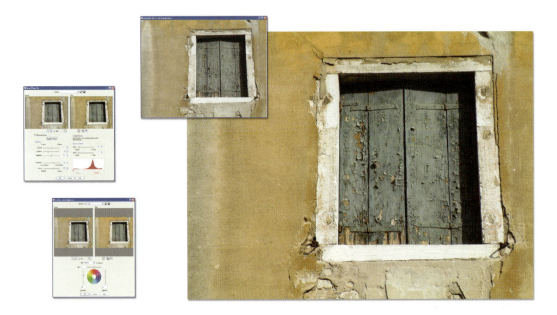

Sometimes, all a photo needs to give it a lift is to boost the color saturation. In this case, the saturation has been increased by +30. You can do this using the Saturation slider in either the Smart Photo Fix dialog box, or the Hue/Saturation Lightness dialog box.

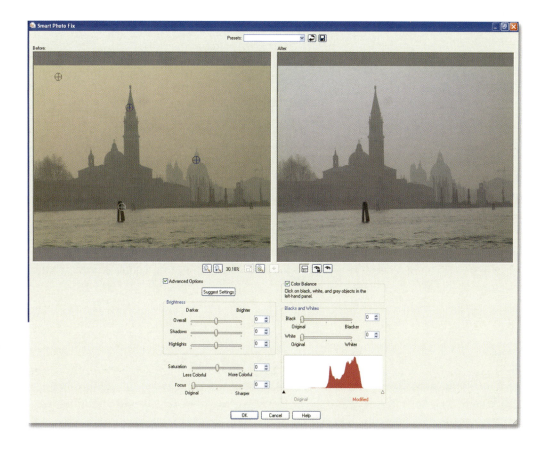

Check the Color Balance box in the Smart Photo Fix dialog to remove an unwanted color cast from a photo. Click in the left thumbnail image to place cross hair targets where the color should be black, white or neutral grey.

adjusts the colors in the image. Often you'll find one target is sufficient; you can place as many as you like, but, at most, three or four will do the job. To remove a target, just click it with the eyedropper.

Focus

The Focus slider applies the Unsharp Mask filter. For most images, the suggestion setting, which will be around thirty, is plenty. Be wary of applying large amounts of sharpening to photos that have had a lot of tonal adjustment as you can end up exaggerating noise. You should also make sure to look at the preview thumbnail at 100% magnification (there's a special button for this underneath the thumbnails).

Color Balance

To use Paint Shop Pro X's new Color Balance tool select Adjust>Color Balance. Like the Smart Photo Fix dialog box Color Balance has a basic and advanced mode. In Basic mode it couldn't be simpler to use – you just drag the slider to the right to make photos warmer, and to the left to make them cooler. If you simply want to neutralize a color cast check the Smart White Balance box and set the slider in the center.

For more control over color balance check the Advanced Options box. This divides the dialog box into two panels. The tools in the White Balance panel are used to identify the original conditions under which the photo was taken; you then use the sliders in the Enhance Color Balance panel to make further minor adjustments.

This can be a little counter-intuitive if you're not used to it because dragging the Temperature slider in the White Balance panel towards warm actually makes the image cooler, or more blue. This is because you're telling the program that the original lighting conditions were warmer than those depicted in the unadjusted image.

> **Tip**
>
> In the Color Balance dialog box, clicking either side of the slider makes a fixed increment adjustment. The Color Temperature sliders increase or decrease by 100 and the tint sliders go up or down (depending on which side you click) by ten. Alternatively you can enter a figure in the number field or use the toggle buttons to increase or decrease the amount by

For example, if you set your camera's white balance for indoor use, and then go and take photos outdoors without resetting it, all of your pictures will have a blue cast. This is because daylight is much cooler (or more blue) than the artificial indoor light that you've set the camera up for.

In the Color Balance dialog, by dragging the White Balance Temperature slider towards cool, you're saying that the actual color temperature of the light this picture was taken in was much cooler than what the camera was set up for and recorded – and the blue cast is eliminated.

There's another way to get rid of unwanted color casts in the Color Balance dialog box and that's to use the Smart Select button. This works in a very similar fashion to the Color Balance option in the Smart Photo Fix dialog box, except that you only get to place one target on a black, white, or neutral grey area. This isn't as much of a limitation as it might seem as one sample is all you really need. If it doesn't produce the desired results just click somewhere else in the image and carry on sampling until you hit somewhere that does.

When you're happy that the color cast has been neutralized you can use the sliders in the Enhance Color Balance panel to fine-tune the result.

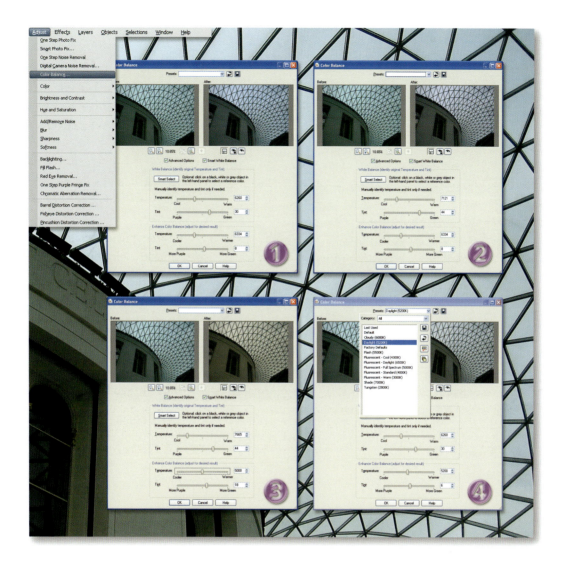

Nearly all digital cameras have an automatic White Balance feature which in most circumstances works well to assess the prevailing lighting conditions. It's not foolproof however and in this instance has resulted in a blue/green cast. (1) When you select Adjust>Color Balance the image is automatically assessed and the preview thumbnail on the right shows you what the corrected image will look like. These settings are based on an automatically selected neutral area indicated by the cross hair target. (2) To select a different neutral area click anywhere in the left thumbnail; keep trying different locations to see if you can improve the result. (3) You can nearly always improve things by making your own adjustments using the sliders – in this case to produce a more neutral, slightly warm result. (4) The Color Balance dialog is one of the few to offer a useful set of ready-made presets – just pick the one that most closely resembles the lighting conditions under which the photo was taken. Here, the Daylight (5200K) preset produces near perfect results.

You can use the Fade Correction on any pictures – not just those that have faded through age. Though it takes a little more effort, you'll get better results with the other color and tonal correction tools.

Other tools for correcting color problems

For most situations Smart Photo Fix provides all the tools you'll need to sort out exposure problems and remove unwanted color casts from your photos. But it's not the best way to deal with every problem, and it's always good to have alternatives. The following tools not only provide an alternative route to sorting out problem photos, but they can be used creatively to introduce new color and tonal effects. Chapter 3 shows you how to introduce color into black and white images using some of these tools.

Channel mixer

Although it appears under the Adjust>Color menu, the Channel mixer isn't the best tool with which to make color changes to photos. The most practical use for the Channel mixer is to produce black and white images – this is covered in Chapter 3.

Fade Correction

The Fade Correction tool is intended for use on, you guessed it, faded photos. The inks and dyes used in photographic printing processes aren't permanent and, as anyone with prints more than a few years old will know, they tend to fade with age. Exposure to the air and light accelerates this process but, even if you keep your photos in a sealed box, after a few years they won't look as good as the day they were printed.

The Fade Correction tool is a one-step solution to this problem. There's only one setting – use the Amount slider to vary how much correction is applied. Fade correction boosts the saturation and makes a levels adjustment, so if you're confident about making those changes individually, you'll have more control using Smart Photo Fix, or Hue/Saturation/Lightness and any of the tonal adjustment tools. It'll take a little longer, but you'll have more control and obtain better results.

Red/Green/Blue

Red/Green/Blue allows you to add, or subtract color from the individual RGB channels in the image. It works a little like the Channel mixer, only slightly more intuitively. The trick with

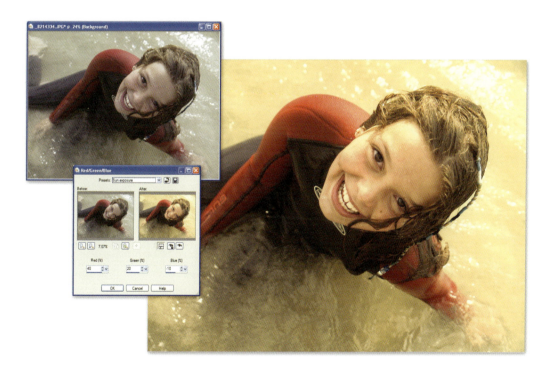

Red/Green/Blue can be tricky to use for color correcting, but it's good for effects like this 'Sun exposure' preset.

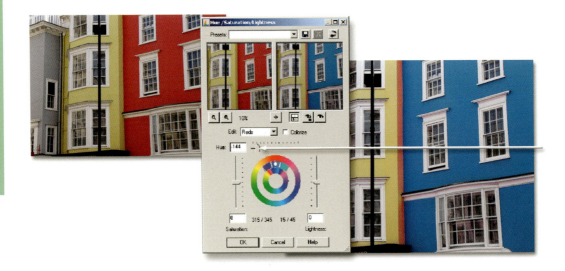

By matching a subject color with one of those displayed under the 'Master' drop-down menu and then shifting the Hue values you can radically change the color in one part of the picture while not affecting anything in the rest of the picture.

Red/Green/Blue is to make sure all your adjustments add up to zero, otherwise you'll affect the brightness of the image. For example, if you add 20 to the red channel you should subtract 10 from both the Blue and Green channels (or two other amounts that add up to 20).

Red/Green/Blue has a few useful presets, like 'Sun exposure' which produces a color cast simulating the warm tones of late afternoon sun. And you can of course save your own presets.

Hue/Saturation/Lightness

While it's simple enough to change contrast and color in a photo using the Histogram and Color Balance tools, not all picture-makers take the time to adjust the color hue and its intensity or 'saturation'.

Paint Shop Pro's Hue/Saturation/Lightness or 'HSL' tool ('Adjust>Hue and Saturation>Hue/Saturation/Lightness') is a specialized feature that encompasses controls to change specific color values within a picture, rather than by simply increasing or decreasing its color shades.

What this means, in English, is that you can choose the yellow values and shift them to blue. When this is done, all other colors shift the same amount. So reds shift to green, blues to yellow, and so on. The outer color circle in this dialog represents the original color while the smaller inner color circle represents where that original color has been shifted to.

This tool can be used to remove slight color casts in a picture or to add specific color effects that you might not be able to achieve using one of the Color Balance tools. For my money, the

real power in this feature is its ability to shift color values in individual color channels. On some pictures this works as if you have custom-made selections built into the picture.

For example, if it's a snap of a green-colored car, you'll be able to select 'Green' from the 'Master' drop-down menu and change the Hue values so that only the car color changes. How neat is that? If there are other green objects in the frame, these will also change color proportionally; while the selection concept works OK, it's important to note that it's color-specific, not pixel-specific. Options include 'Reds', 'Greens', 'Blues', 'Cyans', 'Magentas' and 'Yellows'.

What else can be done using this tool? While hue is an expression of color values within a picture, saturation refers to the intensity of those colors. Saturation is often where we come unstuck! If a photo looks a bit dull you might naturally reach for the Auto Saturation Enhancement tool ('Adjust>Hue and Saturation>Automatic Saturation Enhancement' or from the Photo toolbar) and crank it up fully in an attempt to make the photo more attractive (set to 'More colorful' and 'Strong').

Superficially this might work quite nicely and will certainly produce seriously attractive colors on screen. However, the trouble with radical saturation increase is that often it becomes unprintable because so much color has been added to the image it's impossible to match using regular inkjet printer inks. The machine will keep firing ink at the paper without any apparent color change. Care must be taken at all times not to overdo the saturation and make an unprintable result.

You can also use this dialog to change the lightness of the image – although I'd leave this well alone and choose the Levels dialog to perform these actions. The only exception to this rule might be if you are using the tool to make backgrounds – in which case the picture integrity is not paramount. Another neat effect is to colorize the picture by clicking the tab. What does

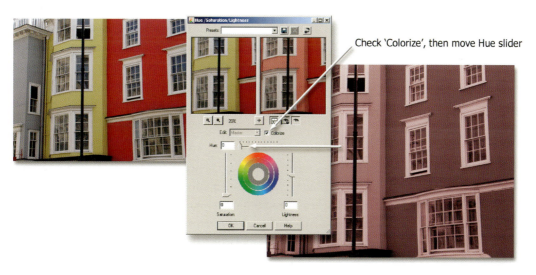

With the Hue/Saturation/Lightness dialog open, check the Colorize box and watch as Paint Shop Pro tints the entire image. Use the Saturation slider to temper the effect.

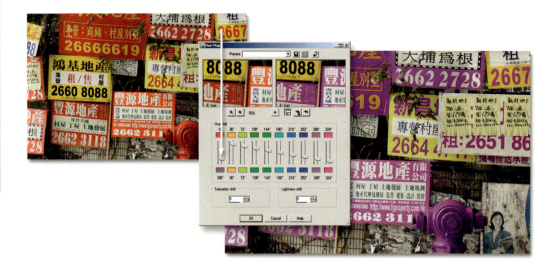

The Hue Map looks a bit scarier. Match a color with one of the colors displayed in the dialog and shift them, using the provided slider, to another value. Fine-tune the effect using the two fields at the base of the dialog for Saturation and Lightness shift.

this do? Colorize essentially applies an old-fashioned tinting effect to the picture by reducing its saturation, almost to monochrome, and adding a specific single color hue. The result is a beautifully tinted light blue/red/yellow/green picture. You see this type of effect a lot in advertising, as it's particularly effective in evoking a mood or specific period in a picture. Click the 'Colorize' tab and move the Hue slider, noting how the color in the tint changes. Move the Saturation slider more to increase or reduce the intensity.

If colorizing as a special effect is all you are after use the Colorize dialog ('Adjust>Hue and Saturation>Colorize'). This is faster and less complicated than the full-on HSL tool, plus it has the additional benefit of having vari-colored 'amount' sliders that display the part of the spectrum that the sample is taken from. This is a nice touch.

Hue Map

The Hue Map is another slightly off-center tool used to change specific colors within a picture. This is similar to applying a color change using the HSL tool on a specific channel, as just described. You can select a particular color, move the appropriate slider to choose another hue for that color only and check the results live. If you then want to change that second color, you must remember to go back to the original slider to make the change, rather than selecting a color that matches the changed state. Paint Shop Pro used the original color information as the source for its changes. Check the preview window to locate the (original) color source. Try the Color Replace tool to get a similar result.

Other tools for correcting exposure problems

On the Brightness and Contrast submenu of the Adjust menu you'll find no fewer than nine tools for adjusting the tonal values in your pictures. Why so many? Well, many of these tools do the same thing in a slightly different fashion. As you become more experienced you'll no doubt find your own personal favorite. For some people, Levels is the only way to make tonal adjustments to an image, others swear by Histogram Adjustment. There is at least one tonal adjustment tool that's probably best avoided, so we'll deal with that first.

Brightness/Contrast

This is the first option on the Adjust>Brightness and Contrast menu – give it a rearward glance every time you flash past it on your way to more useful tools. The problem with Brightness/Contrast is that it applies a blanket adjustment across the tonal range – there's little that's sophisticated or subtle about it.

When you drag the Brightness slider to the right, each and every pixel value is increased by the same amount and the result is that the highlights in your image quickly disappear. The same happens to the shadows when you go in the opposite direction. Let's waste no more time on it.

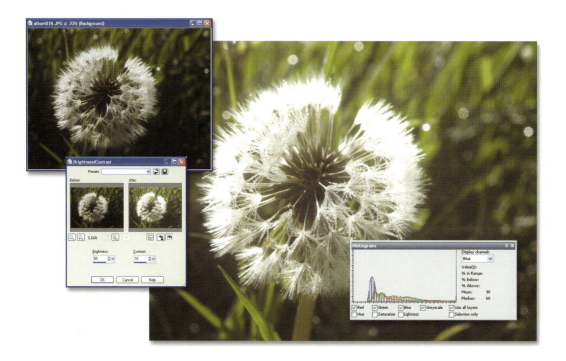

OK, this is the last word on Brightness/Contrast. A quick glance at the histogram reveals the damage – no more highlights and shadows turned to mush. You have been warned!

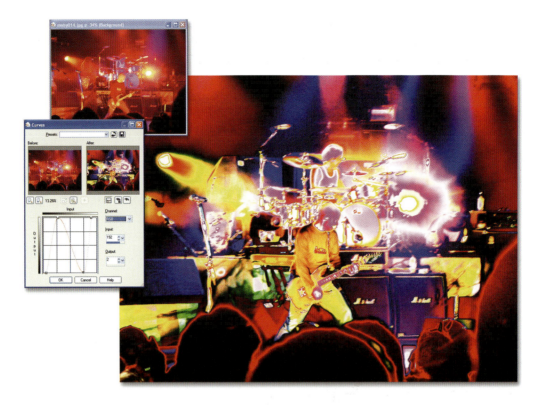

Use Curves for ultimate control over specific parts of the tonal range, or special effects. To create a solarization effect make the curve S-shaped or reverse the slope to produce a negative.

Clarify

Clarify applies a contrast boost to photos and sharpens them. As a one step method for cleaning up photos that lack oomph it works pretty well but, once you've read the section on sharpening later in this chapter, you'll probably want to take a more hands-on approach.

Curves

In some ways, Curves is the most versatile of the tonal adjustment tools because it allows you to experiment with altering pixel values in any one part of the range without affecting the rest. The curve is also a simple concept to grasp. Input values are displayed on the horizontal axis and output values on the vertical axis, so initially the curve is in fact a straight diagonal line running upwards from left to right at 45 degrees.

Dragging the top end of the line horizontally to the left has the same effect as dragging the Highlight Input slider in the Histogram Adjustment or Levels tool to the left. If you click in the center of the line a control point is added and dragging this is akin to moving the Gamma slider in Histogram Adjustment or Levels.

But neither of those tools can match Curves when it comes to tweaking a narrow range of tones. By adding additional points to the curve and adjusting them, you can tweak the shadows whilst leaving the highlights untouched. You can also use Curves for extreme tonal effects. You can create a solarization effect (traditionally achieved in the darkroom by momentarily switching the lights on halfway through processing) by making the curve S-shaped.

Highlight/Midtone/Shadow

This could be quite a useful tool as it provides individual control over the highlights, midtones and shadows in your photos. However, it is complicated by the fact that, instead of actual pixel values in the range 0 to 255, it uses percentages. It also has two different ways of applying the figures – an absolute and relative method, which makes it even more difficult to work out what's going on. There are other tools, namely Histogram Adjustment and Levels that are more versatile, provide better feedback and are easier to use.

> **Tip**
>
> You can apply any of these histogram adjustments to selections. Make the selection first, save it and then run the tone adjustment, as described.

Histogram Adjustment

The Histogram Adjustment dialog box can be a little intimidating at first glance, but if you've read the earlier section on using the Smart Photo Fix histogram, you'll already be well on your way to getting the most from this versatile tool.

As we discovered earlier, the histogram is a graphical representation of the tonal values of all of the pixels in an image. Black pixels appear on the far left, getting lighter as you move towards the right on the horizontal axis. The more pixels there are of a particular value, the higher the line appears at that point.

The three most useful controls in this dialog box are the triangles that appear beneath the histogram, which allow you to remap the black point, white point and gamma. To produce an image with good tonal distribution and contrast you should drag the Highlight Input slider (the white triangle) to the right edge of the histogram and the black triangle to the left edge. Use the central Gamma slider to make overall adjustments to the brightness.

There are other controls, like the slider on the right that allows you to expand, or compress the midtones for solarization-style effects, but Curves is better suited to making these kinds of adjustments.

Histogram equalize and Histogram stretch

These two are essentially one-step applications of specific histogram (or, levels, or curves, depending on how you want to look at it) adjustments. Equalize is the least useful of the two as it averages out all the pixel values across the histogram (try pressing F7 to display the Histogram palette, then applying Histogram equalize and you'll see).

Histogram stretch automatically sets the black and white points to the values of the darkest and lightest pixels in the image. It's exactly the same as selecting Histogram Adjustment and dragging the triangle controls explained in the previous section to the ends of the histogram. As such, it's an excellent one-step contrast fix.

> **Tip**
>
> Though not all the tonal adjustment tools have their own histogram display (Levels being the prime example), the new live Histogram palette can be used instead. Prior to selecting Levels (or Curves, or Highlights/Midtones/Shadows) press F7 to display the Histogram palette. Now, when you click the Proof or Auto Proof button the Live Histogram palette will automatically update.

Levels

The controls in the Levels dialog box work in a similar way to those of the Histogram Adjustment tool. You can use the Output Levels controls to reduce contrast in the shadows and highlights. This is the best way to produce a 'knocked back' image tint for a panel on a website or printed publication that has text running over the top. By dragging the black Output Levels slider to the right, you can lighten the dark pixels in the image and still retain detail in the midtones and highlights.

Threshold

Threshold converts an image to pure black and white – what used to be called 'lineart'. Enter the value that determines whether pixels are converted to black or white in the Threshold dialog box. The default is 128 – any pixels darker than a mid-tone grey are turned black and any lighter are turned white. As with desaturation, threshold removes the color, but doesn't change the image mode, making it possible to add color back in and produce interesting graphic effects.

PAINT SHOP PRO X FOR PHOTOGRAPHERS

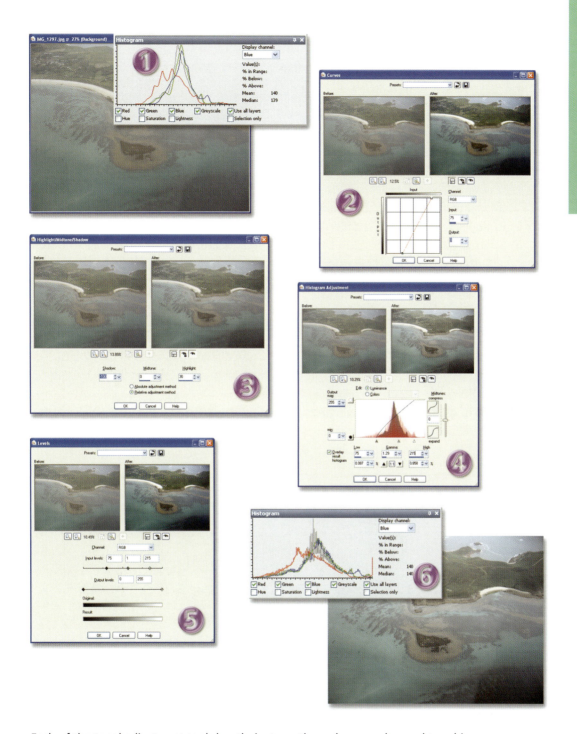

Each of the tonal adjustment tools has their strengths and any can be used to achieve a straightforward contrast adjustment as shown here. (1) Press F7 to display the Histogram palette and confirm the problem. (2) Curves. (3) Highlight/Midtone/Shadow. (4) Histogram Adjustment. (5) Levels. (6) The adjusted image with new histogram covering the entire tonal range.

Using Fill Flash and Backlighting

While the Histogram Adjustment tool provides ultimate control of image tonal values throughout the entire range, sometimes that can be it's biggest drawback. Often you'll want to change tonal values in one part of the range – the shadows or the highlights. The difficulty with using the Histogram Adjustment tool in such circumstances is that, more often than not, while you can make considerable improvements in one part of the image it's at the cost of lost image detail elsewhere in the tonal range.

For example, in trying to get back shadow detail in underexposed areas you'll often find that you lose detail in the highlights. Likewise, attempting to restore detail in overexposed areas, the sky for example, you'll find that shadow detail disappears into the darkness.

You can get around this problem by making careful feathered selections, but Paint Shop Pro X has introduced two new filters aimed at precisely this problem: the Fill Flash filter and the Backlighting filter.

The Fill Flash filter

As it's name suggests, the Fill Flash filter provides the digital equivalent of fill-in flash – a photographic technique that uses flash in daylight conditions to provide fill-in lighting for shadow detail.

The kind of situation where you might use fill-in flash is where the subject is strongly backlit, for example in front of a window or on a beach. Typically, camera automatic metering systems select an average exposure setting for such situations, resulting in very dark shadows. The

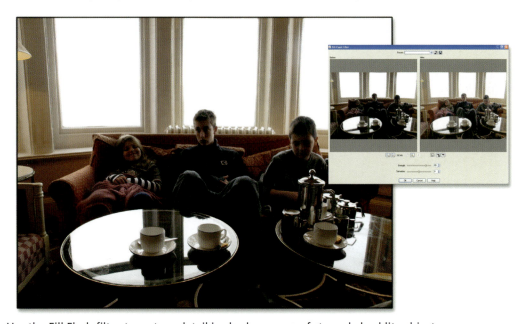

Use the Fill Flash filter to restore detail in shadow areas of strongly backlit subjects.

Fill Flash filter allows you to lighten the tones in the shadows while leaving the midtones and highlights unaffected.

To use Fill Flash click the Fill Flash button on the Photo toolbar or select Fill Flash from the Adjust menu. Maximize the Fill Flash dialog box so you can see a generously sized before and after preview and use the Zoom tools so that most of the photo is in view. You can adjust the amount of fill flash applied by entering a value in the Strength field, or by using the slider just below it. The default setting of 40 works well with all but very underexposed images. If you need to apply more that 60 keep an eye out for noise – a speckled grainy appearance in areas of flat color or tone. Click OK when you're satisfied with the result. The Fill Flash filter also includes a Saturation slider which can be used to add or remove colour,

The Backlighting filter

The Backlighting filter solves the opposite problem to fill flash. Where the camera has made a suitable exposure to capture good shadow detail in an image with a wide tonal range, the highlight detail will be overexposed. This often happens to the sky detail on photos taken in the shade on bright sunny days. The Backlighting filter can help bring back highlight detail without affecting shadow areas. Select the Backlighting filter by clicking its button on the Photo toolbar or from the Adjust menu (Adjust>Photo Fix>Backlighting).

Use the Backlighting filter to restore burnt out highlights.

Making photos (appear) sharper

Sounds too good to be true? While it's acceptable to change color, contrast or saturation in a digital file, changing the sharpness is a little trickier.

For some this might seem a Godsend, along the lines of changing water into wine. However, Paint Shop Pro has several tools designed to make pictures appear sharper than when they were scanned or shot using a digital camera. It's important to note that you can never really change an out-of-focus picture to one that looks as though a top advertising shooter did the job, but you can certainly make it look better!

How does this magic work? Most sharpness tools act on picture contrast. You might have noticed this using the Histogram tools. A general contrast boost usually makes a picture appear sharper.

Paint Shop Pro has several sharpness filters. Clarify is a one-button filter used to add a quick bump in contrast and image sharpness. Most times this works well; however, for total control you have to use the perversely named Unsharp Mask filter. What this does is apply a selected contrast boost, at pixel level, to parts of the picture with varying lightness levels.

The reason that this is the best picture-sharpening tool is that it has three adjustable controls written into the equation: Radius, Strength and Clipping. Radius selects the number of pixels around the point of contrast difference. Strength controls the amount of contrast added to those pixels while Clipping affects the lightness of the chosen pixels.

One of the disadvantages in sharpening digital pictures is that the filter is non-discretionary; it has a habit of sharpening the bits you don't want to sharpen as well as the bits you do. This includes any digital noise, film grain or other electronic imperfections that have been added to the file along the way. So, the more it's sharpened, the more noticeable the imperfections (the digital noise) become. Help is at hand though, because the main reason for the dialog controls is to help in minimizing this inevitable noise increase.

- Too much Radius creates a nasty-looking whitish halo throughout the high-contrast sections of the picture.
- Too much Strength adds an equally fiendish grittiness that looks particularly bad once in print.
- Too much Clipping makes the picture appear soft, destroying the sharpness effect entirely.

Like all sophisticated photo-editing tools, Unsharp Masking requires practice to get right. There's no 'perfect' setting because some pictures need more sharpening than others.

The picture's application also has a profound impact on how you sharpen its pixels; inkjet prints need less sharpening than those designed for newsprint. If you are submitting pictures to a third-party publication, call the relevant art department first to check on that publication's specific material (sharpening) requirements, if any.

As a general rule start with:

The Unsharp Mask filter can be adjusted to extract the maximum (sharpness) from all types of scan or camera snap. Increasing the Strength value alone is not always enough to produce satisfactory results every time. A Radius of 1 and a Strength value of 100 produce a slight improvement. Increasing the Strength to 300 (center dialog) produces a marked improvement – though this needs to be tempered using the Clipping values (see lower dialog).

PAINT SHOP PRO X FOR PHOTOGRAPHERS

- A Radius of one or two pixels.
- A Strength of between 100 and 200.
- A Clipping value of 'zero'.

If nothing seems to improve in the picture with these settings, increase the Strength value. Then try increasing the Radius value (a bit at a time). If the Unsharp Mask effect is applied to a high-contrast picture, you'll need to dial-in a small Clipping value to soften its impact. The beauty of this is that you see what you are getting instantly and can make changes live before applying them to the full resolution version.

Paint Shop Pro comes with two other no-brainer sharpen tools: the Sharpen and the Sharpen More filters. The Sharpen filter is a good place to start; it applies a preset contrast boost to a selected range of pixels. This might be enough to give most digital snaps a nice sharpen. For a stronger filter effect, try the Sharpen More filter. This is slightly more radical, though still by no means as radical as the Unsharp Mask filter can be. The good thing about these effects is that they are repeatable. If the effect isn't strong enough, repeat it using the keyboard shortcut 'Ctrl+Y' till it is.

High pass sharpening

As we've already mentioned, one of the problems with Unsharp Masking is that it can sharpen parts of the image you just don't want to sharpen. Paint Shop Pro X includes a new method of sharpening that doesn't suffer from these drawbacks because it confines sharpening only to edge detail and other high contrast areas within an image. High pass sharpening isn't new, but previously it was a complicated business that involved duplicating layers, applying a High Pass filter, or creating an edge mask and using Layer Blend modes. While all this was great fun, the new High Pass Sharpen filter makes things much easier. See the step-by-step work-through at the end of the chapter to find out how to get the best from High Pass Sharpen.

Use Paint Shop Pro X's new High Pass Sharpen filter to sharpen edge detail without exaggerating noise and other unwanted detail.

Tips for making digital files appear sharper

- If using a digital camera, make sure that the picture is exposed correctly and that the focus is correct for the subject. It's possible to enlarge the image on the camera LCD screen to check this focus closely. If you think that there's a problem, erase that frame and reshoot.
- In Shutter (Tv) or Manual (M) shoot modes, pick a faster shutter speed (a higher number) to 'freeze' action, essential if the subject is fast-moving.
- Learn to use the AF lock in the camera. This works by half-depressing the shutter button that activates the AF system. Once the in-camera audio 'beep' confirmation sounds you can then either press the shutter fully or reframe to position a subject off-center and then take the picture. The most obvious cause of out-of-focus snaps is from the subject not being in the camera's AF focusing area when the shutter button is pressed.
- Scans normally require unsharp masking to compensate for the scan process, which can make things appear slightly unsharp.
- Most scanner software comes with inbuilt Unsharp Mask filters to compensate for quality loss. Most will not be as good as Paint Shop Pro's Sharpen tools. You might want to leave that feature switched 'Off ' and sharpen the files using PSP later. It's always preferable to have an untouched 'Master' file on your hard drive. Once an effect like Unsharp Masking has been added to a file, it's impossible to remove.
- The same can be said for in-camera sharpen functions. Switch this 'Off ' and apply it using your software.
- Use PSP's Overview palette to move the view around the preview picture. Sharpening never has the same effect across all sections of a picture, so it pays to check the important bits up close.
- If you just don't have a clue where to start, try the Randomize tab. It's a good starting place and one that's likely to come up with an answer in a matter of a few clicks.

Adding soft focus effects

TOOL USED

Soft Focus

In a digital file, regular blur filters never produce as nice a result as you'd get using film and real glass soft focus filter screwed to the front of a lens.

Paint Shop Pro addresses this problem with a Soft Focus filter. The difference between this and the straight 'blur everything' filter set (Blur, Blur More, Average, Gaussian Blur) is that the

The Soft Focus filter has an incredible range of possibilities to suit most photos. Increase or decrease the halo amount to match the highlights in the original photo. Too much and the eyes might take on a satanic quality of their own. Checking the 'Include scattered light' box radically softens skin tones.

former actually applies more blur to the highlight rather than to the other tones. This produces an effect frighteningly similar to the effect that you'd get using a regular glass photographic filter – only Paint Shop Pro offers a wealth of controls over how you can influence the way that the blur looks.

You can vary the overall softness of the filter, as well as the edge importance (edge sharpness), plus there are three controls for adjusting the blur halo (Amount, Size and Visibility).

Much time has been put into creating this filter and it works extremely well, emulating the precise look of a glass filter costing more than Paint Shop Pro itself. As with most filters, it's possible to try a combination of effects using the Randomize tab. You can also save a particular combination for use any other time via the Preset tab.

STEP-BY-STEP PROJECTS

Technique: Sharpening photos using the High Pass Sharpen filter

The High Pass Sharpen filter is new to Paint Shop Pro X and it's a real lifesaver with certain kinds of images. While unsharp mask does a fantastic job 90% of the time, as we've seen, it's indiscriminate and can create problems, or at least make existing ones more obvious.

The kinds of photos you should avoid unsharp masking include:

- Those taken on a high ISO setting (400 and above) which will, depending on how good your camera is, display at least some visible noise.
- Photos that were badly exposed and have had a large tonal correction applied using Smart Photo Fix, Histogram Adjustment, or one of the other tonal adjustment tools.
- Photos with high JPEG compression applied, either because they were taken using a low quality camera setting, or have subsequently been recompressed using a low quality JPEG setting.
- Photos that are well exposed, of a high quality and fine in every other respect, but have large areas of flat color, such as an expanse of clear blue sky.

For all of these images and anything else that fails to come up shining using the Unsharp Mask filter, follow these steps.

STEP 1 Open the image to be sharpened. If you plan on using the Proof or Auto Proof buttons to preview the effect then first make sure to zoom in to 100% view (keyboard shortcut Ctrl+Alt+N). Always view sharpening adjustments at 100% magnification as it's the only way you can really see what's happening to the individual pixels in the image.

STEP 2 Select Adjust>Sharpness>High Pass Sharpen to open the High Pass Sharpen dialog box and use the Navigate button to select a representative part of the image.

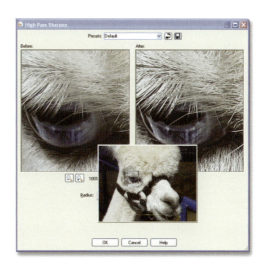

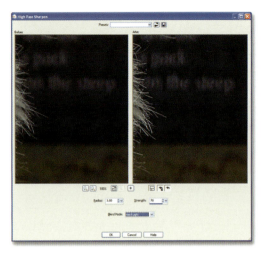

STEP 3 The High Pass Sharpen dialog box has three settings – Radius, Strength and Blend mode. The default values for these are 10, 70 and Hard Light respectively. The Radius setting determines the distance within which the filter looks for dissimilar pixels to sharpen. A larger radius value will result in more of the image being sharpened and a smaller radius value will sharpen less of the image. If the Radius is set to zero none of the image is sharpened. Use the Navigate button to find part of the image you don't want sharpened (the sky, or out of focus background) and adjust the Radius value using the slider to a value just below that at which you can see a change.

STEP 4 Now use the Navigate button to center a part of the image that's representative of what you want to sharpen. If necessary adjust the Amount slider to increase or decrease the amount of sharpening applied.

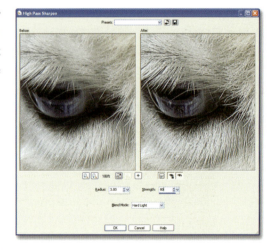

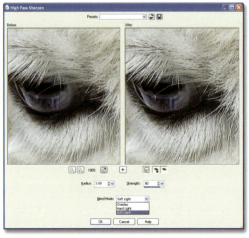

STEP 5 The Hard Light blend mode produces the most dramatic sharpening. To reduce the effect change the Blend mode to overlay and for even gentler sharpening use the Soft Light blend mode.

Tip

Remember that sharpen filters work by increasing image contrast and when you increase contrast you may inadvertently lose highlight and shadow detail from your photos. When using sharpening filters always keep one eye on the Histogram palette (keyboard shortcut F7) to make sure you are not 'clipping' the ends of the tonal range.

Paint Shop Pro X's new High Pass Sharpen filter makes a fantastic job of sharpening edge detail in images like this, without compounding common digital image problems like noise.

3

Simple Picture Manipulation: Moving Past the Basics

TECHNIQUES COVERED AND TOOLS USED IN THIS CHAPTER

Techniques
All about scripting
Controlling digital noise
Creating black and white pictures
Creating color overlay effects
Creating hand-coloring effects
Removing blemishes from scans
Retouching using the Clone tool
Tinting black and white photos
Using the Warp tools

Tools
Automatic Small Scratch Removal filter and other noise reduction filters
Burn tool
Clarify filter
Channel mixer
Clone Brush
Color Balance
Colorize
Curves
Despeckle filter
Digital Camera Noise Removal filter
Dodge tool
Edge Preserving Smooth filter
Fade Correction filter
Flood Fill (Paint Bucket tool)
Greyscale conversion
Histogram Adjustment
Hue/Saturation/Lightness
Levels adjustment
Median filter
Posterize filter
Red/Green/Blue adjust tool
Salt and Pepper filter
Scratch Remover tool
Scripts
Warp Brushes
Zoom tool

In this chapter, we look at tools designed for removing digital noise and scratches from scans, plus dust specks from scanned film and how to restore old photos to new glories. We also learn about using Paint Shop Pro's powerful Clone Brush, its Digital Camera Noise Removal filter and how to convert a color picture to black and white.

Removing scratches and blemishes from scans

TOOLS USED	
Zoom	Scratch Remover

No matter how careful you might be when scanning film or prints, dirt always gets in the way and inevitably ends up on the scan. Paint Shop Pro has a good range of filter-based tools designed for cleaning up or removing these problem areas, however bad they might appear.

Dirty scans? No, it's not a rude movie; in fact you might never realize quite how dirty scans can be unless they are magnified to a size that reveals the mess. If you only enlarge your snaps to about 6 inches × 4 inches, only the worst dust blemishes may never become apparent. If you print to 20 inches × 16 inches, however, you might get a shock when you see the dirt and surface scratch marks picked up by the scanner!

The first thing to do is rescan the print or negative. Clean the flatbed scanner's glass platen, the place where the print is positioned. Use a mild window cleaner and a soft, lint-free cloth (i.e. linen). Finger grease, however minimal, is a great dust attractant so don't forget to gently wipe the surface of the print as well. If scanning film, use an appropriate film cleaning solution and soft cloth.

Tip

Don't use filters to remove large blemishes; they aren't that effective and will degrade the overall picture quality. Use the Clone or Scratch Remover tool instead.

Once the scan is made, open the file in Paint Shop Pro and enlarge the file to between 200 and 400%. Do you see dust specks that weren't there in the original? They probably were there, but were just too small to be noticed. If you are planning to enlarge and print to A3, or bigger, you might need to run one, or more, of Paint Shop Pro's clean-up filters over the file to improve the quality.

Here's how: open the picture and crop to suit. Many scanners are more than generous with their flatbed scan areas, adding extra 'real estate' to the edges of the print or transparency. Select the Crop tool from the Tools toolbar, drag the Crop box and double-click inside the Crop box to

perform the crop. (To maintain the aspect ratio, use the 'Maintain Aspect Ratio' checkbox in the tool's Options palette.)

Assess the damage. Enlarge the file to 400 or 500% by clicking on the picture with the Zoom tool (keyboard shortcut 'Z'. Left-click or push your mouse wheel forward with your index finger to zoom in on the affected area) and, using the Pan tool (keyboard shortcut 'A' – it sits under the Zoom tool), move the picture around the screen for a closer inspection. Increase or decrease the magnification according to the amount of detail you might want to retouch. If it's a high resolution scan (i.e. scanned for A2 output), you'll have to zoom in on the image further, say up to 400%, to see the same (scratch) detail as if it were scanned to A4 and magnified only to 200%.

A quick way to remove dust spots blanket fashion is to run a filter over the entire picture. Select the Automatic Small Scratch Removal filter from the Adjust>Add/Remove Noise menu ('Adjust>Add/Remove Noise>Automatic Small Scratch Removal'), click the Maximize icon in the upper right corner of the window, and try a couple of the settings provided in the dialog window. The result appears in the right-hand preview window.

Try the default settings first. The reason there are many variants is to cover the multiple quality situations scanning introduces. Note that there are checkboxes for 'light' and 'dark' scratches, a contrast inhibitor (move the sliders to the center to limit the contrast range), as well as three filter strength settings. It's important to remember that, with this, and most of Paint Shop Pro's other filter-based tools, the dialog window offers multiple options so that you can customize all actions to suit whatever image you have open on the desktop.

If the filter effect doesn't work fully first time, try another combination. With some filters you can use the 'Randomize' button to get the program to make the decision for you.

Color negatives and transparencies are among the worst culprits for attracting dirt and scratches. Although they may look OK to the naked eye, the high degree of scanning enlargement necessary to produce a decent-sized digital image also enlarges the dirt. A global filter won't do the job – you will need to individually retouch these marks out with the Scratch Remover and Clone tools.

The Salt and Pepper (top), Median (middle) and the Edge Preserving Smooth filter (bottom) can be used for removing dust or subtly softening skin blemishes, but the filter strength required to remove larger spots and scratches results in unacceptable loss of overall image quality. The best result (right) is achieved by repeated application of the Scratch Removal and Clone tools.

Scratch Removal filters apply their effects globally. For specifically difficult or large blemishes, use a scratch removal tool locally first. This is a more effective technique because you can limit the filter's softening action to a small area of the scan only. There is no point in softening the entire picture to remove one or two scratches.

Choose the Scratch Remover tool from the Tools toolbar and drag the cursor over the blemish to remove or soften it. Paint Shop Pro clones/blurs out the damaged pixels. This is quite a fast tool to use and, like most of the tools in PSP, it has a preset save function allowing you to create your own custom scratch remove brushes. If you hit on a good shape/width combination, save it for later use.

Once satisfied that PSP has removed/diffused enough of the small scratches to make the scan appear credible, save the file under another name before continuing with further editing (always keep the original file untouched, where possible).

Other smoothing filters to try:

- Salt and Pepper filter.
- Despeckle filter.
- Median filter.
- Edge Preserving Smooth filter.

(All of which are found on the 'Adjust>Add/Remove Noise' menu.)

Controlling digital noise

Photos taken with a digital camera all suffer, to a greater or lesser extent, from a phenomenon called 'digital noise', which gives digital photos a speckled, grainy appearance. Noise is generated by a camera's electronic circuitry, mostly when the electrical current generated by the image sensor is amplified before being digitally sampled.

If you've owned a film camera, you'll be familiar with film grain – clumps of silver in a photographic emulsion that become visible when enlarged – and you'll also be aware that fast films – those with higher sensitivity to light – exhibit more grain than slow ones.

With digital cameras it's the same story; if you set your camera to a higher ISO rating, to capture images in low light conditions, the digital noise becomes worse. Depending on your camera, you may not notice noise on images taken at an ISO setting of 200 or lower, but at settings above 400 ISO, particularly at larger image sizes, noise can become very intrusive.

Digital noise can also occur as a result of long exposures – shots taken at night are often prone to noise because of the high ISO setting used combined with long exposures.

In some circumstances you can live with noise. Like film grain it can provide a gritty atmospheric realism. Mostly though, it's something you'd rather do without. You can't get rid

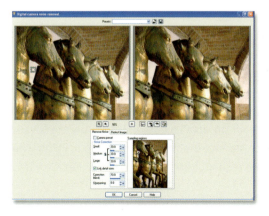 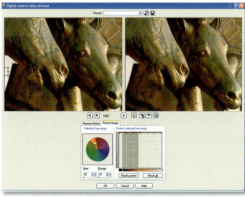

The Digital Camera Noise Removal filter allows you to remove noise from some areas of the image whilst protecting others.

Noise-wise, this is about as bad as it gets. The original image (left) was shot with the camera set to 1600 ISO. The center section shows the results of the DCNR filter on the default settings, and on the right, the same settings with 70% sharpen.

of noise entirely, but you can reduce it. Before version 9, Paint Shop Pro users had to rely on techniques using the Salt and Pepper, Median, Texture Preserving Smooth and other filters on the Adjust>Add/Remove Noise menu. Now we have the Digital Camera Noise Removal filter, which, for the sake of brevity, I'll call the DCNR filter.

Select Adjust>Digital Camera Noise Removal, or click the DCNR button on the Photo toolbar. The DCNR filter provides a quite sophisticated dialog box with the usual before and after preview windows and two tabbed panels labelled Remove Noise and Protect Image. Maximize the dialog box to get the biggest preview possible so that you can see the noise and what the filter is doing to the image detail. Use the Pan tool (it appears automatically in most of the filter dialog boxes when you mouse over the right-hand {after} preview) to select a representative area of the image.

In the Noise Correction pane, the three input boxes and sliders control the degree of noise removal for small, medium and large noise artifacts. Clicking the Link Detail Sizes box locks these three together, maintaining the relationship between them – so if you increase one of them by, say, 5, they all increase by 5.

> **Tip**
>
> You can save DCNR filter settings as a preset and easily reapply them to other images taken on the same camera with the same ISO settings.

In practice, you'll get better results by using a higher value in the small field than in the other two, but much depends on the image and you'll need to experiment. When you apply the DCNR filter it combines the corrected image with the original one and the value in the Correction Blend field determines the proportions of the two. 100 is all corrected image and no original. By lowering this value you lessen the degree to which the correction is effective, but also minimize overall loss of image detail. Finally, you can sharpen, which will help restore detail softened by the noise reduction process.

On the left of the Remove Noise tab there's a thumbnail preview with, initially, two cross hair targets on it. These are the sampling regions; they appear in the before preview window as rectangular marquees with resize handles. You can move and resize the existing sampling regions (by clicking and dragging them) and create new ones (by clicking and dragging anywhere in the left preview window). Try to sample image areas where noise is particularly bad, or that are representative of noise in large areas of the picture. Careful sampling will help the DCNR filter to distinguish noise from genuine image detail.

Another way to protect parts of the image from the unwanted attention of the DCNR filter is to use the Protect Image tab, where you can select a range of colors from within the image that you don't want processed by the filter. The simplest way to use this feature is to Ctrl-drag the area you want to protect in the left preview window.

Paint Shop Pro also has a filter that is ideally suited for adding noise (Add Noise). Why add

Adding noise can transform a regular photo into something quite special. Here I have drawn an elliptical selection.

The next stage is to apply a feather to this selection to soften the edges (in this example, by 143 pixels).

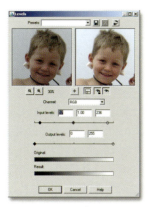

Now it's time to add some digital noise.

I now use Levels to brighten the center of the picture (i.e. the bit that's selected). You could at this stage invert the selection and, still using Levels, darken the edges of the frame for effect.

The final stage involves the adding of a motion blur type effect to the outside of the selection (i.e. invert the selection if you have not already done this). This adds the blur to the outer section of the photo so that the boy is preserved in relatively sharp focus.

The result, which can be made in a matter of a few minutes, is quite pleasing to the eye.

noise to a digital photo? For several reasons.

All retouching, whether you are using a filter effect or a specific retouching tool (like the Clone or Scratch Remover tools), smooths out textures. This is an excellent result for portraits, glamor, fashion and any other applications where flattery pays.

But if one area of the picture has had too much retouching, it will look smoother than the rest of the image. Add noise to the retouched section to make it appear more like the rest of the photo rather than attempt to smooth out the entire picture. You can also add noise to increase the grittiness and overall impact in a picture (see illustration). There are several ways to do this:

- Add noise to the retouched section using one of the textures from the Materials palette.
- Copy the background layer, make sure that the new layer is selected and use Paint Shop Pro's Add Noise filter to add a suitable quantity of noise to match the rest of the image. Then, using the Eraser tool, rub out the bits of the top layer that have had no retouching done to them.
- Apply noise using a selection.

Retouching using the Clone Brush

TOOL USED

Clone Brush

The Clone Brush is possibly the most useful of all Paint Shop Pro's retouching tools because it can be used for repairing damaged pictures and for improving photos with distracting background, or other unwanted detail. Learn how to use this tool with skill and it'll open up potential you never thought possible with your current photo-retouching skills.

There's no big mystery to the Clone Brush. What it does is simply to copy one part of a picture into the clipboard or temporary memory (this is called the 'Source') and paste it over another part of the picture (called the 'Target'). Typically this tool is used for repairing damaged prints. Tears, scratches, blemishes, and dust spots picked up by a scanner can all be things of the past using the Clone Brush. Where the Clone Brush has a distinct advantage over dust and scratch removal filters (discussed earlier in this chapter) is that the Clone Brush has a local effect. You only retouch the bits that need retouching. Filters, on the other hand, apply a blanket effect, softening the entire picture rather than just the blemishes. You can, of course, apply a selection to limit the action of the filter's softening (effect) but this is time-consuming and not always practical.

In use

Choose the Clone Brush from the Tools toolbar (keyboard shortcut 'C'). This is shared with the Scratch Remover and Object Remover tools so you might have to click the latter's icon and

The Clone tool can do a lot more than remove a few spots and scratches from old photos. Use it to remove distracting background detail, unwanted objects and even people from your pictures.

reselect 'Clone' from the drop-down menu. Make sure that the Tool Options palette is also open on the desktop by right-clicking on the Menu bar and choosing 'Tool Options' from the palettes sub-menu.

To make the Clone Brush work properly you must select a Source area. First off, find a spot in the picture that is tonally close to the tone in the section to be replaced. There's no point in trying to copy a dark patch over a light patch. The light patch goes dark with the copied pixels and ends up looking unconvincing.

Move the brush over this area and right-click once with the mouse. This sets the Source point and copies the pixels that are under the brush. Move the brush to the target section of the picture, left-click and drag to paint. This pastes, or 'clones' the copied pixels over the damaged pixels. You should see the target section disappear or, at least, reduce in intensity. (Note that this is just like copying and pasting sections of a Word document from one section to another.)

The Clone Brush has several options designed to fine-tune the brush performance. These include brush 'Size', brush 'Shape', brush 'Step', brush 'Density', brush 'Thickness', brush

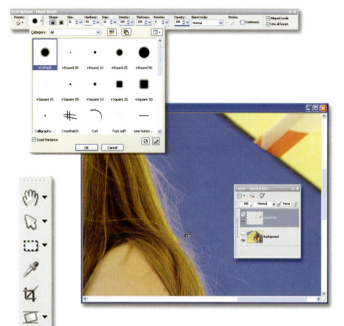

The Clone tool Options palette provides a wealth of brush presets and other settings so that you can adapt the tool to the job in hand. Before you do anything, create a new Raster layer to clone into, keeping all your changes in one place and keeping the original unmarked. Make sure to check the 'Use All Layers' box on the Options palette so that you can clone from one layer to another.

Start with a small brush and use lots of small strokes so that if you make a mistake you can easily undo. Change brush size frequently to match the area being cloned and experiment with brush hardness, Opacity and Blend mode to get the best result.

Here, the background layer opacity has been reduced so you can more clearly see the cloning on top. If you're not happy with your first effort, just erase the cloned sections from the 'cloned bits' layer and start again.

'Rotation', brush 'Opacity' and 'Blend mode'. The most important controls to try first are the brush Size, its Opacity and, finally, the Blend mode.

Setting brush size is important. If there are huge scratches, large fade spots or ripped sections in the picture, choose a brush size that's smaller than the damaged areas. Do this because building up the repair gently is preferable to trying to do it with a single brush stroke, and besides, there might not be enough of the Source area to copy from. Several softer brush strokes always produce a smoother finish and inevitably a more convincing result.

Change the brush size during the retouching operation as well as the Source area. So many novices copy-and-paste with such enthusiasm that they don't notice the tell-tale step-and-repeat tracks left across the print surface because they have not reselected the Source area. This is something to be avoided. Moving the Clone Source point often is the best way of avoiding these tell-tale marks and (usually) produces a more convincing retouched result.

> ## Tip
>
> To replace larger sections of an image with background detail try making a feathered-edged selection and copying and pasting it.

The Options palette also offers an Opacity setting. This affects the brightness of the pixels copied from the Source area. Effectively, this slows the retouching process noticeably as you end up by trying to cover damaged areas with less dense pixels (reduced opacity). Several mouse-clicks might have to be made to achieve the same as one set at 100% opacity. However, it's always better to reduce the opacity to get a smoother tonal result. Top fashion retouchers use this technique to dramatically soften skin tones even if the model appears 'perfect'. Setting the opacity to a low value, say about 10–15%, and cloning again and again can produce a surreal, almost porcelain-like effect on skin tones, especially if the contrast is kept quite high (using the Levels tool for this).

Another control to experiment with is the Blend mode. Blend modes, which we discuss in detail in Chapter 5, influence the way copied pixels react with the underlying, original, pixels. For example, click the default 'Normal' drop-down menu in the Options palette and try cloning using Burn (darken), Dodge (lighten) or the Color Blend mode.

Other tools for fixing up damaged pictures

- Scratch Remover tool (to remove blemishes locally).
- Small Scratch Remover tool (to remove small blemishes only).
- Clarify filter (to make a picture sharper and clearer).
- Fade Correction (to rejuvenate contrast and color).
- Histogram Adjustment tool (to increase the contrast).

Other tools to try

Like many of Paint Shop Pro's tools, the Dodge and Burn Brushes perform the digital equivalent of a conventional darkroom technique. During print-making areas of the paper exposed under the enlarger are held back, or given additional exposure using masking tools. In this way it's possible to bring out detail in parts of the print that would otherwise be over, or underexposed.

The Dodge and Burn Brushes do exactly the same thing. Dodge lightens the pixels to which it's applied and the Burn Brush darkens them – the equivalent of giving more exposure under the enlarger. You need to be careful not to overdo it with these tools, or your intervention will become obvious. With each application of the tool the effect becomes more obvious. It's a good idea to duplicate the background layer before using the Dodge and Burn Brushes and apply the changes to the copy. Use large, soft-edged brushes and reduced opacity settings to avoid burning hard-edged holes. You can use the left and right buttons to switch between Dodge and Burn, but I wouldn't recommend this; if you've over-burned an area, undo, or use the History palette to get back the detail.

The Dodge and Burn tools provide, in the form of a brush, the power to add (or subtract) exposure to a photo, something that costs a small fortune to have done at a professional photo lab on a film-based print. This is a fairly ordinary snap taken in unremarkable weather. I first converted the color picture to black and white by desaturating it. Then I chose the Burn tool and, making sure that I had a low value set in the Opacity field (in the Tool Options palette), I added exposure to selected parts of the sky.

Too much burning produces these tell-tale dark smudges. Back off, reduce the opacity of the brush and try again.

This is what the Burn tool can do for a photo – completely transform an image that would have otherwise perhaps found its way to the trash bin but is now something worth showing to others.

Creating black and white pictures

> **TOOLS USED**
>
> Black and White Film effects
> Channel mixer
> Greyscale
> Hue/Saturation/Lightness

Despite the fact that digital photography makes it no more difficult or expensive to shoot in color than black and white, monochrome images are proving as popular as ever. For some subjects removing the color altogether produces an aesthetically desirable result and digital image processing makes it easier than ever to produce toning effect like sepia, split toning and cross

processing that, in the days of chemical processing were messy, time-consuming and often produced hit and miss results.

One of the simplest ways to produce black and white photos is to set your camera to Black and White mode but, other than in exceptional circumstances, I'd advise against this. Shooting color in the camera and converting the images to black and white, as we shall see, gives you a much greater degree of control over the process and provides many more creative opportunities. It also gives you the option of keeping the color photo as well.

Paint Shop Pro X provides several methods of converting color images to black and white ones. These are:

- image>Greyscale. This converts the image to an 8-bit single-channel greyscale image and discards the color information. Once the image is saved in this mode there's no getting the color data back, so if you want to keep the color image, make sure to keep a back-up copy and choose File>Save As so you do not overwrite your original.

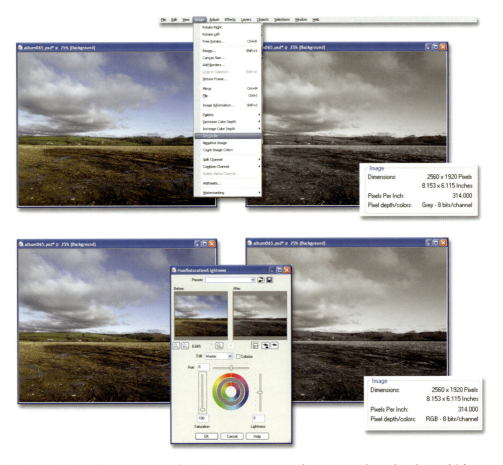

Top: Converting a photo to greyscale using Image>greyscale removes the color data which results in a smaller file size, but is irreversible. Use Hue/Saturation/Lightness to convert to black and white, but retain the color data should you want to reintroduce color to the image later.

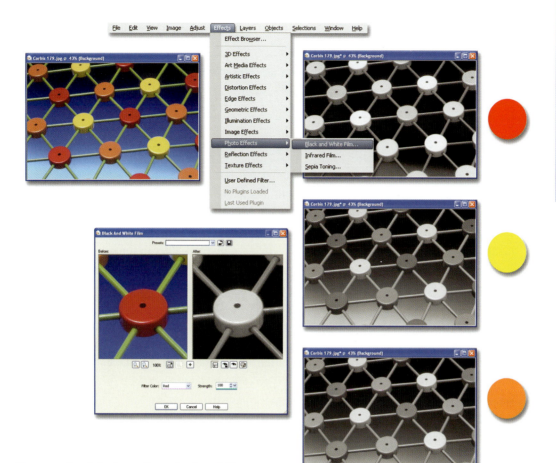

You can simulate the action of colored filters on black and white film using Black and White Film photo effects. Colored filters used in this way lighten the tone of same-colored objects and darken those with complementary colors. On this image, the red filter lightens the red discs and darkens the blue background. Because of its proximity to yellow and orange, the red filter also lightens the yellow and orange discs to a degree, but the yellow and orange filters have a greater effect on their respective colors in the image. The blue filter has the reverse effect, lightening the blue background and darkening the discs.

Bottom: You can also use the Photo Effects Sepia filter to apply a quick sepia tone to an image, but the Colorize option on the Hue/Saturation/Lightness dialog box provides more scope for color tinting of black and white photos.

> **Tip**
>
> The Channel mixer produces the same effect as yellow, red, or other colored filters on the camera with black and white film; use it to create dramatic skies and other effects.

- Adjust>Hue and Saturation>Hue/Saturation/Lightness. By dragging the Saturation slider all the way to zero in the Hue/Saturation/Lightness dialog box, you can completely desaturate the image, The difference between doing this and converting to greyscale is that, although you can no longer see it, the color information is still there. You can go back to Hue/Saturation/Lightness at any time and put the color back by dragging the slider in the opposite direction. You can also introduce new color in ways we'll look at shortly.
- Effects>Photo Effect>Black and White Film. This filter, which is new to Paint Shop Pro X can convert your photos to black and white and at the same time simulate colored filters placed over the lens to help differentiate color with similar grey tonal values. For example, when shooting black and white landscapes a yellow filter is commonly used to darken blue skies and help pick out cloud detail. Like Hue/Saturation/Lightness, using the Black and White Film effect retains the color channels in the file so you can add new color effects, but the effect isn't reversible – you can't get the original colors back once the file is saved.
- Adjust>Color>Channel mixer. The Channel mixer works in a similar way to the Black and White Film effect, only it provides a lot more control. Whereas the Black and White Film effects are confined to a limited number of filters – Red, Green, Yellow, Orange and Blue – using the Channel mixer to combine the data from the red, green and blue channels you can produce a widely variable range of tonal effects.

Tinting black and white photos

TOOLS USED

Adjustment Layers Hue/Saturation/Lightness
Color Balance
Colorize

In the last section we described ways to use Paint Shop Pro to convert a color picture to black and white Now we'll take a look at how to color-tint a black and white photo. Why color-tint? Most black and white pictures reproduce only a limited tonal range; 256 tones to be exact. The

addition of color, albeit in subtle amounts, produces a print apparently much richer in tonal scale.

This process is sometimes called a 'duotone'. Adding two colors to a black and white photo in the same fashion is called a 'tritone'. Adding a third color makes this a 'quadtone'. Aside from increasing tonal depth, making a duotone can be a cheaper way of introducing color to commercially printed jobs (because adding a second color is cheaper than producing the full four-color print process).

How it's done

Aside from using Effects>Photo Effects>Sepia toning which, as we've seen, limits you to fairly crude applications of a single color, the simplest way to tone a black and white photo is using Color Balance. Remember, you can only produce color effects like this (or in fact carry out any color editing, such as adding colored text) on an image that, though it may appear black and white, is an RGB color file. So, if you're starting with a full color image, desaturate it, as explained on the previous page. If it's a greyscale image convert it to an RGB one by selecting Image>Increase Color Depth>RGB - 8 bits/channel. Now open the Color Balance dialog box by selecting Adjust>Color Balance and uncheck the Advanced Options box to turn off the advanced controls if they are displayed. Now all you have to do is drag the slider to the right or left to make the image warmer or cooler. Warmer adds red and yellow to the image and Cooler adds blue. The further you drag the slider the more color is added. To add other colors to the image, check the Advanced Options box and use the More Purple/More Green slider.

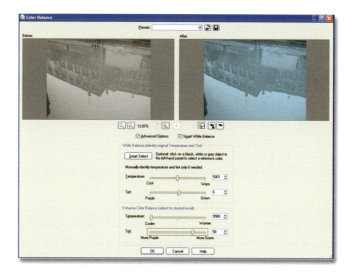

Use the Color Balance dialog box to add a tint to previously desaturated images. Stick to the sliders in the Enhance Color Balance panel which work more intuitively than the others.

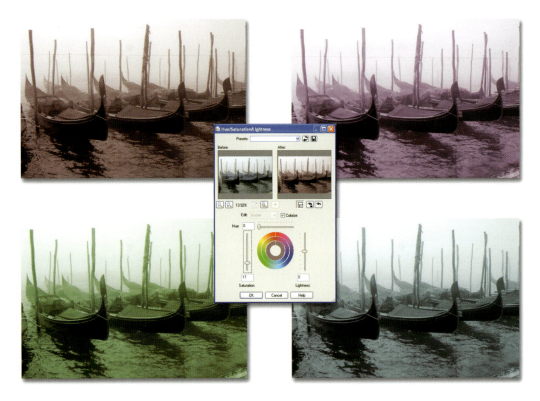

For the ultimate in tinting control the Hue/Saturation/Lightness dialog box is hard to beat. Control the tint color with the Hue slider and strength using the Saturation slider. You can also adjust image brightness using the Lightness slider, though adjustments of this kind are usually best left to Levels.

It's easy to get confused when using the Color Balance dialog box in advanced mode. It helps if you stick to using the sliders at the bottom of the dialog box in the Enhance Color Balance (adjust for desired result) panel as these work intuitively. The sliders at the top are for manual identification of an existing color cast in the image that you want to remove and so can appear to work counter-intuitively. For example, if you drag the Tint slider towards purple, this is telling Paint Shop Pro that the image has a purple cast that you want to remove – so it adds green.

You can add a wider range of tints to a photo using Adjust>Hue and Saturation>Colorize. This is actually pretty simple to use. First select a color using the Hue box on the left – the colors

Tip

Color Balance and Hue/Saturation/Lightness are best applied as Adjustment layers, so that changes remain editable and can easily be removed later if required. (See Chapter 5.)

The Colorize command provides the best balance between control and ease of use. Just select your tint color using the Hue color picker, then adjust the strength using the Saturation slider.

won't mean much to you so click the down arrow to display a color picker. Next, adjust the strength of the tint using the Saturation slider. Again, if you click the down arrow you can work with a visual tint gradient rather than a number.

You can also use the Hue/Saturation/Lightness dialog box with the Colorize box checked to tint a monochrome photo. This works in pretty much the same way as the colorize method, using the Hue and Saturation sliders to set the tint color and strength. The Hue/Saturation/Lightness dialog box (as its name implies) also provides a Lightness slider.

Tip

For an interesting effect use a Hue/Saturation/Lightness Adjustment layer in Colorize mode to apply a tent, then reduce the layer opacity to blend it with the original color.

Whenever you're tinting images in this way its a good idea to use an adjustment layer, rather than applying color changes directly to the image. Using an Adjustment layer will allow you to easily make changes to the tint at a later stage in the editing process – for example, if you add some text and decide that a different colored tint would work better. You can even remove the tint altogether if you decide against it.

Adjustment layers also provide additional control over the effect. You can reduce the strength of the effect and blend it with the original using layer opacity and Blend modes. See Chapter 5 for more about how you can use Adjustment layers to edit images non-destructively.

Creating color overlay effects

TOOL USED	
Color Balance	Blend Range

In the previous edition of this book we devoted these pages to a technique that involved using the Color Balance tool to apply a multi-tone effect, using different colors for the image shadows, highlights and midtones. While Paint Shop Pro X's new Color Balance tool is easier to use, it no longer lets you apply color changes individually to the highlight, midtone and shadow regions of a photo. But we're not going to let that get in the way of a good technique! Here's how to achieve the same effect using a layer property called Blend Range, which masks parts of a layer that fall within a tonal range that you specify.

Tip

Like Adjustment layers, the changes you make using Blend Ranges aren't permanent and you can go back and edit them at any stage. Try combining Blend Ranges with Blend modes to produce interesting graphic effects.

Open the image you want to want to tint and duplicate the background layer twice by selecting it in the Layers palette, right-clicking it and selecting Duplicate from the context menu. Rename the new layers after the color you intend to use for the tints; here I've called them red and blue. Tint the layers using the colorize technique described earlier.

Double-click the top 'blue' layer in the Layers palette to open the Layer Properties dialog box and click the Blend Ranges tab. If it isn't already selected, choose Grey Channel from the Blend Channel pull-down menu and take a look at the two graduated bars underneath it. You can use these bars to control how pixels in the two layers are displayed. The top bar, labelled 'This layer' can be used to hide pixels on the upper layer using the four triangle-shaped buttons. Drag the buttons on the left to hide pixels in the shadows and those on the right to hide highlight pixels. By dragging the top and bottom triangles to different positions you can create a smooth transition between the layers, rather than have the color change abruptly.

The bottom slider essentially does the same thing in a different way. Think of it as forcing pixels on the lower layer to show through the top one. Personally, I find it keeps things simpler to ignore the Underlying Layer controls and just use the controls for the upper layer to choose which parts of the tonal range I want to appear in that color.

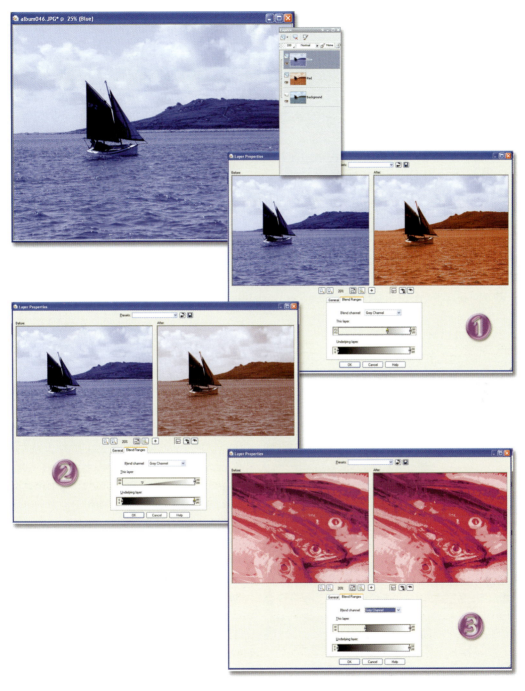

Use Blend Ranges to confine color tints to parts of the image like the highlights or shadows. 1) Confining the top blue layer to the highlights creates a hard-edged transition between red sea/land and blue sky. 2) Soften the transition by creating a 'ramp' allowing the red to bleed into the sky and vice versa. 3) You can use this technique on high contrast images to produce two-color posterization effects.

Using the Warp tools

> **TOOLS USED**
> Warp Brushes

Paint Shop Pro has several powerful brush tools that can be used to radically bend and distort the pixels in a photo. These are the Warp Brushes.

Why use a Warp Brush?

- To create zany, surreal pictorial effects.
- To increase eye size in a portrait (i.e. to enlarge a model's pupils for that wide-eyed look; it can also be used for reducing the size of other unsightly body parts like noses, if it's important).
- Straighten facial detail (i.e. a broken nose).
- To entertain your kids.

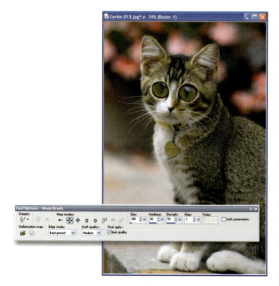

Like many things digital, it is quite easy to use the Warp tools but hard to get a result that is useful, flattering, funny (or all three). Care must be taken not to overdo things. On the other hand let your kids run riot and have fun creating weird photo effects like this one!

The Warp Brush works just like any other brush in Paint Shop Pro in so far that you can run it over the picture and it applies a direct change. In this situation you have massive influence over how the pixels bend and warp under the brush. Some computing power is needed to make this work swiftly.

There are seven warp modes to choose from. All can be combined – or you can use them individually to create some digital black magic. Brush effects are: 'Push', 'Expand', 'Contract', 'Right Twirl', 'Left Twirl', 'Noise' and 'Iron Out'.

If you don't like what this extremely powerful brush does to the photo, click the 'Cancel' tab. Other options with this tool include 'Brush Size', 'Hardness', 'Strength', 'Step' and 'Noise'. When you have finished the warping process, click the OK tab to render the warping action. The neat thing about this tool is that you can preview everything

in four different 'Draft' quality modes depending on how much of a hurry you might be in, and then finish the job in two final 'Render' Quality modes.

If you are in a hurry, use the Coarse Draft mode but render it in the Best mode. For best quality results, go for the Finest Quality settings in both modes.

Scripting

> **TOOLS USED**
>
> Script toolbar History palette
> Batch Process

Scripting is a powerful Paint Shop Pro feature introduced in version 8. It allows you to automatically combine several editing steps and apply them to another image. Say, for example, you have a whole folder of images and you want to do the same thing to each of them – open them, resize them, unsharp mask them, add a frame and save them. That's the kind of repetitive work that scripting was designed for. (Paint Shop Pro's One Step Photo Fix is a script.)

Scripts are easy to create, The Scripting toolbar works a little like a VCR, with a record button that when pressed keeps track of everything you do and produces a script so that the same process can be applied with a single click to any other image. There's also a selection of pre-supplied scripts including 'Border with drop shadow', 'Black and white sketch', 'EXIF captioning', 'Photo edges', 'Sepia frame', 'Simple caption', 'Vignette' and 'Watercolor'.

You can add scripts as buttons to toolbars, which makes them even easier to apply. Right-click on the toolbar and select Customize from the contextual menu, click the Scripts tab in the Customize dialog box and select the script you want to add from the pull-down menu. Choose an icon, click the Bind button and the Script button will appear in the Bound Scripts pane. Now drag this icon from the Bound Scripts pane onto the toolbar. Now all you have to do to apply the script to any image is click the button.

Pre-written scripts are all very well, but what if you want a script to handle a repetitive task

At a basic level, scripting allows users to run a pre-recorded action over an image (or images) in order to produce a quick – and predictable – result. Or you can record your own script and save it for use another time.

that doesn't appear on the Scripts toolbar drop-down list? Well, you can record your own, but you can also edit the existing scripts. Paint Shop Pro's scripts are written in a scripting language called 'Python'. You don't need any special scripting knowledge to edit existing scripts, but if you're interested in finding out more about Python take a look at the Python website at www.python.org/doc/Newbies.html.

To edit a script click the Edit Script button on the Script toolbar. Some of the Paint Shop Pro scripts provide editing tips. For example, the Thumbnail 150 script begins:

if you want thumbnails generated at a different size just change this to the desired value.
MaxThumbnailSize = 150

The # symbol at the beginning of the first line denotes a comment – what follows is ignored by the script interpreter – but it's meaning is clear enough to anyone else.

Paint Shop Pro X has an even easier way of creating scripts – called 'Quickscripts' – using the History palette. The History palette automatically records everything you do in Paint Shop Pro. You can use the History palette as a super-undo feature. While selecting Undo from the Edit menu (or pressing Ctrl+Z) will take you back through recent editing in linear steps, the History palette can be used to selectively undo. You can, for example, undo the Lens Distortion filter effect you applied 10 minutes ago, but keep the cropping, Red-eye Removal and Automatic Color Balance subsequently applied.

To create a Quickscript select the steps you want to use by Shift-clicking (Ctrl-click to select non-contiguous steps) them in the History palette and click the Save Quickscript button. To apply the Quickscript to the current image click the Run Quickscript button. What could be simpler? Well, it would be nice if you could save more than one Quickscript. As it is, when you save a new

Use the Script toolbar (left) to select and apply scripts to the current image. You can create Quickscripts from the new History palette (center). Combining scripts with Batch Processing (right) is the route to major effort-saving automation.

Quickscript it overwrites the old one. Perhaps multiple Quickscripts are something we can look forward to in Paint Shop Pro 11.

Clearly, scripts can save you a lot of legwork if you need to apply the same editing sequence to a large number of images. But you still have to open the image and click the button. It may not sound like hard work, but if you have to do it 300 times, or every time you download a batch of pictures from your digital camera, you'd be forgiven for considering it quite a chore. This is where Batch Processing comes in. Batch Processing can automatically apply editing commands to an entire folder of images. Combine Batch Processing with Scripting and you have some real image-editing power at your fingertips.

Paint Shop Pro's Batch Processing feature grew out of a Batch Convert feature designed to allow you to convert a bunch of files from one format to another. It was extended in version 8 to allow you to apply scripts and there's also a useful Batch Rename feature which you can use to change the anonymous names of digital camera images to something more meaningful.

To open the Batch Process dialog box select File>Batch Process. Click the Browse button, navigate to the folder of images you want to process and click the Select All button. Before you do this make sure to back up the originals somewhere safe and work on a copy of the images so that, if something unexpected happens, you still have the originals to fall back on.

Check the Use Script box, select a script from the pull-down menu and check the Copy Radio button. This will save a copy of the processed image into the folder you specify in the Save Options pane. Click the Browse button and create a new folder called something like 'processed files' on your hard disk. The Save Mode pane provides other saving options. If you have included a Save As command in your script, check the Obey Script Radio button to use this rather than the Batch Process save instructions. If you check the Silent Mode box Batch Process will run the selected script and apply the settings you used when you recorded it. If you leave the Silent Mode box unchecked, a dialog box will open at relevant points in the script for each processed image, requiring you to enter values.

When you're sure everything is correctly set, click the Start button, sit back and watch while Paint Shop Pro does the hard work for you.

STEP-BY-STEP PROJECTS

Technique: repairing damaged photos

Global scratch removal techniques

In the analog world, prints often suffer from dust spotting and scratches, a legacy from the darkroom. These blemishes are difficult to avoid and require careful treatment with ink and a fine spotting-out brush to remove. Digital files don't suffer from dust specks – but scanned pictures do because we either forget to clean the film before it's scanned or because the scanner picks up

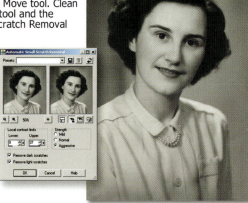

Lasso damaged section with the Magic Wand tool and move it back into place with the Move tool. Clean up with the Clone tool and the Automatic Small Scratch Removal filter

For really large scratches, blemishes and other assorted rips, tears and missing pieces, like the join seen in this illustration, you'll have to use the Clone tool. Select the scanned edges, copy and paste the missing bit to a new layer and, using the Move tool, push it back into place. In this example I used the Magic Wand tool to make the initial selection and pushed it into place before fixing up the join line using the Clone tool then flattening the file to its original single layer.

details not normally visible with the human eye on a small strip of film.

Paint Shop Pro has a range of scratch removal filters and specific retouching tools. Begin by trying the Automatic Small Scratch Removal filter (rather than simply applying the default filter effects, you can get better results by fine-tuning the controls provided in the tool dialog).

All scratch removal filters work quite efficiently but, in order to remove all the blemishes, the picture must be blurred all over. The resultant picture often looks softer than the original. Too little filter and you may not see any improvement. Sometimes scanned photos look worse than the original because they pick up too much detail from the print surface, resulting in a spotty-looking scan. The Despeckle filter ('Adjust>Add/Remove Noise>Despeckle') is suitable for reducing this kind of scan flaw – but be aware that it will also soften the picture, so try not to overdo it.

Local scratch removal techniques

If you don't want to apply a global effect to the image, use Paint Shop Pro's Scratch Remover tool. This works a bit like a band-aid, laying a strip of blurred tone over the selected area to conceal damage. The results can be quite subtle or quite marked, depending on how many times it's used over the same spot. (Note: in the Tool Options palette, you can alter the pixel width and shape to better match the scratch size.)

Paint Shop Pro has a range of manual tools designed to significantly refine the retouch/repair process. For greater accuracy, use a graphics tablet. These tools include:

- Dodge tool. As in the traditional black and white darkroom, this aptly-named tool reduces the exposure reaching the picture, effectively lightening it.
- Burn tool. This tool works exactly like the Dodge tool, only in reverse, by darkening parts of the picture. Use the 'Size' control to change the area affected and the opacity to change the amount of change added with each mouse-click.
- Smudge tool. Use this tool to move and soften the pixels under the brush.
- Push tool. Use this to physically displace the pixels under the brush (i.e. to push them out of the way).
- Soften tool. Use this to make the pixels appear out of focus. Great for emphasizing the optical effects of a long telephoto lens or for diffusing parts of the photo.
- Sharpen tool. This one works in the reverse fashion to the Soften tool, actually sharpening the pixels under the brush. Care must be taken not to overdo this, otherwise you end up with harsh, over-pixellated areas. By using the Options palette for each of these tools you can add tremendous flexibility to the speed at which each works, as well as to its density and efficacy.

Heavily retouched photos often appear softer. This may be an illusion created by less grain, but, more than likely, it will be softer! Scanning also does this.

To fix this I'd suggest reassessing the contrast in the picture. If the photo appears on the flat side, increasing contrast will improve the apparent sharpness significantly. However, if the contrast is already fine, add sharpening using one of the available sharpen filters (like the Unsharp Mask filter).

Unsharp Masking gives you incredible control over how the final picture looks. However, don't use this until you have finished cleaning up all blemishes. Too much Unsharp Masking can also increase the appearance of the film grain. As with most filter effects, the Unsharp Mask filter dialog has a resizeable preview window, enabling you to fiddle about with the settings before making a commitment to the original file.

Begin with a Radius of around 5 or 10 pixels, a Strength setting of about 100–200% and a Clipping level of less than 20. Note that these figures are quite arbitrary for each different picture but, with practice, you'll pick up on which are best for your style of image-making.

Technique: flood fill coloring effects

Like many photo-editing programs, Paint Shop Pro has a Flood Fill (keyboard shortcut 'F') tool (also sometimes called the Paint Bucket tool). This feature is used to flood an area in a photo with color selected from the program's Materials palette.

Though Paint Shop Pro's Flood Fill feature is quite sophisticated, it can be used to create a range of hand-painting style effects with little or no previous knowledge.

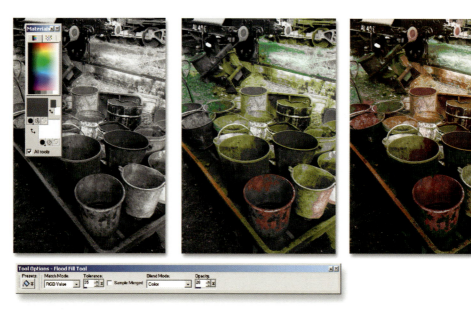

Bit by bit, you can add layers of color, chosen by clicking on the Materials palette, into the monochrome original. If too much color floods into the picture in one hit, Undo that action and reduce the Tolerance value in the Tool Options palette. Then try again.

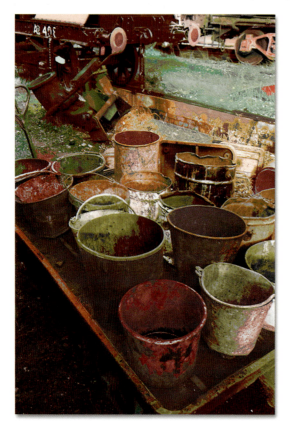

In this example I toned the final image further by reducing the color saturation. If a darker than normal color is chosen for the Flood Fill tool, you can also lower the contrast and brightness of the image – adding mood and atmosphere. Don't overdo it though!

How does this work? Open a picture, choose the Flood Fill tool (the paint can symbol on the Tools toolbar) and click anywhere in the photo.

If the tool's tolerance value is set to 200%, the Flood Fill tool 'floods' the entire canvas with the foreground color. If you are not used to using the Materials palette with its fore- and background colors, don't despair. Select 'Edit>Undo Flood Fill' or keyboard shortcut 'Ctrl+Z' and reduce the tolerance value to '20' or less. With the tool still selected, click the photo again. Note that with a drastically reduced tolerance, the paint flood is greatly restricted. Tolerance controls the action of any tool to similar-colored pixels. Reduce this value and you narrow the amount of nearest-neighbor type pixels that can be drawn into the effect – whatever this might be. The Flood Fill effect might still not be apparent.

> **Tip**
>
> Use the Flood Fill tool to add contrast by selecting dark colors from the Materials palette and adding them to the shadow areas. Setting a low opacity value makes the color addition seamless, although it also requires more mousing to bring the effect up to strength.

Choose the Materials palette and select a color that you'd like to flood over parts of the picture (if this is different to the default already used). Double-click the foreground Color Properties box and choose a new color. Reduce the opacity value in the Options palette to 50% or less. Click the picture again. You should be able to see the selected color being 'washed over' the print. If you set the opacity to a low value (say 12%) and the tolerance to a high value (say 150–200%), the Flood Fill tool applies a color wash over the entire picture.

Reduce the tolerance and it begins to drop the color into restricted pixel tones only. So, for example, if there's a white cat sitting on a black mat, you can change it quickly to a yellow or red cat, without affecting the mat color. All that's required to achieve this kind of color swap is the right balance between tolerance and the opacity values.

The real power of this tool can only be realized once you begin to experiment with its Blend modes in the Options palette. Although Blend modes will be dealt with in greater detail in Chapter 5, it's important to note that using the default, 'Normal', Blend mode usually produces the most abrupt result. Modes like 'Color', 'Overlay' and 'Soft Light', on the other hand, might produce an effect that's far more attractive and, ultimately, more useful to the image-maker.

Technique: hand-coloring black and white photos

In the days before color photography, a commonly used technique was to add color to black and white prints using inks and a small retouching brush. The aim of this process wasn't to create an exact facsimile of a scene in full color, but rather to add a little color detail to heighten the realism and add a little life to what otherwise may have appeared a little drab and austere.

If you've ever seen a hand-colored black and white print you'll know just how charming they can be. Using Paint Shop Pro you can recreate this effect either to add a new dimension to archive family photos, or to produce an interesting new take on more recent digital images.

STEP 1 If you're starting off with a scanned black and white photo in greyscale mode you'll need to convert it to RGB by selecting Image>increase color depth>RGB - 8 bits/channel. If it's a color image, desaturate it using Hue/Saturation/Lightness as described earlier in the chapter.

STEP 2 You'll get a more realistic result using a limited color palette. Using the Materials palette in Swatch mode, create up to six colors. Depending on the image you might for example choose a skin color, red to add color to lips and cheeks, one or two colors for items of clothing and another one or two swatches for other detail such as sky, a car or, as in this case, a pedalo. You might also find it helpful to name the swatches appropriately e.g. 'skin tones'.

STEP 3 Select the Paint Brush and choose one of your color swatches. Use the Tool Options palette to set the brush size, shape, hardness and other parameters. To a degree these will depend on the detail you are coloring, but generally, you'll find that soft-edged brushes with reduced opacity give good results. You might also try the Airbrush.

Tip

You'll find it much easier to hand-color and carry out other retouching tasks using a pressure-sensitive tablet and stylus. It's much more natural to paint with a stylus than with a mouse, and Paint Shop Pro's Brush tools respond to pressure – the harder you press, the more paint is deposited. Some styli even have an eraser on the end, so you can flip them over and rub out!

STEP 4 Create a new layer on which to add the color. There are two reasons for this. Firstly, it's always a good idea to keep any retouching on a separate layer as it leaves the original untouched on the background layer and if things go drastically wrong you can always delete the retouching layer and start again. Secondly, it gives you a lot more control over your editing. You can change the opacity to fade the retouching and make it less obvious and use Paint Shop Pro's Blend modes to produce a more natural look.

STEP 5 Making sure the new layer is selected, start to paint over the background image. At this stage the paint will go on thickly and may even completely obliterate the detail below, producing a crude and ugly result. Don't worry!

> **Tip**
>
> When you change the Layer Blend Mode to color (Legacy) the paint that you've applied with the Brush tool adopts the tonal characteristics of the underlying (grey) pixels. Dark pixels pick up darker color and vice versa. It pays to be realistic in your choice of colors. If your subject is wearing a dark shirt, you won't be able to paint it light blue. If colors don't come out as expected, try using the Hue/Saturation/Lightness controls to change the color of the paint layer – another good reason for keeping each color tint on a separate layer.

STEP 6 In the Layers palette change the Blend mode from Normal to Color (Legacy). Now, your brush strokes apply color to the image, but maintain the original tone, producing a more natural effect. As well as retaining the underlying detail, you'll notice that the color varies from your original swatch, depending on how light or dark the underlying pixels are.

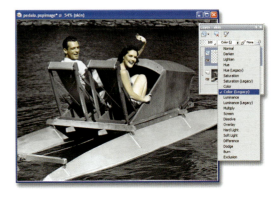

STEP 7 When you've finished painting all of the image detail in one of your palette colors, for example all the skin tones, create another new layer and continue painting in the next color. You could put all your colors onto one layer, but using a different layer for each color gives you more control over the finished result. Suppose, when you are nearing completion, everything looks OK, but the skin tones look a bit over the top, like everyone's had a bit too much sun. By reducing the opacity of the skin tones layer you can correct this problem without affecting the other colors.

STEP 8 The great thing about hand-coloring is you don't have to be a great artist or even incredibly accurate, as this screen of all the paint layers at 100% opacity in Normal mode shows!

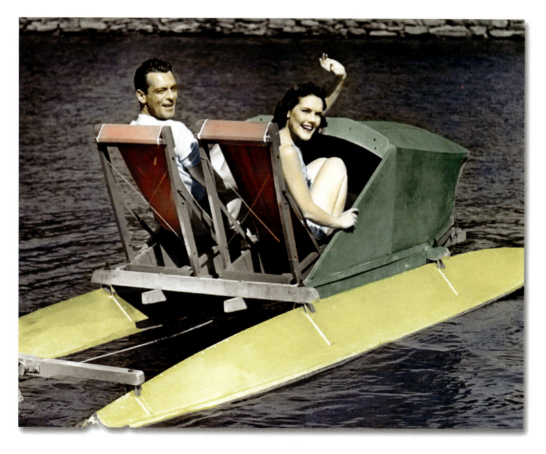

The final result.

4

Controlling Change: Using Selections

TECHNIQUES COVERED AND TOOLS USED IN THIS CHAPTER

Techniques
Cutting out an image
Fixing overexposed sky
Freehand selections
Making a basic selection
Selection feathering
Selective color desaturation
Using alpha channels
Using mask layers
Using the geometric selection tools
Using the Materials palette

Tools
Alpha channels
Background Eraser brush
Create New Layer
Edit Selection mode
Feather
Freehand selection tool
Geometric selection tools
Hue/Saturation/Lightness
Lasso tool
Levels
Magic Wand tool
Mask layers
Match modes
Materials palette
Selection Modifiers

This chapter will help you to learn how to control change in a picture using the power of selections. Understanding Paint Shop Pro's various selection tools and methods will enable you to achieve subtle and sophisticated effects that go beyond anything we've covered up to now. Making selections is the first step in 90% of advanced image-editing techniques.

Understanding selections: adding creative power

TOOLS USED

Lasso
Geometric selection
Magic Wand

Selection Modifiers
Edit Selection mode

There comes a point in the digital learning curve where it's vital to embrace the concept of selection. We have seen that Paint Shop Pro's filter effects, tonal adjustments and various color controls work on the entire image. Each is said to function 'globally'. For a lot of pictures you'll find this works well enough, but there'll come a time when it's necessary to limit this global effect to a smaller, more controlled section in the picture. The easiest and most accurate way to make this happen is to generate a specific selection that inhibits the action of a tool to a certain physical area.

Paint Shop Pro has several tools that allow the isolation of specific areas within the picture based on certain selection criteria such as color, tonality, contrast or simply by drawing round it. Because of the irregular nature of digital pictures, you have to distinguish the best selection tool, or tools, to use for the picture in question. For example, sometimes it's possible with one mouse-click to get a good, clean selection round an object. Sometimes this is not so easy because the photo might be multi-colored or irregular in tone. In this case you'd use a combination of selection tools to successfully 'grab' the object cleanly. Paint Shop Pro also has a number of tools that you can use to clean up these selections once started. These are called Selection Modification tools.

Selection tools are divided into three types:

- The Freehand selection tool that has edge-seeking ('magnetic'), point-to-point (polygonal line), smart-edge (linear 'magnetic') or just freehand characteristics.
- The Geometric Marquee selection tool that comes in rectangular, square, circular, star, triangular and 10 other preset shapes.
- The Magic Wand tool. This finds pixels either of a similar contrast, color, hue, brightness or opacity within the picture.

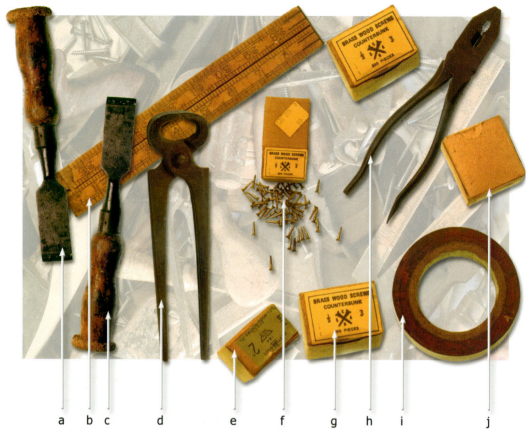

a b c d e f g h i j

Paint Shop Pro has a wide range of special selection tools for different objects. For example, irregular shapes (a, c, d, f and h) can be quickly grabbed using the Magic Wand tool, while more regular-shaped objects can be selected using either a rectangular Marquee tool (for objects like b, e, g and j) or the Freehand Selection tool set to a special Match mode like Edge Seeker, that assists in lining up object edges to be selected. Round objects (i) can all be selected using a circular Geometric selection marquee.

That's a combination of 20 selection tools to choose from.

Bear in mind that the Options palette has more refining controls for most of the tools mentioned (some already mentioned are accessible through this palette only). Controls include a Tolerance level, Blend mode, Anti-aliasing, Smoothing, Feathering and Match mode.

What else can you do with selections?

- All selections can be saved and stored for later use in an alpha channel, or to a designated area on your hard drive like any other file.
- Selections can be used like a painter's drop sheet – to inhibit brush actions along straight edges, and to stop paint from getting into areas that you don't want to get paint into.

- All selection tools have an 'Add To' and a 'Subtract From' function. Hold the Shift key when making a second selection and it's added to the first. Keep holding the Shift key to add further selections. In this way you can build, or reduce, extremely accurate selections.
- To further refine the process, selection tools are interchangeable. Make an initial selection using the Magic Wand tool, for example, and add to that using a Marquee tool. Finish off using the Freehand selection tool. Use the Shift and Control keys to apply additions and subtractions, or set the same parameters in the Tool Options palette.
- Use the Options palette to make custom selections using numerical values in the fields provided ('Customize Selection' in the Options palette).
- Paint Shop Pro also has an Edit Selection mode ('Selections>Edit Selection'). In this mode, all the raster painting/drawing tools and many filter effects can be used to modify the selection marquee. In this mode the selection is rendered in a red opaque color so it's easy to see. This is a powerful and fast way to make an average-looking selection into something that has professional accuracy.
- Perfect the selection using the Selection Modify tools. These will allow you to produce surprising accuracy from even the roughest of initial selections.

By setting the right Match mode, you can add tremendous grabbing power to the Magic Wand tool.

Shooting objects on a plain white background will make selecting them much easier.

The Geometric selection tool has a number of preset shapes that make the job of grabbing regular-shaped objects far easier.

If the background is 'clean', selection using any tool is far more efficient. You might even like to make the background lighter (using the brightness and contrast tools) so that it is easier to grab objects cleanly.

Remember, even if the regular-shaped object is not in a linear alignment, it can be rotated on a layer, selected with a regular selection marquee and then rotated back into place. In this example, rotate the ruler to lie horizontally and 'Add' a small circular selection to the first to complete the object grab.

Using the Geometric selection tools

TOOLS USED

Rectangular Marquee	Magic Wand tool
Feather	Masks
Alpha channels	Match modes

Paint Shop Pro's Geometric selection tools are the easiest to use because they are 'preset'. They don't rely entirely on the accuracy of the mouse action.

Open a picture and duplicate the Background layer ('Layers>Duplicate') so that you can practice on a copy of the original rather than the original itself. Make sure that the top layer is active (click once on its title bar on the Layers palette to do this).

Choose the Rectangular Marquee selection tool from the Tools toolbar, left-click and drag the cursor across the picture about 20% from the edge of the image. The moving line that appears where the selection was drawn is called the 'selection marquee'. Any further editing on the picture applies to the area inside this selection only. Because we want to add an effect to the area outside this selection it must be reversed or 'inverted'.

Choose 'Selections>Invert' from the Selections drop-down menu and note how it selects the entire image up to the borders of the original area selected. Use the keyboard shortcut 'Ctrl+Shift+M' to hide the marquee to make it easier to see any tone changes you make. Note that, though it is hidden, the selection is still active.

Open the Levels dialog window ('Adjust>Brightness and Contrast>Levels') and slide the right-hand slider (in the Output scale) to the left. This darkens the selected area. Push the slider far enough to make the edges significantly darker, but still keep them semi-transparent.

You can refine all selections using the Feather adjustment. This blurs the selection line across an adjustable pixel width so that you can soften those typical scalpel-sharp selection cut-lines.

Adding to the selection

To add to a selection, hold the Shift key down and make several more geometric selections, adding one on top of the other to build up a complex irregular but still geometric selection with each new mouse drag. Change the shape of the selection (circular, square, octagonal, etc.) using the Options palette. Remember at all times to update the save to preserve the selection information in an alpha channel ('Selections>Save to Alpha Channel').

Introducing the Magic Wand tool

You may find that the Geometric selection tools are not accurate enough or simply not the right shape to capture the subject in the picture. In this case, the Magic Wand tool is what you need. This is the most versatile selection tool available to you and can capture just about any selection you ask of it. The key to success with the Magic Wand tool lies in correctly setting the options and this often involves some trial and error. With a little experience, however, it will become second nature to you and take very little time. Certainly a lot less time than having to make the same selection manually.

> **Tip**
>
> Feathering is measured in pixels. If you feather a selection by 10 pixels on a low resolution image, it will have a much bigger effect than on a large resolution one.

Select the Magic Wand tool from the selection tool flyout on the toolbar and click inside an image on an area of fairly similar color and tone. The resulting selection marquee may cover a little of the image or a lot of it, and it may be one big selection or there could be smaller islands of selected image dotted about – it all depends on the image.

What the Magic Wand does is select pixels of similar values, within a range that you specify, throughout the image. As a starting point the Magic Wand tool uses the pixel that you click on. It then selects all the pixels with an RGB value within the range specified by the value in the Tolerance field of the Tool Options palette; the larger the tolerance the more pixels will be selected. If what you're trying to select is a very specific color, a red door for example, you can

Successful use of the Magic Wand tool depends on making good tool options choices and adopting appropriate techniques. In this case it's easier to select the background and invert the selection to capture the subject. Rather than increasing the tolerance in an attempt to get everything in one bite, which will most likely just capture unwanted areas of the image, use a smaller tolerance setting and Shift-click to add to the original selection.

use a low tolerance setting to select all of it. If it contains a wider range of colors, like a sky or the leaves on a tree, you might need to increase the tolerance to capture all of the hues.

Sometimes, increasing the tolerance means you capture pixels you don't want, which happen to have similar values to those you do. If this happens you need to try a different tack. One method is to Shift-click to add to the existing selection. If you get an unsatisfactory result press Ctrl+Z, rather than trying to subtract from the selection by Ctrl-clicking with the Magic Wand tool. Alternatively, it's often easier to select a background with the Magic Wand tool then invert the selection (Selections>Invert or press Ctrl+Shift+I) to capture the subject.

There are other options that can help you fine-tune a Magic Wand selection. Match modes enable you to make a selection on the basis of color, hue, brightness and opacity as well as RGB values. Using the Tone Match mode is one way to select shadow or highlight detail if you want to make selective tonal adjustment to an image.

Tip

The results of a Magic Wand tool selection depend on the precise pixel you click on. Even in what looks like an area of flat color pixel values vary, so if your first attempt isn't successful, press Ctrl+Z to undo and click again on a neighboring pixel.

Click the Sample Merged checkbox if you want the Magic Wand tool to base its selection on all pixels in the image, rather than just those in the active layer (if you get very unexpected results with the Magic Wand tool, e.g. everything selected wherever you click, it's probably because you're clicking in an empty layer with Sample Merged turned off). 'Contiguous' selects only pixels that are next to each other, so you get one selection marquee. Turn off Contiguous

and the Magic Wand tool can jump over non-selected pixels to select in-range pixels anywhere within the image. In Non-Contiguous mode you'll get little pools of selection all over the image.

Finally, you can elect to anti-alias a Magic Wand selection's edge pixels. Use the pull-down menu to determine whether pixels outside or inside the selection border will be anti-aliased.

The Tool Options palette isn't the last word on modifying Magic Wand selections. On the Selections>Modify menu you'll find a host of additional fine-tuning adjustments that will allow you to, among other things, expand, contract, select similar, feather, smooth and remove specks and holes from your selections. These can, of course, be used with any selections, not just those created with the Magic Wand tool.

Alpha channels and masks

When you make a selection, Paint Shop Pro stores it in an alpha channel. Channels are a bit like layers; an RGB image is composed of three channels, one each for the red, green and blue image data. Alpha channels are grayscale – pixels in them are either, black, white, or one of 254 shades of gray. In an alpha channel, pixels within a selected area are white, unselected pixels are black,

This selection was made using the elliptical selection tool feathered by 200 pixels. The corresponding alpha channel shows the selected area in the center, gradually fading to black, and the bottom right image shows the actual selected pixels.

> **Tip**
>
> Using the Brush tools to paint directly onto a mask layer is often a much easier way to obtain a selection than using any of the selection tools.

and gray pixels are partially selected. How can you have a partially selected pixel? Well, pixels in a feathered selection are partially selected. If you looked at the alpha channel for a circular feathered selection, there would be a white hole in the middle with a soft edge gradually fading to black. Any editing applied to image pixels selected using an alpha channel with gray pixels will have a partial effect, which is extremely useful for subtle image editing without 'hard' edges. It means you can apply filters and other effects with a gradually tapering effect.

At their simplest, alpha channels are simply a useful method for permanently storing selections. To do this all you have to do is click Selections>Load/Save Selection/Save Selection to Alpha Channel. Usually, you'll want to save a selection to the image you created it from, but you can also save and load selections into other documents.

Masks

Masks are a little like alpha channels in that they use a grayscale image to determine what happens to corresponding image pixels. Masks are in fact a special kind of layer. Grayscale mask pixels determine the opacity of image pixels in underlying layers. Masks provide a useful means of hiding image pixels without actually deleting them. By directly editing masks (and, for that matter, alpha channels) you can perform sophisticated image-editing techniques in a non-destructive way, without altering the pixel values in the affected layer.

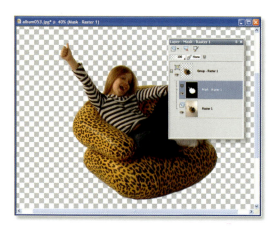

A Mask layer hides parts of underlying layers without actually deleting pixels.

To create a mask, first make a selection, then choose Layers>New Mask Layer>Show Selection to show the selected parts of an image layer and hide the rest. To mask (hide) the contents of the selection and show the unselected bits choose Layers>New Mask Layer>Hide Selection.

Selections, alpha channels and masks are interchangeable. You can turn a selection into an alpha channel or a mask, create an alpha channel from a mask, load a mask from an alpha channel and, of course, load selections from masks and alpha channels. You can discover more about masks in the following chapter.

STEP-BY-STEP PROJECTS

Technique: creating an artificial point of focus

Because life is never straight, Paint Shop Pro has a Freehand selection tool. This is used to manually draw around an object for the purpose of isolating it from the rest of the picture. While this can be the most accurate of all the selection tools, it can also be the most tricky because you have to rely on the accuracy of the mouse, which is a bit like drawing with a bar of soap at the best of times.

I'd recommend buying a graphics tablet so that you can get the most from this tool. The developers of Paint Shop Pro have spent a great deal of design time incorporating pressure-sensitive tool features optimized for use with a tablet. Once you've had a go with one of these remarkable (and inexpensive) drawing tools, you'll wonder how you ever managed with a mouse!

As with all tools, the Freehand selection tool comes with a wide range of control options available through its Tool Options palette.

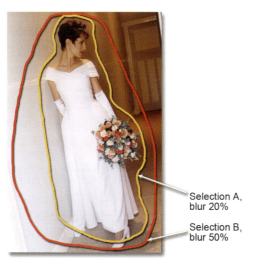
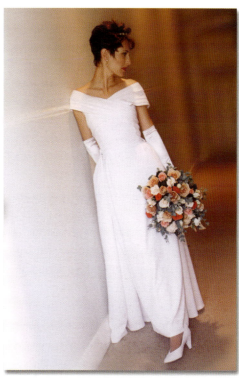

The more outline selections you can make around the subject (as shown by the colored outlines), the better the resulting defocus technique appears. Done as a one-off blur, the result can look like it was fixed using software rather than a genuine photographic visual.

STEP 1 Open the photo and copy (duplicate) the layer. This gives a reference 'before' and 'after' picture (by clicking the eye icon in the Layers palette 'on' and 'off').

STEP 2 Choose the Freehand selection tool and decide its selection parameters: 'Freehand' works simply by dragging the mouse over the canvas. Its 'Edge Seeker' option works as if it has slightly magnetic properties. Use the Smoothing option to make the selection line, well, smoother. 'Point to point' draws a straight line from point to point, creating points with each mouse click, and is ideal for selecting regular objects such as products. The 'Smart Edge' mode drops a wide line over the desired edges and locates the contrast or color differences underneath that line.

STEP 3 Save the selection to an alpha channel ('Selection>Save to Alpha Channel').

STEP 4 Choose a blur filter from the 'Effects' drop-down menu and add diffusion to the picture to simulate an out-of-focus effect. Photographers have perfected this software technique to simulate the effect you might get if the picture was shot using a specialist wide aperture lens, like the Canon EF85mm f1.2L USM. Develop this software technique to avoid spending US $1000 plus on the hardware.

STEP 5 Using the Freehand selection tool, make a series of three complete selections around the subject, moving further away with each one. The closest selection should be blurred lightly while the outer, final, blur can be applied heavily. The idea is that, with a good quality lens, the 'out of focusness' increases the further the eye travels from the subject. Objects in the far distance are no longer annoyances (nor are objects in the immediate foreground areas of the picture).

Technique: fixing an overexposed sky

All cameras have a habit of making exposure 'mistakes'. Very often this produces a picture with a correctly exposed land section and a poorly exposed sky section. This is usually because the CCD in the digital camera (the light recording bit) cannot cope with the contrast differences between the land and the sky – so it opts for the land! Even with many film types, a wide contrast range is hard to record accurately. If you shoot color slides (which have the narrowest scene contrast ranges), the answer is often to return to the scene when there's less contrast (earlier or later in the day) or to use a graduated filter over the lens to balance out the brightness in the sky.

For the digital photographer there are other solutions.

Return to the location at a time of day when the sun is not so high in the sky (and the contrast is lower). For static subjects, secure the camera on a tripod and take two snaps – one exposed correctly for the sky and one exposed for the dark(er) landmass. Combine the two exposures in the same document on two layers using Paint Shop Pro and erase the under and overexposed pixels. Make an 'average' exposure of the scene and use selections to grab the sky and apply local contrast, color and tonal changes to that.

Fixing an overexposed sky

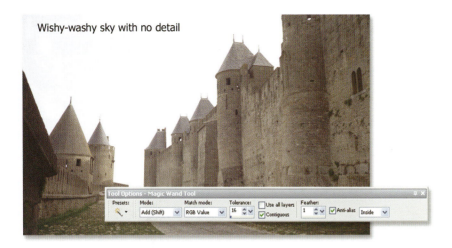

The sky holds no real detail while the foreground is too dark. Lightening the foreground would remove what little sky detail there is.

STEP 1 Use the Magic Wand to select the sky. You might need to Shift-click the sky several times to grab all the tones. Use the Tool Options to vary the Tolerance value to make this easier/more accurate. Consider using the range of Selection Modifiers ('Selections>Modify') to make the sky 'grab' more accurate. Here I have chosen the 'Edit Selection' mode (the visible red opaque layer) so that a brush and/or eraser tool can be used to paint/add to the Magic Wand selection. You can also apply a small feather value to this selection to soften the line where the sky and the land join (i.e. set the selection feather to a value of two or three pixels only). Alternatively, try using PSP's new Background Eraser Brush to cut out the sky (i.e. to make a matte).

STEP 2 Check the accuracy of the selection up close and, if there are any missing bits, I'd suggest using the Remove Specks and Holes Selection Modifier(Selections>Modify >Remove Specks and Holes) to clean it up.

STEP 3 Another effective modifier is the Smooth Selection dialog. Again, this is chosen from the 'Selections>Modify' drop-down menu. Use it to straighten out all ugly jagged edges.

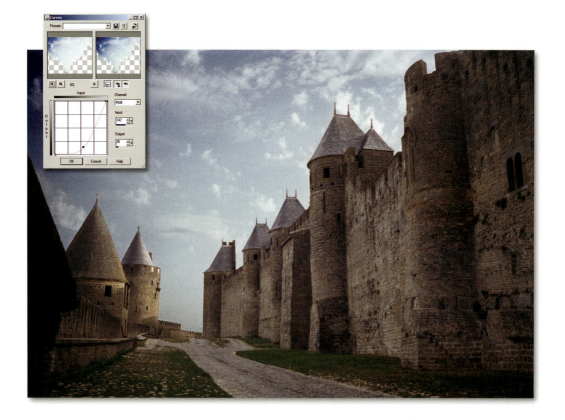

STEP 4 The trick is to use the Histogram Adjustment tool to make the sky section darker via the selection. Use one or both Tone sliders to increase the contrast and density by squeezing them into the center of the histogram. If there's no tone in the original (unlikely, unless the sky is drastically overexposed), you'll have to copy another sky from a different picture.

Paint Shop Pro's Background Eraser tool is fantastic for jobs like this. Once the Opacity and Tolerance levels have been set to the right level it's a simple matter of painting out the sky and either pasting in a new one or using a selection tool to make a very accurate grab of the landscape or sky areas so that they can be modified using a tone command such as Levels.

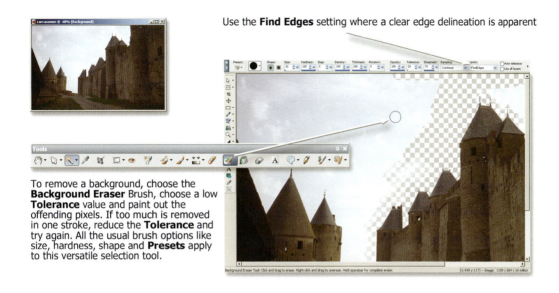

Use the **Find Edges** setting where a clear edge delineation is apparent

To remove a background, choose the **Background Eraser** Brush, choose a low **Tolerance** value and paint out the offending pixels. If too much is removed in one stroke, reduce the **Tolerance** and try again. All the usual brush options like size, hardness, shape and **Presets** apply to this versatile selection tool.

Technique: object cut-out

Creating a cut-out, either to replace the background in a photo or to move an object from one photo into another without its background, requires a high degree of selection accuracy. If your cut-out isn't pixel accurate, tell-tale messy edges will give the game away. But with a little care and a technique designed to make the work of the selection tools easier you can achieve seamless cut-outs that even an expert would be hard pushed to recognize as digital manipulation.

STEP 1 Open the image to be cut out and rename the Raster 1 layer 'Original'. Duplicate it twice and rename the two new layers 'Cut-out' and 'Selection'.

STEP 2 Click the Selection layer in the Layers palette and select Adjust>Brightness and Contrast>Highlight/Midtone/Shadow and increase the highlight value to 100. This creates a greater contrast in edge detail between the figurehead and the background, making it easier for the selection tools to differentiate between the two.

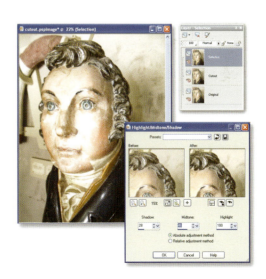

STEP 3 Make sure the Sample Merged box in the Tool Options palette is unchecked and use the Magic Wand tool, with a fairly low tolerance setting, to select portions of the background by Shift-clicking. If you

inadvertently select object pixels press Ctrl+Z and try again, changing the Tolerance or Match mode if it helps. Don't worry if the selection isn't perfect at this stage.

STEP 4 Choose Selection>Modify >Remove Specks and Holes, then save the selection to an alpha channel (Selections>Load/Save Selection>Save Selection to Alpha Channel). In Edit Selection mode (Selections>Edit Selection) paint out any remaining holes in the selection and tidy up the edges using a small soft-edged brush.

STEP 5 Exit Edit Selection mode (Selections>Edit Selection) and resave the selection, overwriting the existing alpha channel. Press Ctrl+Shift+I to invert the selection then – and this is very important – in the Layers palette click the eye to turn off the Selection layer and click the Cut-out layer to make it active.

STEP 6 Press Ctrl+C to copy the selection and open the image you want to paste it into. Press Ctrl+E to paste the selection and position it. Press Ctrl+Shift+M to hide the selection marquee.

STEP 7 Finally, press Ctrl+Shift+F to defloat the selection and add it to the current layer, or Ctrl+Shift+P to promote it to its own layer and save the new image.

5

Combining Images: Working with Layers and Layer Masks

TECHNIQUES COVERED AND TOOLS USED IN THIS CHAPTER

Techniques
Advanced layout tools
Combining layers and layer masks
Combining pictures
Copying and pasting layers
Deformation tools
Layer Blend modes
Layer transformations
Modifying layer masks
Painting on masks
Resizing layers while maintaining aspect ratio
Saving masks
Understanding layers
Using Adjustment layers
Using Mask layers

Tools
Adjustment layers
Background Eraser tool
Blend modes
Deformation tool
Floating selections
Flood Fill tool
Grid, Guide & Snap Properties
Layer opacity
Layer transparency
Layers
Lens correction filters
Mask layers
Merge (command)
Mesh Warp
Move tool
Paste as New Image
Paste as New Layer
Paste as New Selection
Paste as Transparent Selection
Perspective tool
Rulers
Selection Modifiers
Snap to Guides
View (command)
View Grid
View Guides

PAINT SHOP PRO X FOR PHOTOGRAPHERS

This chapter shows how to combine and create multi-picture documents using the power of layers. Layers allow you to combine several images – each stacked one above the other – in a single document. The biggest advantage of layers is that they allow you to put elements on top of one another without destroying what's underneath. But, as we shall see, the advantages of using layers go far beyond that.

Understanding layers

What is a layer? A layer is simply one picture sitting directly on top of another. Layers can contain whole photos, text, vector drawings, scanned art or anything else that can be digitized. You can add as many layers as you want in one document, depending on your requirements. The reason for building up these layers is to maintain the pictures' editability. While a picture retains its layers, it can always be edited. Flatten (or squash) those layers, so that it can be emailed, for example, and you lose the power to edit it.

Paint Shop Pro has quite sophisticated layering capabilities. What I mean by that is not only does it allow you to create montages from multi-layered documents, but it also has a range of features like Adjustment layers that open up even more editing possibilities. So much so that

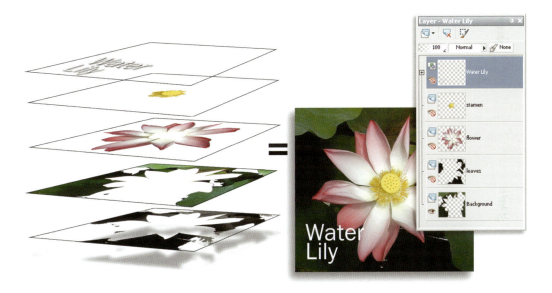

The illustration here shows how a layered image works. Viewed from above (i.e. in the work area) the picture looks perfectly normal, but exploding the Layer palette shows that it is in fact composed of five separate layers – all of which can be moved or can have their color/tones changed independently. Layers files must be saved as either '.pspimage' files or, for more cross-computer compatibility, in the '.psd' (Adobe Photoshop) file format. Using either of these file formats preserves the layer integrity.

every stage in the image-building process can be deconstructed, changed, altered, improved and returned to its place, over and over again, with incredible accuracy and remarkable ease.

Who uses layers?

Layers are used by anyone who adds text to a document, whether a single character or a page of copy for a brochure. Layers are used to make multi-image montages where several pictures blend seamlessly into one. Layers are used extensively by designers, illustrators and web designers. Anyone, in fact, who uses images that have more than one picture element in them.

What can you do with layers?

A layer is like a clear sheet of acetate. Layers can be opaque or transparent, and they can contain pixels (bitmap) or vector data (text and shapes).

You can cut, copy and paste layers from one document to another. Layers can be flipped, rotated, resized, distorted, rearranged or grouped in any number of combinations. You can apply color and tonal adjustments to single layers – and you can add a full range of filter effects, as if one layer were a single picture. Only while the layered document retains its original layers does it remain editable. For seasoned image-makers, this layer editability remains a powerful attraction. How many times have you finished creating a particular work of art only to spot something that you missed but that you now can't change? If you use layers, and have saved the layered version of the image (as mentioned previously), you can make that change!

Before you get too excited, layers have disadvantages:

- Multiple layers create a spaghetti-like complexity that can be hard to keep track of and results in latency (the program taking a moment or more to execute or finish a command).
- The more layers you add to a document, the harder it becomes for the computer to process changes. Each additional layer adds to the document file size.

Layers offer a tremendous potential for the creative image-maker. Simply adjusting the opacity of an individual layer allows you to see everything on the layer beneath. Each layer also has a range of Blend modes. These can be adjusted in order to radically change the way the pixels in the layer react with the pixels in the layer directly below.

Once you understand that layers are similar in appearance to Disney-style punched animation cells or kids cartoon flip-books, you can begin to appreciate the idea behind their function.

We already know that Paint Shop Pro has an almost limitless Undo feature ('Ctrl+Z'). This means that you can reverse the picture building process by up to 1000 steps; however, in accepting an Undo command and then saving, those steps are lost for ever. If you are working with layers, you can apply major editing stages to different layers and retain everything in the one document, regardless of whether you are using it or not. Each layer has a small eye icon called the 'Visibility

toggle'. Click the Visibility toggle to switch the layer 'off', click again to switch it back 'on'.

Like the Disney animation process, layers sit perfectly aligned ('registered') over the layer beneath. If the top layer has an opacity of 100%, you won't be able to see through it to the layer underneath. Reduce its opacity (or change the Blend mode) and you'll see the layer, or layers, beneath it. Reduce the size of the contents of the top layer and you'll be able to view the content of at least some of the layers below.

If you build up the number of layers in a document, the total file size increases. Image-makers need to be aware of this because if the computer has limited amounts of RAM or processing power (megahertz or MHz), it might affect performance. To make this less of a hassle, Paint Shop Pro allows you to merge selected layers into each other. You'd do this to layers, or groups of layers, that are similar or are finished with (i.e. you are sure that they'll never need changing).

You might also do this to layers that, once merged, can be separated again if necessary using a selection. Though merging or flattening layers frees valuable computer resources, RAM is cheap enough, so I'd suggest buying more and keeping the layers for editing because you never know.

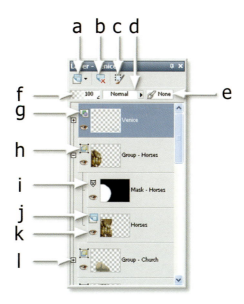

The Layers palette is the control center for layers and the things on them. It helps you organize and keep track of all the layers within an image. There are five distinct layer types – Raster layers, Vector layers, Art Media layers, Adjustment layers and Mask layers. Layers are arranged in order in the Layers palette. The topmost layer in the image appears at the top of the palette; you can rearrange the layers by dragging and dropping. This is the Layers palette showing the individual layers and thumbnail images of the content on each for the montage created in the step-by-step project at the end of the chapter. It is composed of several layers organized into groups. Each group consists of two layers – a Raster layer containing the image and a Mask layer. (a) new Raster layer (other layer types are available from the pull-down menu), (b) Delete layer, (c) Edit Selection, (d) Layer Blend mode, (e) Layer Link toggle, (f) layer opacity, (g) layer group, (h) Raster layer group, (i) Mask layer, (j) Raster layer, (k) Visibility toggle, (l) Click the plus sign to expand and see each object in a layer group and the minus sign to contract it.

What features can be found in layers?

- Layers in the master file are called the 'Stack'.
- Move the picture elements on layers in any direction.
- Change the tone, color, contrast and alignment of any layer.
- Mix Vector and Bitmap layers in one document.
- Create new, blank Vector and Bitmap layers at the press of a button.
- Collect selected layers into Layer Groups.
- Copy single layers, or groups of layers, into the same or a new document.
- Convert selections into layers.
- Paste layers and selections from other documents into a new document.
- Layers can be reordered by dragging them up or down in the Layers palette.
- Layers can be switched 'on' and 'off ' by clicking the Visibility button (the eye icon) in the Layers palette.
- A new layer is created every time you paste the contents of the clipboard into a master file.
- Duplicate a layer using the Duplicate command (Layers>Duplicate) or by pressing the duplicate tab in the palette.
- Use the 'Edit>Layer' tab in the Layers palette to edit a selection (Selection Edit mode).
- Create an art media layer for painting with the new Art Media tools which behave like real-world oil paints and other natural media. Using one of the Art Media tools automatically creates an new art media layer if you haven't already done so.

Combining pictures

TOOLS USED

Move tool
Paste as New Image
Paste as New Layer
Paste as New Selection

Floating Selection
Paste as Transparent Selection
Pick Tool

Paint Shop Pro permits the user to save every stage of the image-building process as a separate state or layer. These layers can be switched on or off according to their application. You can also store masks and selections as separate channels in layered documents. These too can be switched on and off. In Paint Shop Pro, any document that has layers, masks or selections has to be saved in a special native Paint Shop Pro file format with a unique '.psp' (< version 8) or '.pspimage' (> version 8) file ending.

As layers exist in this native file format, you cannot use '.pspimage' files for email and (some)

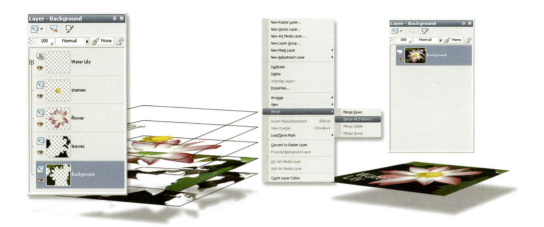

A layered (.pspimage) document is more editable than any other format. Because of this it's also too large for many applications, such as emailing or storage on a limited size disk. For this reason it is important to make a copy and to Flatten or Merge those layers so that the resulting single-layered document can be resaved in a smaller file format, like JPEG or TIFF.

other jobs. The file has to be converted first or copied to a more suitable file type, such as JPEG or TIFF. First you must flatten the file ('Layers>Merge>Merge All (Flatten)'). Doing this turns it into a single-layered document. This loses all of its editability, which is why you should only do this to a copy of the original .pspimage file. Save your layered documents as master files and then, when required, make copies from that master for use in other, non-layered file applications.

There are two quick ways to combine two pictures into one document:

- Copy one picture and paste it into another document.
- Use the mouse to click-select and drag a thumbnail from the Browser or Layers palette to the picture.

Tip

The base layer is called the 'background' and is, in fact, not a layer at all. However, it can be 'promoted' (converted) into a layer if needed (right-click on the Background layer in the Layer palette and choose 'Promote to Layer' from the contextual menu). If you don't want to promote the background, you can simply duplicate it.

While these multiple layers are totally separate to each other, it's important to note that they can be edited at any time as if they were two totally different picture elements. However, because they are in the same document, you also have to contend with their relationship. While copying and

> **Tip**
>
> To maintain the aspect ratio of a layer while resizing it (in other words, to avoid stretching or squeezing it), use the right mouse button to drag a corner handle.

pasting one picture into another is by far the easiest way to add another picture to a document, there are a few points to consider first.

The resolution of the pasted image, measured in pixel dimensions or dots per inch, is relevant. For example, if this is larger than the receiving image it will overspill (bleed off the edges) once pasted. However, even though it looks as if the edges of the pasted image have disappeared, the program does not discard them; they are still there but only become visible if dragged into view using the Move tool ('M').

Another factor to watch out for when combining pictures is their respective color spaces. Providing that the color space of the master document is either 24-bit or greyscale, it will prevail over what is being pasted into it. So, if you copy an 8-bit picture into a 24-bit color picture, the color space of the pasted picture will be increased to match that of the host document. On the other scale, if you try to paste a color picture into a black and white image, it will be converted into the mono layer.

How to create a multi-picture document

STEP 1 Open two photos in the Work Area. Select Window>Tile Horizontally or Vertically. It makes things easier when you see both images as you work. Select the first by clicking once on its title bar (the bar at the top of the window; light blue is unselected, dark blue means it's selected) and copy the picture into the program's clipboard ('Edit>Copy').

STEP 2 The picture is now in memory (called the clipboard). Select the second picture by clicking on the title bar, and paste it ('Edit>Paste') from the clipboard into the target picture window. If the pasted image has the same dimensions as the master document it will cover it exactly.

STEP 3 Once the picture has been pasted and positioned over the second image (now called the 'background' image), you might need to resize the new layer to fit the overall design or to simply reveal some of the background layer. Do this using the Pick tool in one of two ways.

- Ensure that the layer to be resized is selected (click once on the title bar in the Layers palette), select the Pick tool from the Tools toolbar and note the handles that appear in the corners of the layer (you can only resize a layer). Handles are used to change the proportions and

PAINT SHOP PRO X FOR PHOTOGRAPHERS

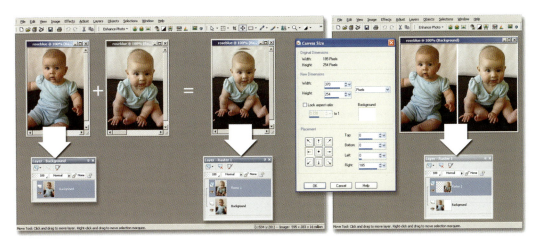

Copy the first open photo (Edit>Copy), select the second (click on the title bar once to bring it to the front) and paste the contents of the clipboard into it (Edit>Paste as New Layer) to produce a two-layered document. Use the Image>Canvas Size feature to increase the physical size of the canvas (the white background) so that the photos can be positioned side-by-side, rather than on top of each other (as seen here, center, left desktop view). You can resize the canvas at any time to accommodate one or more extra photo or vector (text) layers. In contrast, changing the Image Size actually increases the picture size (or pictures) on all layers, as well as the canvas background.

> geometry of a layer. Move the cursor over the corner and note that it changes into a rectangle. Click-hold the corner handle and drag out to increase the layer size and inwards to decrease the size. This is a freehand operation so you will probably change the proportions of the layer and the picture sitting on it. To lock the proportions, drag the layer using a right-click.

> ■ Alternatively, use the deformation settings in the Options palette. There are numerical fields for changing all possible axes in the picture including rotation, shear and perspective distortion. Click 'OK' and the layer is resized to that proportion. This will not work on the background unless it is first promoted to a layer.

Tip

If the image you are copying and pasting is relatively large, first resize it using Image> Resize. Choose the same resolution as the target image if you are using the Print Size pane.

STEP 4 Use the Move tool to position the newly-resized layer. Save the layered document in the Paint Shop Pro ('.pspimage') format so that you retain all the layers for editing later. To add more pictures to the same document, repeat steps 1–3.

Paint Shop Pro offers a number of ways to paste copied images into another document via the Edit menu or by right-clicking in the new document. These are:

- Paste as New Image. This creates a new picture on its own background.
- Paste as New Layer. This adds the contents of the clipboard to the selected document background. Paint Shop Pro automatically creates a new layer for the pasted image. If the pasted image matches the physical dimensions of the target image, it will obscure the lower layer or background picture.
- Paste as New Selection. This pastes the newly-selected picture into the target document, but it remains attached to the cursor so that it can be positioned somewhere other than directly on top of the background. Left-click to offload the layer and view the selection marquee. The pasted layer then becomes a floating selection until it is deselected. You can save this selection as an alpha channel (in case it is needed again: 'Selections>Save To Alpha Channel'). If you already have a floating selection, it will be defloated and deselected before another picture can be pasted into the document (i.e. you can't have two floating selections in one document).

Tip

Deleting the Floating selection at this stage removes the picture contents. Deselecting the image ('Selections>Select None') affixes the Floating selection to the layer below. If you decide that you want to save that Floating selection as a separate layer, either delete it and repaste the contents of the clipboard as a New Layer or select 'Selections>Promote to Layer' from the Menu bar. Paint Shop Pro creates a new layer for it to sit on.

- Paste as Transparent Selection. This command does the same as the Paste as New Selection command, but enables you to import transparency from another image. Because of this transparency, the pasted layer is attached to the Move tool for easy repositioning. Click in the image to free it once it is in the right position.

What can you do with layers?

- Change the individual tonal appearance of each layer.
- Make and edit selections on individual layers.
- Add Blend modes to individual layers for special effects.
- Save layer selection and mask information to an alpha channel and to disk.
- Add Adjustment layers.
- Apply any of Paint Shop Pro's filter effects to a layer.
- Bend and transform the shape of any object on a layer.
- Convert Vector layers to Bitmap layers.

Advanced Layout tools

> **TOOLS USED**
>
> Rulers
> View
> View Grid
> Grid, Guide & Snap Properties
> Merge
>
> Arrange
> Layer Opacity
> View Guides
> Snap to Guides

As we have seen, there are many ways to use Paint Shop Pro for combining multiple layers into a single document. In this exercise we'll use several advanced features designed to make laying out and arranging multiple picture documents less confusing, and faster.

Under Paint Shop Pro's View menu there are a number of highly useful productivity-enhancing features designed to make aligning and arranging multi-layer images faster and easier.

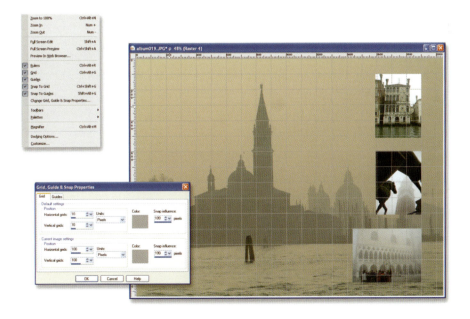

Paint Shop Pro's rulers, guides and grid enable you to accurately position and align elements. Snap to Grid and Snap to Guides makes the grid and guides behave as though magnetized – they attract and hold dragged objects which are in close proximity. Double-click the rulers (or select View>Change Grid, Guide and Snap Properties to change grid spacing and other grid and guide properties.

These are:

- Rulers. Keyboard shortcut 'Ctrl+Alt+R' adds rulers along the X- and Y-axes of the picture window. You can change the units of measurement (pixels/inches/centimeters) through the program's General Preferences ('File>Preferences>General Program Preferences, then click on Units in the Preference Column on the left). Place the cursor anywhere in the image and you can read out the exact location in the corresponding margin. It's a handy tool, especially if you are working with extremely small picture elements on multiple layers.
- View Grid. If you find the grid too heavy, double-click on the rulers in the margin and you'll see the Grid, Guide & Snap Properties dialog. Change the units used and the color to make it appear friendlier. You'll need to make adjustments every now and then for different-sized pictures. This is a useful feature for precise layer or picture element alignment.
- View Guides. This is one of the neatest design assistants in Paint Shop Pro. They work only if 'Rulers' are switched 'on'. Guides are colored lines that can be pulled out of the margins (using the cursor regardless of the tool currently selected) and dragged over the picture to form, well, design or layout guides. There are no limits to the number of guides that can be used in one document. Guides can be repositioned by grabbing the guide handle (that's the thicker bit of guideline that appears inside the ruler margin as you move the cursor over it). If you want to change the guide properties, double-click the ruler to open its window or just click the guide handle in the margin to open the Grid, Guide & Snap Properties dialog. This allows you to change its color, position or existence!
- Snap to Guides. This function adds tremendous power to the task of aligning multiple layers along a common axis – by selecting this option and making sure that, in the Grid, Guide & Snap Properties dialog, the Snap Influence setting is set to more than one. What this does is if you grab an image layer using the Move tool and drag it towards the guide it appears to be magnetically attracted to the line. In fact, it 'snaps' to the line. Increase this value to increase the magnetic power.

You can change any of these settings for the opened document only, or for the default settings. This feature is a real production enhancer. Under the Layers palette:

- Layer Opacity. All layers have an opacity scale controlled from the Layers palette. Default setting is 100%. Reducing this allows you to see through the layer to whatever lies beneath. Do this to help align specific pictures or graphic elements with stuff that lies beneath.

Under the Layer menu:

- Arrange. This feature allows you to swap the layer order, although you can also do this by using the cursor to grab a layer in the palette and dragging it to another position in the stack.
- View. Controls which layers are visible and which are not. You may also switch a layer on and off by clicking on the eye icon in the palette itself.
- Merge. Merge allows you to do just that: merge or blend selected layers. Merge Visible flattens only the layers with the eye icon switched 'on' (i.e. those that are visible on the desktop).

Using Adjustment layers

TOOLS USED

Adjustment layers
Selection tool
Flood Fill tool
Hue/Saturation/Lightness

Making tonal adjustments to a digital photo, for example brightening the midtones and shadows with a Levels adjustment, changing the color balance, or using the Fill Flash filter, changes the value of pixels within the image. Other than by pressing Ctrl+Z to undo, these changes

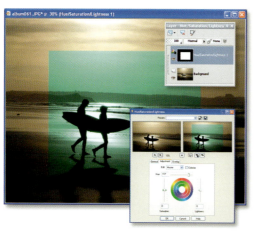
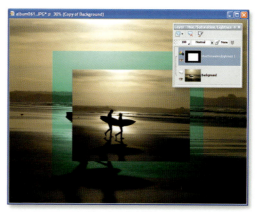
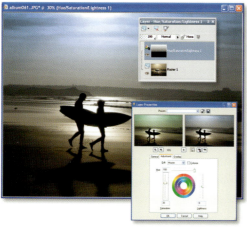

Clockwise from top left: 1. Here, I've made a rectangular selection and added a Hue/Saturation/Lightness adjustment layer. The new Layers palette displays a thumbnail of the mask. 2. The background layer has been duplicated, resized and dragged to the top of the stack – the Adjustment layer affects only the original background layer below it. 3. Filling an Adjustment layer with a linear gradient applies more correction at the top, gradually reducing towards the bottom. 4. An adjustment layer is infinitely editable with no loss of image quality.

are irreversible. Opening, say, the Levels dialog box and making an adjustment in the opposite direction will not get you back to where you started.

But what if you could apply such changes and, if you later changed your mind, remove them, as if they'd never been applied in the first place? Adjustment layers allow you to do exactly that. Adjustment layers are a safer, more versatile way of applying image adjustments because, as well as turning them on and off just like other layers, you can apply adjustment layers to one or several layers within the image.

You can also go back to Adjustment layers and edit the settings at any time without causing any degradation in image quality. With adjustment layers, doing the opposite to a previous adjustment does get you back exactly where you started. Earlier we spoke of layers as being like acetate sheets stacked on top of the background image. Think of Adjustment layers in the same way – as a clear sheet to which you can apply adjustments and through which you view layers below. The appearance of the pixels in the underlying layers is affected by the adjustment layer, but the pixels themselves are not altered.

> **Tip**
>
> To create an Adjustment layer that applies to a single layer, create a Layer Group containing the layer you want to adjust and add the Adjustment layer to the new Layer Group.

Whereas an adjustment affects only the active layer an Adjustment layer acts on all the layers beneath it, or all the layers within a Layer Group. By careful positioning of Adjustment layers you can change only one part of an image. Adjustment layers are frequently used when combining images to make the new image elements match in terms of color and lighting.

Another way of limiting Adjustment layers is by editing them in the same way as Mask layers. You'll remember from the previous chapter that mask layers are grayscale and pixel values in the Mask layer affect the opacity of corresponding pixels in underlying layers. Adjustment layers are also grayscale and their effect on underlying layers is likewise dependent on the pixels within the mask. Black pixels apply no correction, white pixels apply the full amount of correction and gray pixels apply varying amounts of correction in-between.

You can vary the overall effect of an Adjustment layer using its Opacity slider in the layers palette. Alternatively, you can apply the Adjustment layer to a selection, or paint directly onto it to isolate the parts of the layer you want the adjustment to affect.

Layer types

You can add the following types of Adjustment layer:
- Color Balance
- Hue/Saturation/Lightness

- Channel mixer
- Brightness/Contrast
- Curves
- Levels
- Invert
- Threshold
- Posterize.

Advantages of Adjustment layers

- Add a range of tone and effects changes to a layer or layers without actually changing the original layer.
- Useful for applying overall color or tone changes to multiple layers at a time.
- Can be removed by deleting the Adjustment layer, or switching it off.
- Ideal for anyone working with panoramas.

Creating Layer Blend Mode effects

TOOLS USED

Blend modes

Blend modes determine how pixels in a layer interact with corresponding pixels in underlying layers. The default Blend mode is 'Normal' – the pixel in the top layer is superimposed on (and therefore hides) the pixel in the underlying layers (subject to transparency settings).

There are 20 other blend modes in addition to 'Normal' and each provides a slightly different result. 'Darken', for example, displays only pixels in the selected layer that are darker than corresponding pixels in underlying layers; lighter pixels in the selected layer disappear. The Lighten Blend mode does the opposite. 'Color' applies the hue and saturation of pixels in the selected layer to underlying layers without affecting lightness and 'Difference' subtracts the selected layer's color from the color of underlying layers.

Some Blend modes have practical applications. 'Darken' and 'Lighten' are useful for retouching and cloning. You can also use 'Darken' to get rid of a white background on a logo or other arwork. 'Multiply', which combines the colors in the selected layer with underlying layers to produce a darker color, is useful for producing realistic drop shadows.

Because the outcome depends on initial pixel values in the selected and underlying layers, the results of some Blend modes can be hard to predict. If you are working with two layers, simply swapping the layer order can produce very different results. This makes blend modes an excellent tool for creating special effects with multiple images, and works especially well with

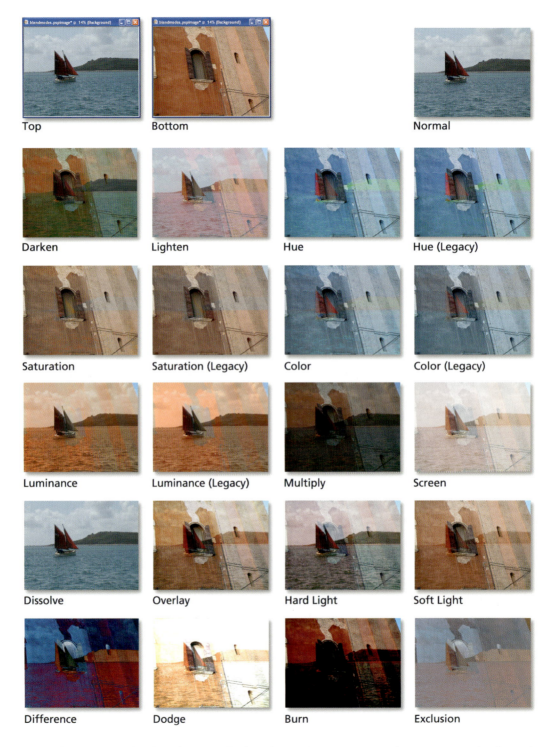

Paint Shop Pro's 21 Blend modes as applied to the two images 'Top' and 'Bottom'. Results depend greatly on layer content and order. Legacy modes maintain compatibility with earlier versions.

text, but a certain amount of experimentation is often required to get a good result.

Blend modes can be selected for most of Paint Shop Pro's Brush tools as well as layers – the Blend Mode pull-down menu in the Tool Options palette provides exactly the same options as are avaiable in the Layers palette.

Using Mask layers

A Mask layer works a bit like a stencil – holding back some parts of the image and revealing others. We briefly looked at Mask layers in the previous chapter on using selections. The truth is Mask layers, alpha channels and selections are a bit difficult to pin down in terms of definitions because they all do pretty much the same thing – control which parts of the image are displayed or affected by an adjustment – in slightly different ways.

Earlier, we saw how Adjustment layers could be used as mask layers to confine their corrections to one part of the image, but a Mask layer is more often used to hide parts of the image without actually deleting it. The advantage of this should be fairly obvious; you can subsequently edit the mask to reveal hidden parts of the underlying layers or, conversely, to hide more.

Usually, the best starting point for creating a mask is a selection. Make a selection using one or a combination of the selection tools and modifiers and from the Layers menu choose New Mask Layer>Show Selection to create a mask that shows the selected parts of the layer and hides everything else. To create a mask that hides the selected area choose Layers>New Mask

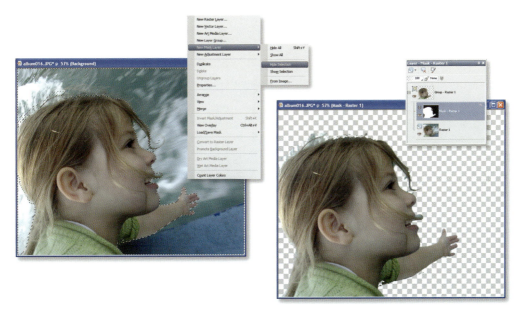

A selection is often the best starting point for a mask. The existence of two options – Show Selection and Hide Selection – negates the need to invert the selection if you want to hide the selected area, as here.

Layer>Hide Selection. If you are masking a background layer, Paint Shop Pro will display an alert box notifying you that 'the target must be promoted to a full layer'; click OK.

Paint Shop Pro automatically creates a new Layer Group containing the selected layer and the new mask. This is so that the mask doesn't affect other layers in your image. If you want the mask to apply to all the layers beneath it, drag it in the Layers palette from the Layer Group to the main level. With the mask in place, you can press Ctrl+D or Selections>Select None. If you need it, you can recover the selection at any time with Ctrl+Shift+S or Selections>From Mask.

Modifying masks

One of the best things about masks is that you can use Paint Shop Pro's Brush tools to edit them. Painting masks is often an easier and more accurate way to clean up selections than using the selection modifiers. You can, for example, use a soft-edged brush to clean up the edge-detail of difficult subjects like fur, hair, or indeed anything that doesn't have a clearly defined edge.

To use the Brush tools to directly edit a mask layer, select the layer in the Layers palette and choose the Paint Brush tool. You may have noticed that the foreground and background swatches in the Materials palette change to gray when a Mask layer is selected; remember, mask layers are grayscale, so you can only paint on them using black, white or one of 254 levels of gray. Painting on the mask with black will add to the mask and remove detail from the underlying layer. Painting with white will remove the mask and reveal detail on the underlying layer. If you

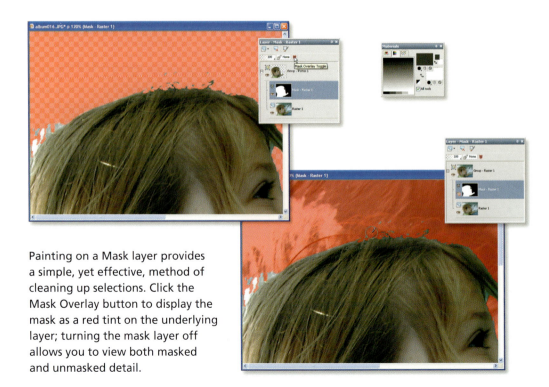

Painting on a Mask layer provides a simple, yet effective, method of cleaning up selections. Click the Mask Overlay button to display the mask as a red tint on the underlying layer; turning the mask layer off allows you to view both masked and unmasked detail.

paint with gray, you'll make parts of the underlying layer semi-transparent. It's usually easiest to use just black and white and change the brush settings in the Tool Options palette to achieve the required effect. Select black for the foreground swatch and white for the background swatch so that you can add black to the mask with the left mouse button and white with the right mouse button. As we've said before, this kind of editing is made much easier using a tablet and stylus.

> ## Tip
> Displaying the Mask Overlay, but turning off the Mask layer itself, shows the mask on top of the unmasked layer below, making it much easier to see what you're doing when painting onto the mask.

Adding to the mask – painting out detail on the underlying layer – is quite straightforward because you can see what you are doing. Painting detail back in by removing black areas from the mask is trickier because you can see neither the mask, nor the detail. To display the mask click the Mask Overlay button on the Layers palette. This overlays the Mask layer with black areas displayed as a 50% red tint over the target layer(s).

Combining layers

Some digital image-makers work with multiple images and image masks. In this situation it is vital to remember exactly what you are doing and what the final planned result should look like.

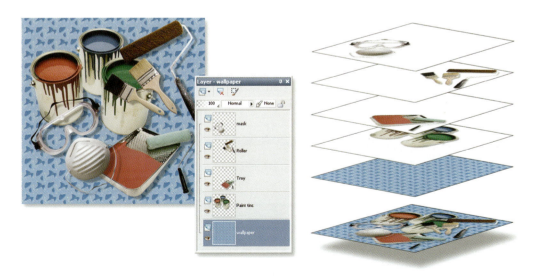

Combine Raster layers, Vector layers, Art Media layers, Adjustment layers and Mask layers to simplify images and produce smaller files. Keep a back-up copy with all the layers intact in case you need to re-edit the image.

To this end, use sketches to keep your mind clear where each image is to be placed in the frame and try to label all the layers, Layer Groups and masks. Doing this (by double-clicking each layer and entering the details in the dialog) will make the masking and blending process somewhat clearer, especially when there are 20 or more layers to contend with.

As we've seen, images with lots of layers create large file sizes and it's often difficult to discover which bits of the image are on what layer. You can simplify Paint Shop Pro images and drastically reduce the file size by flattening them, or merging layers together. There are four merge options on the Layers>Merge menu – Merge Down, Merge All (Flatten), Merge Visible and Merge Group. Masks that are associated with underlying layers as part of a Layer Group can easily be merged using Layers>Merge>Merge Group. When you do this, the mask is applied to the image and masked areas are deleted. Simply deleting the mask has the same effect.

Merging layers means you no longer have the editing flexibility that they provided, so if you're likely to want to carry out further changes later make a back-up copy with all the layers intact using File>Save Copy As before you start merging.

Saving masks

To save an image with masks use the .pspimage format. You can save a Mask layer to its own file on disk – choose Layers>Load/Save Mask> Save Mask To Disk. The default location for saved masks is in the Masks folder in the My PSP Files folder which is installed to your My Documents folder by default. This folder is where all your custom content (Tubes, Masks, Selections, etc.) is saved. You will also find a selection of ready-made masks in the Masks folder in the Paint Shop Pro program folder. These can be used for framing and other effects.

Only two formats support images with masks and other types of layer: they are the .pspimage and .psd (Photoshop) formats. If you want to save your image with all layers intact use one of these two file formats. If you attempt to save your image in a file format that doesn't support layers, Paint Shop Pro warns you before flattening the image and saving it.

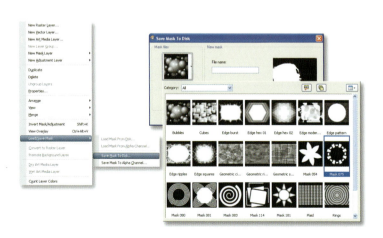

As well as saving your own masks to disk, Paint Shop Pro provides a selection of existing masks that you can use to frame layers and create special effects.

STEP-BY-STEP PROJECTS

Technique: creating a photomontage

Using Paint Shop Pro's selection tools in conjunction with Mask layers you can easily create a montage of overlapping images with soft-edged boundaries. It's often difficult to know how this kind of thing is going to look until you get the images on the page. Because Mask layers hide pixels in underlying layers without deleting them, you can edit the composition at any time.

When you create a layer mask from a selection, Paint Shop Pro automatically creates a Layer Group containing the mask and the Raster layer to which it applies. This makes it easy to move the layer, together with its mask, around the canvas until you find the right spot for it. Overlapping areas can be tricky, but again, because the mask is grouped with its Raster layer, you can easily drag the group up or down the layer order in the stack.

Sometimes, having the Raster layer and Mask layer locked rigidly together isn't helpful. But by clicking the Group Link toggle you can free the mask from the raster layer and move it independently. This allows you to move the mask around on top of the Raster layer like a window, until you get the part of the image you want.

STEP 1 Creating a montage involves bringing together lots of images to create a single photo composition. You can make life easier by first doing a little planning and preparation. Use the browser to view potential candidates, trying to keep an eye out for images that work well together and fit the theme. Think about the final image size – do you want an A4 landscape for framing, or something smaller for use on a website? When you've decided on the size of the montage, take a look at the resolution of the composite images; if they are bigger than a quarter of the size of the whole montage (at the same resolution) resize them all before moving on to Step 2.

STEP 2 Select the images you want to use in the browser and Ctrl-click to select all of them. Press Enter to open the selected photos and choose one of the tile views from the Window menu to display them all simultaneously. Window>Tabbed Documents displays one image and minimizes the others to tabs at the top of the screen.

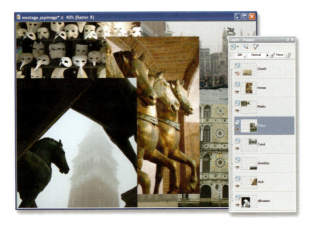

STEP 3 Create a new document and save it; call it 'montage', or something similar. Click on the title bar of one of the original images and press Ctrl+C to copy it then click the title bar of the montage image and press Ctrl+L to paste the copied photo as a new layer. Do this for all of the open images, then close them, so that only the montage image, with all of the constituent photos pasted in as layers, is open. At this stage it's also a good idea to rename the layers so you can instantly see what's what. Double-click the layer name in the Layers palette and rename it with something more descriptive in the Layer Properties dialog box.

STEP 4 Click the Layer Visibility toggles (the eye icons) in the Layers palette to turn off all the layers bar one. Using the Freehand selection tool with a feather setting of around 50 (the amount of feather will depend on the size and resulotion of your montage file), make a rough selection around the central subject of the picture. Don't worry if the selection goes slightly beyond the picture edge – the feather will take care of it.

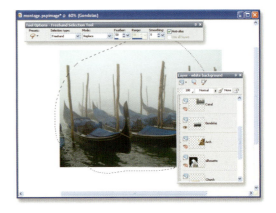

STEP 5 Select Layers>New Mask Layer>Show Selection to create a new Mask layer from the feathered selection. Paint Shop Pro creates a new Layer Group containing the Raster layer and the Mask layer. Now you can press Ctrl+D to select 'none' as you no longer require the selection.

> **Tip**
>
> If the images are too big when you paste them into the montage document, press Ctrl+K to select the Pick tool and right-click and drag a corner handle to resize them while maintaining the aspect ratio.

STEP 6 Select and show the next layer in the Layers palette and repeat Steps 3 and 4 to create a mask for this layer. Position the newly masked layer so that it overlaps the first one.

STEP 7 The great thing about using layer masks is that you can edit them. Click the Mask layer in the Layers palette and select Layers>View Overlay to show the mask as a red overlay. Use a large soft-edged brush and select white to paint the mask away, black to paint it back in.

STEP 8 When you've created masks for each of the layers, position and reorder the layers to achieve the best composition.

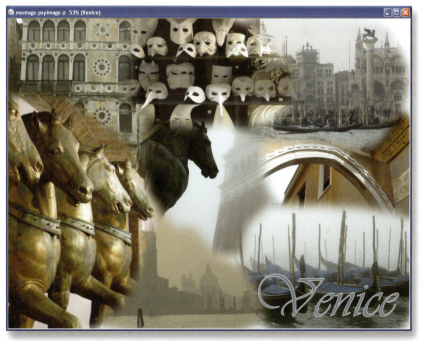

Technique: layer deformations – creating the perfect shadow

Paint Shop Pro's drop shadow filter (Effects>3D Effects>Drop shadow is great for adding drop shadows to two-dimensional objects like photos and text, but if you want to add a realistic drop shadow to a 3D object you need to create additional layers and use the deformation tools to produce a realistc shadow shape. It's not a difficult technique, and once you've mastered it you'll be able to add realistic shadows to all manner of things from signposts, cars, and coffee cups to people, even painters and decorators.

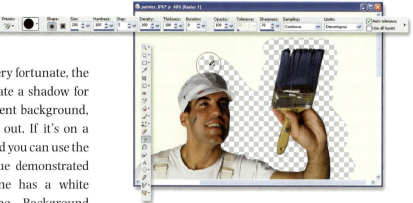

STEP 1 Unless you're very fortunate, the object you want to create a shadow for won't be on a transparent background, so you'll have to cut it out. If it's on a complicated background you can use the object cut-out technique demonstrated on page 115. This one has a white backgound which the Background Eraser makes light work of. While you're using the Background Eraser, hold down the space bar to temporarily access the Pan tool and move around the image.

The Background Eraser makes quick work of removing unwanted pixels.

STEP 2 When all of the background is removed, duplicate the layer by right-clicking it and selecting 'Duplicate' from the context menu. Rename the duplicated layer by clicking its name in the Layers palette (or by right-clicking the layer and selecting 'Rename') and overwriting it. Call it 'shadow' The layers palette should now look like this.

STEP 3 Open the Levels dialog box (Adjust> Brightness and Contrast>Levels) and drag the Output level highlight slider (the right-hand diamond on the lower of the two slider bars) all the way to the left. You'll see the preview thumbnail turn black and the image window will mirror this change if you check the Auto Proof button. Click OK to apply the adjustment.

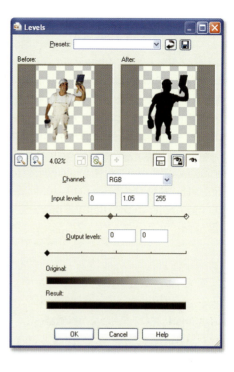

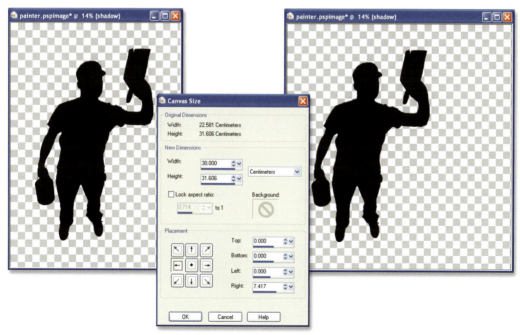

STEP 4 You may need to add more canvas to fit the shadow in. Select Image>Canvas size and increase the width and height as necessary. We're going to simulate directional light from the left-hand side so use the placement buttons to add canvas on the right.

STEP 5 Select the Pick tool and click on the shadow object. Hold down the Shift key and drag the middle handle on the top edge sideways to the right to skew it. Let go, then drag the handle (this time without holding down Shift) downwards to shorten it. Make further skew and shortening adjustments until the shadow shape fits with the kind of lighting setup you are trying to create. The higher the light the shorter the shadow will be and the further to the right the more skew you will need.

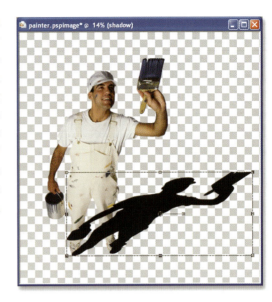

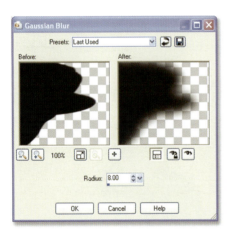

STEP 6 It's beginning to look more like a shadow, but we're not there yet. Select Adjust>Blur>Guassian Blur and enter a value in the radius field of around 8, just enough to soften the edges. Click the Proof button to preview the effect in the image window. Pixel value settings like radius are dependent on the size of the image, so if you're working on a smaller photo for the web a lower radius value of 2 or 3 would be enough.

STEP 7 The problem with adding computer-generated effects to photos is that they lack texture, and everything in a photo, even shadows, has texture. Use the Add Noise filter (Adjust>Add/Remove Noise>Add Noise) to put some texture into the shadow. Check the Gaussian button and Monochrome box and use a noise setting of around 15%. Click OK to apply the noise.

STEP 8 Shadows generally appear behind, rather than in front of objects, so drag the shadow layer to the bottom in the Layers palette. You could also rename the other layer 'painter' or something else appropriate to your subject. Naming of layers like this can help you keep track of things. It's not so important when there are only one or two layers, but in more complex images with multiple layers and Mask layers it helps to keep things organized.

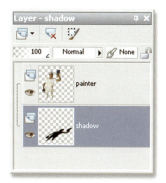

STEP 9 Shadows are rarely solid black. Reduce the shadow layer opacity by dragging the opacity slider in the Layers palette to around 50%.

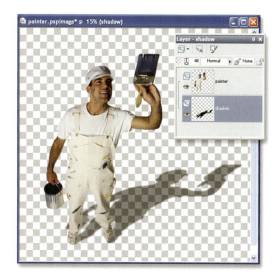

STEP 10 Add a background layer. Select Layer>New Raster Layer and click OK to accept the default settings. Drag the layer to the bottom of the Layers palette, then use the Materials palette to select and apply a solid colour, gradient, or pattern to the new layer,

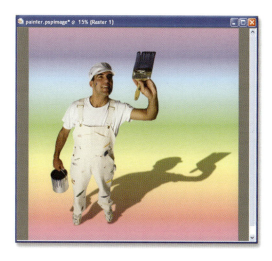

You can, of course, place your transparent object and shadow on any background including other pictures. Here, the painter has been superimposed on the rock image from Chapter 7. His shadow has been deformed, like the type, to follow the contours of the rock face using the displacement map technique described on pages 197–201. The paint on the brush and in the tin has been changed from blue to red using the Hue Map.

6

Using Text: Understanding Vector Graphics

TECHNIQUES COVERED AND TOOLS USED IN THIS CHAPTER

Techniques
Adding basic text elements
Adding special effects to text
Adding special effects to vector shapes
Combining photos to make a calendar
Creating basic vector shapes
Creating text on a path
Editing text shapes
Making a greetings card
Working with the Pen tool

Tools
Chisel/Cut-out filters
Convert Text to Curves
Drop Shadow filter
Grid
Guides
Inner Bevel filter
Kerning
Layers
Leading
Pick tool
Preset Shape tool
Symmetric Shape tool
Rulers
Text tool

In this chapter we take a look at Paint Shop Pro's text and vector drawing tools. These features expand Paint Shop Pro's capabilities and broaden its use beyond photo editing into the realms of illustration and graphics. In practical terms it means that as well as editing photos you can create illustrations from scratch and produce a range of photo-based projects like greetings cards, invitations, calendars, flyers and even brochures.

How text and vectors work

Up to now nearly everything we've done in Paint Shop Pro has involved manipulating pixels. Text and vector objects work in a different way to pixel-based images and this provides them with some advantages. Whereas a pixel-based bitmap is composed of many individual dots, each described in terms of its red, green and blue component values, vector objects and text are mathematically defined shapes. The object's properties are defined and from these the computer constructs them. A circle, for example, might be described in terms of its radius, stroke weight and color, and fill. The user isn't necessarily aware of this and just uses the available Shape tools and the Materials palette to draw the required shape, or the Text tool to enter type.

Vectors have two distinct advantages over bitmaps. Because they need minimal data to describe them, they take up very little memory and disk space. And because they are generated by the computer they are resolution independent, which is another way of saying you can make them as big as you like with no loss in quality.

Vectors also have their limitations. They're a good way of producing regular shapes like letterforms, geometric shapes and even irregular curvy shapes, but they're not great at representing real-world textured, detailed scenes, which is why we need the pixels for photographic images. For this reason vectors tend to be confined to type and 2D illustration with flat color or mathematically predictable gradations.

Adding basic text

> **TOOL USED**
> Text tool

Paint Shop Pro's Text tool is used to add text to any type of document, whether photo, vector illustration or scan.

Choose the Text tool from the Tools toolbar and double-click anywhere in the document. This opens the Text Entry dialog box. Type what you want in this box, click OK and watch as the text appears somewhere in the document canvas. The program automatically places the text data

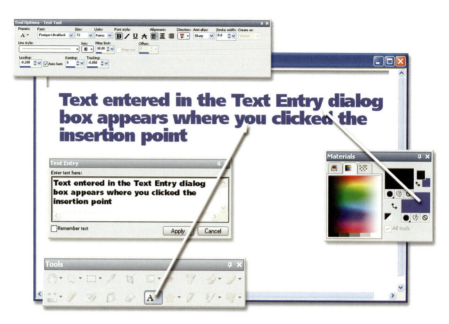

Select the Text tool; click the picture once and type into the Text box that appears. Each time this is done PSP makes a new Vector layer to hold it. Double-click the text with the Text tool to open and re-edit that particular layer.

onto a Vector layer in the Layers palette. It remains in a vector format until you need to apply special effects to it. If this is the case, Paint Shop Pro asks you to convert the layer from vector to raster (more on this in the next section).

Either click the Apply tab in the text box and edit it later or make your changes live in the Text box and then click the Apply tab. You can refine this basic text addition process in several ways:

Use the Text Alignment checkboxes to arrange text left, center or to the right of the box, as illustrated.

- As new text is being typed it's automatically placed on a new (Vector) layer.
- Add as many separate Text layers as needed.
- Use the Move tool to shift the text to get a more accurate positioning (this appears once you move the cursor over the text's 'Center' handle in the bounding box).
- Use any of the bounding boxes' four corner handles to resize the text in the document. Use the left mouse button to freely resize the text. Use the right mouse button to lock the vertical and horizontal proportions.
- Use the bounding box's rotation handle to rotate the text as a block (a spherical arrow indicates the cursor is in the right place for a rotation).
- Use the Tool Options palette to add a staggering range of sophisticated changes to the text.

Ariel Text 12pt
Chicago Text 12pt
Geneva Text 12pt
Hoefler Text 12pt
Monaco Text 12pt

Times New Roman Text 6pt
Times New Roman Text 8pt
Times New Roman Text 10pt
Times New Roman Text 12pt
Times New Roman Text 14pt
Times New Roman Text 16pt

Paint Shop Pro can make use of all the fonts installed on your PC. These can be preset to appear in a variety of heights or point sizes.

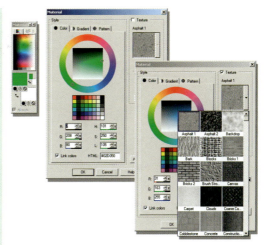

Text is 100% editable at all times as long as it remains on its unique vector layer. Special effects can be added at any time using the Materials palette and a range of filter-type effects. Some effects might involve you having to render the Vector layer to a bitmap state in order to execute the action – this is perfectly OK but is irreversible, so if the text needs to be grossly enlarged after this has been done some quality will be lost.

> **Tip**
>
> To detach text from a path, right-click the Text layer in the Layers palette and select Detach Text From Path from the contextual menu.

- You can also change the typeface, point sizes, add Bold, Italic commands and all the usual formatting instructions to the body text.
- To change spelling or content to a specific text layer, simply click the appropriate Vector Text layer in the Layers palette or double-click on the text. Bear in mind that if you need to add effects to the text, the layer needs to be converted from vector to bitmap (raster).

The beauty of working with Vector Text layers is that they are infinitely adjustable. You can increase or decrease text size at any time with no loss of quality.

Anti-aliasing is the process of introducing semi-transparent pixels at the edges of an object, or text character to smooth out jagged edges, or stepping, caused by square pixels. This is more noticeable at low resolutions, where fewer pixels are used to make up the characters. Paint Shop Pro has three anti-aliasing options: none (left), sharp (middle) and smooth (right).

Special text effects

> **TOOLS USED**
>
> Text tool Cut-out
> Chisel Inner Bevel
> Convert Text to Curves Pick tool

Now that you have had practice adding text to a picture, you'll want to try adding special effects to jazz up the results. In this section we run through some techniques for making your text look simply stunning.

Special effects?

With Paint Shop Pro you can add a wide range of effects to your text layers. For most actions the Vector Text layer must first be converted to a Raster layer – a warning dialog appears and Paint Shop Pro asks you if this is OK (if you don't want to be asked every time, click the 'Don't remind me' checkbox from the dialog that pops up on screen).

Select 'Drop Shadow' from the 'Effects>3D Effects' menu. The opening dialog offers a range

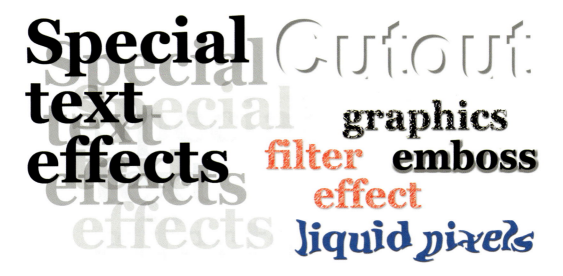

Over and above regular text effects, added via the Materials palette, it's possible to add tremendous three-dimensional power using any of Paint Shop Pro's filter effects. To do this you might have to convert the layer from vector to bitmap but still, the resulting effects, as seen here, are very impressive.

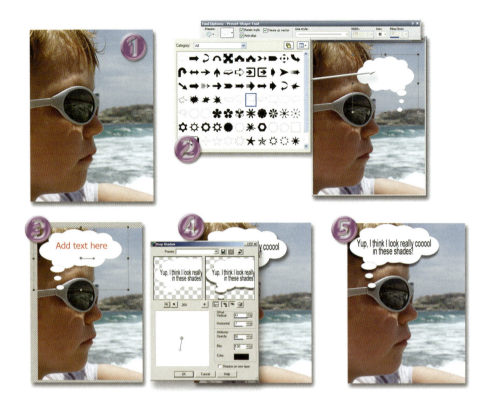

Adding a vector shape and text to a photo. (1) Open the photo. (2) Choose a suitable preset shape from the drop-down Preset Shape Tool menu. (3) Use the handles to reposition and rescale the shape if necessary. (4) Reposition, rotate or flip the vector shape using the Pick tool, then choose the Text tool and enter appropriate text in the Text box. Press 'Apply' once happy with the size and positioning of the new text. Use Paint Shop Pro's Drop Shadow filter to add an effect to the speech bubble and save as a '.pspimage' file. (5) Alternatively, flatten those layers and save another version of the picture in the JPEG file format so that it can be emailed.

of control options: try the Randomize tab or simply grab the shadow 'tail' in the window and drag that to the desired point to create the right depth and shadow angle. Click OK.

Drop shadows make a tremendous difference to the appearance of the text. As a general rule, place the shadow under the text and to the right (there are obvious exceptions to this depending on the type of font chosen and its use).

Other 3D Effects for adding impact to text include: Chisel, Cut-out and Inner Bevel.

Besides the usual formatting changes that can be made in any word processing program, these would be the most useful for adding impact to your text. If you need to add something slightly more esoteric, then try some of the filters from the 'Artistic', 'Art Media', 'Distortion' or 'Texture' filter drop-downs. Any of these filters will work on the Text layer as long as it has been converted into a Bitmap (Raster) layer first.

Using filter effects: a warning

Though almost all the filters under the Effects menu will have an effect on Raster Text layers, not all work well and some may not appear to do anything at all. The reason for this is that the filter action works across the entire frame and not just on the text on its own. If the filter has a global effect then it is more than likely to be seen on the text layer, but if it is of a more random nature, it might or it might not. To make it work correctly you must first select the text and then apply the filter action. Do this by choosing 'Selections>From Vector Object' or use the keyboard shortcut 'Ctrl+Shift+B' and then apply the filter. Most filter combinations will produce an impressive result.

Adding text to a path

Adding text to a path can make for a dynamic and interesting design and is especially useful for creating company logos, web buttons, badges, CD and DVD labels and the like. You can add type to shapes created with any of Paint Shop Pro's shape tools, but it works best on gently sloping

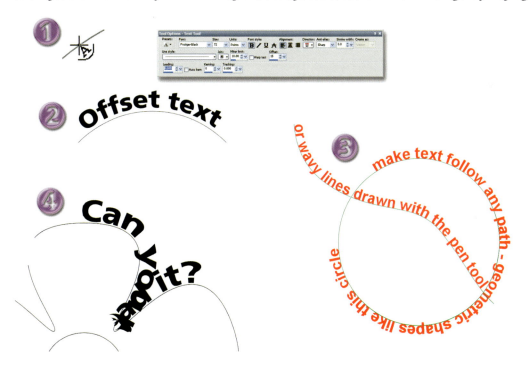

To align text to a path position the Text tool over the object's edge – click to enter the text when the tool changes (1). To move the text above or below the path enter an offset in the Text Tool Options palette (2). You can run text along any vector path (3), but avoid sharp curves and sudden direction changes which will render it unreadable (4).

curves. Anything with sharp angles and lots of turns is unlikely to look good, or even readable.

To add text to a shape all you need to do is first draw the shape, then select the Text tool and position the cursor on the edge of the shape. You'll see the cursor change from the normal cross-hairs with a capital A in the bottom right quadrant to cross-hairs with an A at 45 degrees and a curved line below it. When this happens, click on the shape and the Text Entry box will appear as usual, but any text you type will follow the outline of the shape.

- To move the text along the path choose the Pick tool and click-drag the text. The small circle icon indicates the new start position of the text.
- To raise or lower the text on the path enter a value in the Offset field of the Text Tool's Options palette. A positive value raises the text above the path, a negative value lowers it.
- If you don't want the path to show, either select a transparent stroke and fill, or click the Layer Visibility icon in the Layers palette to turn it off.
- To detach text from the path, select either the text or its path using the Pick tool and choose Objects>Detach Object from Path.
- To attach existing text to an object select the text with the Pick tool, Shift-select the object and choose Objects>Fit Text to Path.

Editing text shapes

By converting text to a vector object you can use Paint Shop Pro's Vector Editing tools to alter the shape of individual characters by adjusting individual nodes. To convert text to a vector object select it with the Pick tool and choose Objects>Convert Text to Curves. There are two options

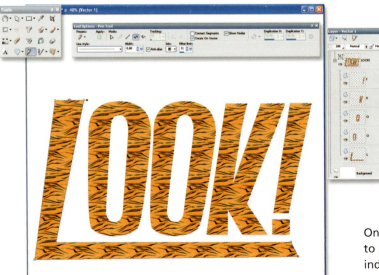

Once text is converted to paths you can edit individual character shapes using the Pen tool.

– you can convert the entire text block into one vector object by choosing Objects>Convert Text to Curves>As Single Shape. Alternatively, Objects>Convert Text to Curves>As Character Shapes, converts each letter of the text into a separate vector object. Once the text is converted, select the Pen tool and click the Edit mode button in the Tool Options palette to edit the character shapes.

Bear in mind that once the text has been converted to curves it can no longer be edited in the usual way, so now is not the time to discover you've made a spelling error! You can cover yourself by duplicating the layer before converting it, so you have the original text to go back to if necessary.

Making selections from text

Text selections form the basis for all kinds of text effects using photos. You can paste photos inside a text selection, a technique which is particularly effective when combined with layers. Typically, an image layer is copied, pasted inside a selection and overlaid on top of the original with the opacity reduced, the color desaturated, or some other effect applied.

You can make a text selection directly by selecting the Text tool and choosing Selection from the Create As pull-down menu in the Tool Options palette. This is useful for a quick text selection, but once the selection is made it can't easily be edited. A better method is to create the text as a vector, then choose Selections>From Vector Object. That way, if you decide to edit the text, even if it's only to open up the tracking a little, or reduce the leading, you can easily make a new selection.

Vectors: learning the basics

> **TOOL USED**
> Preset Shape tool

Vector images are different to bitmap (raster) images. Whereas a bitmap image is made entirely of pixels, a vector image is made from a set of mathematical instructions or coordinates. Advantages of vectors are:

- Vectors are quick to work with.
- Vector file sizes can be small and still display a large dimension.
- Because of their size, vector graphics are fast to load/download and are ideal for Web use.
- Vector graphics are fully editable with absolutely no loss of quality.
- They create perfectly clean, alias-free lines and curves.

Disadvantages of vectors include the fact that they lack good tonal gradation and depth. Bitmaps have the disadvantage that they are:

- Not scalable.
- Physically large and bulky to store.
- Slow to open.
- Slow to save.

Vectors, therefore, are ideal for illustrations where scalable drawing, text and shapes are required. Paint Shop Pro's Preset Vector Shape tool has a myriad range of fully editable subjects in its library.

If, for example, you like the shape in one of the presets, but not the color or edge detail, you can edit it using its Edit palette. If you need to create your own vector illustrations from the ground up, use the Pen tool.

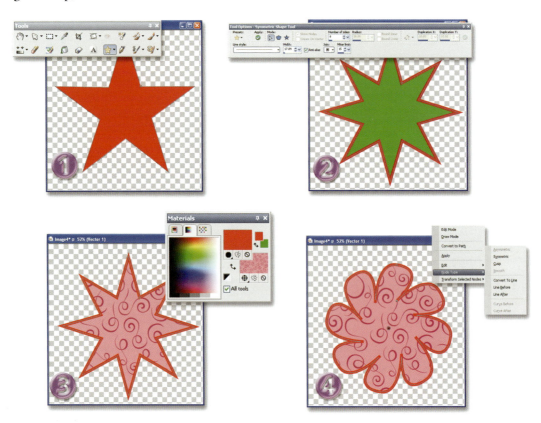

(1) Use the Symmetric Shape tool to create highly editable polygons and stars. (2) Edit the line style using the Tool Options palette and choose Stroke and Fill colours from the Materials palette (3). You can edit all of the nodes on a symmetric shape at once (4), so it's easy to quickly create variations on a basic shape theme.

PAINT SHOP PRO X FOR PHOTOGRAPHERS

The Preset Shape tool is a powerful and quick way to make almost any size or shape of object for illustration.

Take this one step further, adding drop shadows, bevels and a range of other specialist (filter) effects to make those flat, unexciting shapes something special.

Working with the Pen tool

TOOL USED
Pen tool

The Pen tool is the ultimate vector shape creation tool. With it, illustrators and graphic designers can create any type of shape, line or layer object they'd care to imagine. The Pen tool gives you scope to design any shape you can imagine; however, because the shapes it creates are formed using vectors, whatever is created remains infinitely editable at all times.

Drawing tools rely on manual actions for their accuracy and we all know how silly it is to try and draw with a mouse! It's like sketching with a house brick, only less accurate. The Pen tool allows you to ignore many of the physical limitations of the mouse and to apply extreme linear accuracy to the most delicate of shapes.

The principal driving force behind this is the ability to draw using Bezier curves. These are infinitely editable lines that can be used to describe mathematically perfect shapes such as curves and circles. The curves were invented by Frenchman Pierre Bezier, who worked for the car manufacturer Renault. If you are not into vector illustration then this might not be a tool that you are likely to need but, for the designers among us, it's essential.

Check out the stack of controls provided in the Options palette and you'll get an idea of how powerful this tool is. Here are some of its most important features:

- Draw lines and shapes of any size freehand.
- Draw a myriad range of shapes using point-to-point techniques.
- Fill objects with color, texture and transparency using the Materials palette.

On a superficial level the Pen tool works by dropping editable nodes into the picture, whether blank canvas or existing picture. Each mouse-click adds another node that's automatically joined to the previous one with a straight or curved line, depending on the type of drawing implement chosen. Clicking a node back onto the original start point completes the shape. You can add as many, or as few, nodes as needed.

The Pen tool can be used to create new vector shapes and edit existing pictures in a wide range of styles. You can change any aspect of the Pen tool, at any time, for example, thickness of line, color fill, texture, linear aspect, curve aspect and more. Right-clicking displays its principal attributes, which include: Edit, Node Type and Transform Selected Nodes. Using these allows you to perform more than 30 different edit functions.

Uses for the Pen tool

- Creating accurate masks.
- Creating complex vector shapes and illustrative elements using rectilinear or Bezier-controlled lines.
- Creating perfectly curved lines around irregular objects.

Here's how to make a vector illustration:

STEP 1 Create a new document with a white background and a resolution of your choice ('File>New').

STEP 2 Click the Pen tool icon on the Tools toolbar.

STEP 3 Select the Line Style required from the Tool Options palette.

STEP 4 Select the line width.

STEP 5 Select a line application (Lines and Polylines, Point to Point – Bezier Curves or Freehand, found in the Mode section of the Tool Options).

STEP 6 Check 'Anti-alias' and 'Create on vector' boxes before drawing in the document. Select the path with the Pick tool to display its bounding box. The handles on the box allow you to rotate, stretch and deform the vector shape without fear of losing detail. If at any time you decide to change the appearance of the line, open the Layers palette, select the Vector layer and click the '+' tab. This opens the Vector layer to display the individual elements. Double-click the element concerned to open the Vector Properties box.

STEP 7 Save the vector document as you would a bitmap file.

Note the following:

- 'Draw Lines and Polylines' draws straight lines between two points.
- 'Draw Point to Point' – Bezier Curve' is an infinitely editable freeform line controlled by Bezier technology – grab a controlling handle to bend the line any which way. Bezier curves are ideal for creating seamless freehand shapes.
- 'Draw Freehand' is the same as drawing on a piece of paper.

(1) Creating geometric shapes with the Pen tool is easy – but you can use the Symmetric Shapes tool for that. (2) Change node properties by right-clicking or, (3) create curves of any shape by click-dragging. (4) Use the Pen tool to trace shapes from photo layers.

STEP-BY-STEP PROJECTS

Technique: creating a greetings card

TOOLS USED	
Layers	Guides
Grid	Rulers

To make a greetings card you'll need one large picture and possibly another smaller snap for the back, an inkjet printer and a few sheets of A4 inkjet paper (preferably photographic quality).

STEP 1 First create a new document ('File>New'). Make it the size of the paper to start with (i.e. 210 mm × 297 mm). Select a background color. Most greetings cards have a white base color but that does not need to apply to you! Choose a resolution that's suitable for your printer. Most produce pretty good results at a setting of 200–250 dpi. Set the document in a landscape format (i.e. wider than it is high for a portrait card, taller than it is wide for a landscape card).

STEP 2 To make the layout easier, you can use Paint Shop Pro's Grid or its Guides. Do this by choosing Grid from the View menu. To get the guides displayed, first bring up the Rulers and then, clicking in the ruler margin, drag the guides one at a time onto the canvas. To change the color and the pattern of either, double-click the ruler margin to bring up the Properties dialog.

STEP 3 Now open the main photo and, if color and contrast are to your liking, select it all, copy it, click once in the new document and paste the clipboard contents into the document as a New Layer. Your new document should now have two layers in it (open the Layers palette to check). To keep the work area from becoming cluttered, close the image (click on the X in the upper right-hand corner) when you are done pasting it into your greeting card template.

STEP 4 Open the second photo to be used for the back of the card and repeat the actions in Step 3, pasting the second image into the master file. Save this as 'card01' or something similar.

STEP 5 Set the guides so that you have an edge marked out, a center line and a top for positioning purposes. Remember, neither grid nor guides will appear in the print. They are there for assistance only and remain invisible to the printer. Choose the Pick tool and adjust the size of the main picture elements so that it fits the right-hand half of the document. Repeat the sizing on the second photo. After selecting your photo with the Pick tool, you can hold down the Ctrl or Shift keys then hit the Arrow keys to position your photos more precisely. This is there as a signature

PAINT SHOP PRO X FOR PHOTOGRAPHERS 161

USING TEXT

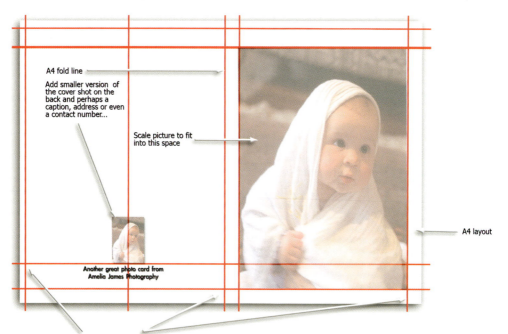

A4 fold line

Add smaller version of the cover shot on the back and perhaps a caption, address or even a contact number...

Scale picture to fit into this space

A4 layout

Another great photo card from Amelia James Photography

To assist in the card layout, make extensive use of Paint Shop Pro's **Grid** or, even better, its adjustable **Guides** (shown here in red). Remember to leave room for the center fold - and for a caption on the front of the card, if appropriate.

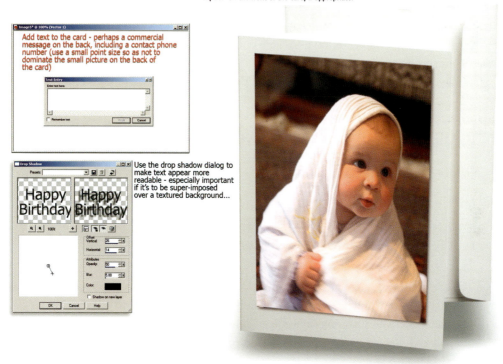

Add text to the card - perhaps a commercial message on the back, including a contact phone number (use a small point size so as not to dominate the small picture on the back of the card)

Use the drop shadow dialog to make text appear more readable - especially important if it's to be super-imposed over a textured background...

Paint Shop Pro has a range of tools designed to assist in the creation of projects like business and greetings cards. Guides especially help in lining up objects, text layers and pictures. The beauty is that, though they are visible to the designer, they do not print.

image – it can be your portrait or an image that is common to all your cards and invitations or you can change it with every creation. Most top-of-the-line greetings cards have a similar design, although you can of course make your own should you wish.

STEP 6 Now that the two pictures are in position we are ready to add text. Choose the Text tool and add the text to the main picture. This might be a simple Happy Birthday or Thanksgiving or you might want to add a more personalized, humorous or just plain silly header (I usually go for the latter!). Easy enough to do but hard to keep readable if it is laid on top of the photo. To fix this, either make the main picture smaller, the text larger, add an effect like a drop shadow or, as a final touch, you might want to drop the text into a flat-colored box to separate it from the background.

STEP 7 Once satisfied with the main copy, add your own text to the back of the card, such as 'Another great masterpiece from the camera of Robin Nichols' or something equally modest, and run it in small text under the postage stamp photo on the back.

STEP 8 Now that all the components are assembled into the one document, save it and print it onto a sheet of regular photocopy paper to check the positioning of the card. If it is possible, set the printer to print the image in the center of the paper. Also check the driver and click the Fit to Page setting to make it print to the edges. I find that printing on photo-realistic paper works especially well, but for the 'genuine look', try one of the many textured inkjet papers on the market. These produce a far nicer result (in most cases) and can be folded more easily.

Now all you have to do is find an envelope that fits!

Technique: pasting text inside an image for effect

TOOLS USED

Text tool

Selection from Vector Object

Inner Bevel

As we saw earlier in this chapter, Effects filters don't work with Vector layers, which must first be rasterized. The same thing goes for text, which by default is rendered as a Vector layer. One of the easiest ways to create stunning type effects, however, is to make a selection from your type and then apply the effect to an image using that selection. Here we're going to produce a bevelled glass type effect in four steps.

The success of type effects like this depends very much on choosing the right typeface. The Inner Bevel filter works well on big bold type. So avoid script fonts or anything with fine detail and keep the word count to a minimum – make a bold one-word statement.

STEP 1 Open your image and create a copy of the background layer by right-clicking it in the Layers palette and selecting Duplicate.

STEP 2 Select the Text tool and enter the type. For maximum effect keep it short – one or two words at most – and use a bold typeface, use capital letters for improved readability and make the type as large as you can. Click the Apply button in the Text box when you are happy with how it looks, then position the type where you want it on the background with the Move tool.

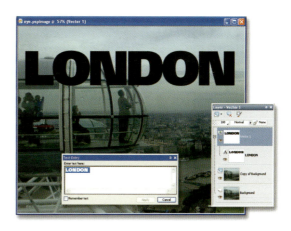

STEP 3 Choose Selections>From Vector Object (keyboard shortcut Ctrl+Shift+B), then turn off the Type layer by clicking its Layer visibility toggle (the eye) in the Layers palette. Click the Copy of Background layer in the Layers palette to make it active.

STEP 4 Choose Effects>3D Effects>Inner Bevel and apply the filter using the default settings. Click the Preview icon to see the result in the main image window. You can experiment with angle, smoothness, depth and other settings, or try one of the available presets, but the default setting gives a pretty good result.

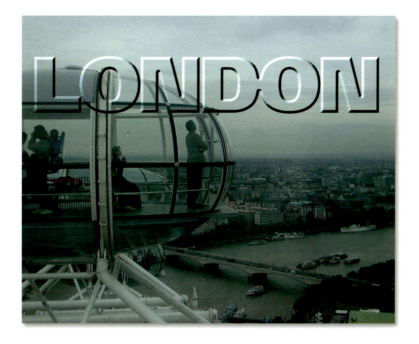

Technique: combining text and photos to make a calendar

TOOLS USED	
Grid	Kerning
Guides	Leading
Layers	

Making your own calendar requires a higher degree of skill because we are not only using a greater number of photos but we also have to use, and lay out, text in a very precise manner. In this exercise we'll be using Paint Shop Pro's Grid and Guides tools.

STEP 1 Create a new document to the required size of the calendar. (As most of us only have an A4 printer this is a good place to start – although you can make equally good mini-calendars to A5 proportions.) Set the optimum resolution for your inkjet printer (this might be anything from 200 – 250 dpi) and choose a white background (this can be changed later to another color or a texture if you wish).

The trick in making calendars is to assemble all 12 months into the one (large) document and then to print only selected layers at a time (a group for each month).

STEP 2 Choose Rulers and Guides from the View menu and drag guides to the required layout positions. To make this function better, make sure that the 'Snap to Guide' function is 'on'.

Note: It helps to have all 12 monthly pictures sized to the same resolution and proportions before you proceed (although it is possible to resize each on its own layer using the Pick tool). As the final file size will be large (and therefore the computer might slow down noticeably), you might want to resize before importing pictures to the master file.

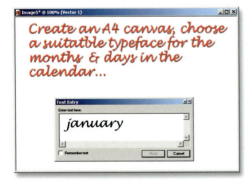

Create a blank white A4 canvas. Choose a suitable typeface for the months and days in the calendar.

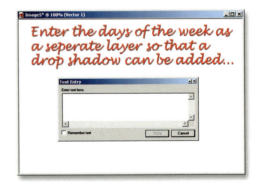

Enter the dates, adding spaces and returns to tabulate the data for the correct layout.

PAINT SHOP PRO X FOR PHOTOGRAPHERS

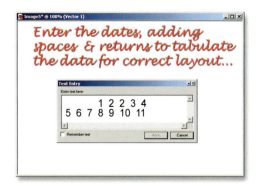

Enter the days of the week as a separate layer so that a drop shadow can be added.

STEP 3 Open the picture slated to be the January pin-up, select it all ('Selections>Select All' or 'Ctrl+A'), copy it into the clipboard ('Ctrl+C') and then paste it into the new document as a New Layer ('Ctrl+L'). Double-click the layer as it appears in the Layers palette and rename it 'January picture'.

STEP 4 Repeat this performance for all remaining months, creating a new layer for each month.

STEP 5 Now design the calendar dates. You have two options: either make a scan from an existing commercial calendar (this shouldn't infringe copyright unless the specific design or images are copied as well). All we are interested in are the numbers. If there's any doubt, don't make the copy and proceed to the second choice, which is to enter the text dates yourself.

STEP 6 Use the Grid feature to position the days of the month into a regular grid layout on a new Vector layer placed into the appropriate layer group for that month. You can offset grid line dimensions so they are further apart if you wish. To do this access the Grid and Guide Properties

Add the drop shadow effect (if required).

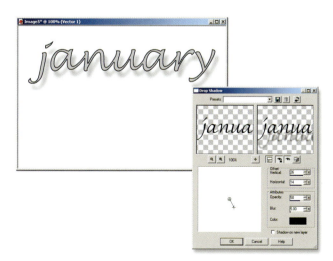

Open the photo for that month and add it to the document. Repeat for all 12 months and save as a .pspimage file in case it requires editing at a later stage.

and set the units accordingly. Use the Kerning feature (in the Text Options palette) to spread the numbers further apart from each other and the Leading feature to add space between each new line. Although these formatting changes don't physically appear in the Text box, they'll appear 'live' in the document so keep an eye on the positioning so it can be repeated for the next month, and so on.

STEP 7 On a separate vector text layer in the appropriate layer group, add the month using another typeface or point size, depending on the design required.

STEP 8 Repeat this performance for all 11 months with the appropriate layer names. You should now have 12 groups of layers for each month: a January picture layer, a January text layer and a January dates layer (one Raster and two Vector layers). It's important to name everything, otherwise you'll become confused when printing the calendar months.

PAINT SHOP PRO X FOR PHOTOGRAPHERS

STEP 9 Using January as the 'base' month, switch off all other layers by clicking the Visibility Toggle icons in each layer. Now check that the alignment is consistent with all layers by switching each month on and off to see if it sits directly over the layer (January) beneath. Use the Move tool to rearrange the position of any layer that's not in the right place.

STEP 10 Now comes the fun bit! Even though you have all 12 months stacked into a very large 'master' document, Paint Shop Pro will only print those layers that are visible. Switch everything 'off' and print the month of January (i.e. all three January layers together).

STEP 11 Switch January off, switch February on and print that. Repeat this procedure for all 12 months.

STEP 12 Use an office services bureau to coil bind the calendar for the final touch. You might want to add a cover sheet with all 12 images displayed as thumbnails and a front page. Service bureaus normally supply a choice of backing and cover sheets for a minimal extra charge.

Most local office supplies businesses will be able to add coil binding to the calendar for the final touch.

The easiest way to make a calendar is to print it using an inkjet printer. Use high resolution inkjet paper, as this is very fine-detailed, yet still quite thin so as not to add weight to the product – especially important if the calendar is to be posted.

7

Manipulating Images: Creating Special Effects

TECHNIQUES COVERED AND TOOLS USED IN THIS CHAPTER

Techniques
- Adding edge and frame effects
- Adding lighting effects
- Applying filter effects
- Creating a panorama
- Creating realistic depth effects
- Distorting images
- Fun with Picture Tubes
- Painting from photos
- Using the Color Replacer tool
- Using the Materials palette

Tools
- Airbrush
- Art Media brushes
- Blend modes
- Convert to Raster Layer
- Displacement map
- Filter sets
- Flatten
- Layers
- Lens Correction filters
- Lights
- Materials palette
- Merge
- Mesh Warp
- Mixer palette
- Move tool
- Opacity
- Paint Brush
- Pick tool
- Perspective Transform
- Picture Frame
- Picture Tube
- Text tool

In this chapter you'll learn how to add special effects to your digital photos. Applying a special effects filter may be all that's needed to turn a so-so image into something special. But with a little more effort you can create jaw-dropping effects that defy reality – or what passes for reality in a photo.

Using the Materials palette

> **TOOL USED**
>
> Materials palette

One of the most used palettes in Paint Shop Pro is the Materials palette. This is where you go to change the colors used in any of the program's paint or drawing tools. In this section we look at how the Materials palette can be used in the creation of special effects and how it's used for mixing colors.

Choose the Materials palette from the 'View>Palettes' menu (keyboard shortcut F6). There are three modes in which to work with this tool: Frame, Rainbow and Swatch modes.

The Frame mode provides a quick and fairly intuitive method of picking colors. First left-click to select a foreground hue from the rectangular frame (right-click to select a background color), then click in the center Saturation rectangle to alter the saturation and brightness for the selected hue. If you hold down the mouse button and drag within the Saturation rectangle the value updates and a tool tip window tells you the RGB values at the cursor position. Alternatively, you can fine-tune the saturation and brightness by adjusting the triangular sliders at the bottom and side of the Saturation rectangle.

In Rainbow mode position the cursor over the central colors panel; it changes to an eyedropper and a tool tip window displays the RGB values of the color beneath. Left-click to select

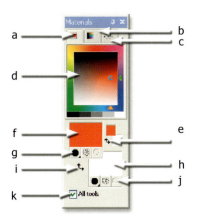

(a) Frame tab. (b) Rainbow tab. (c) Swatches tab. (d) Color picker. (e) Click here to swap foreground with background colors. (f) Foreground and Stroke properties. (g) Click the black circle to change the Color/Gradient and pattern selected. Click the middle circle to change the texture and the right button for transparency. (h) This is what is chosen as the background fill color. (i) Swaps foreground and stroke properties with background and fill properties. (j) Click the black circle to change the Color/Gradient and pattern selected. Click the middle circle to add a texture and the Transparency button to add transparency. (k) Check this to apply your Materials palette settings to All tools.

the foreground color and right-click to select the background color. The Rainbow tab only needs one click to select a color, but provides less accuracy than the Frame tab.

If you're working with a limited palette, you may find Swatch mode simpler to use because you can make your own swatches. In many ways it's faster and more accurate to work with.

The two large colored boxes on the right of the palette influence the Foreground and Stroke properties (upper left), and the Background and Fill Properties (lower right). Underneath the Foreground and Background Properties boxes a Style button provides three options: Color, Gradient and Pattern. To these three modes can be added texture or transparency using the appropriate buttons. Two smaller colored boxes to the upper right are used to set the foreground and background colours.

Double-click either the Foreground or Background Color box to open the Color picker. Use this to choose more colors. To modify the gradient or texture double-click the Foreground and Stroke or Background and Fill Properties box to open the Material Properties dialog box.

■ Use the Swap buttons (double headed arrows) to swap foreground and background colors and materials.

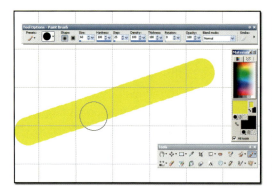
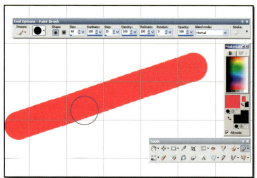
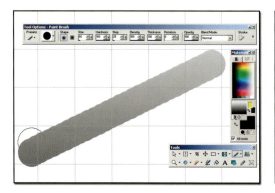
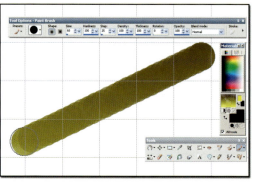

Top left: Click once in the Color picker to set the foreground color and paint. **Top right:** Click again elsewhere in the picker to change the color in the brush. **Bottom left:** Clicking the Gradient button at the base of the Foreground and Stroke Properties box accesses the gradients, all of which can be edited. **Bottom right:** Use the Texture button to choose a texture for the brush.

PAINT SHOP PRO X FOR PHOTOGRAPHERS 173

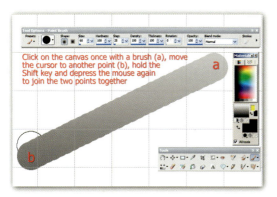

To draw a line between two points, mouse-click once, move the cursor to the end point and, holding the Shift key, mouse-click again.

(a) The integrated Style palette. (b) Click this menu to view the texture choices displayed (e). (c) Click this tab to choose new patterns. (d) This allows you to define the path to the pattern files. (e) Textures available. (f) Once happy with choice and edit status, click OK.

(g) Clicking here displays the textures on offer. (h, i) These give great edit power if the selected pattern/texture is not right for the drawing involved. (j) Change the gradient style here. (k) Click this small tab to bring up the Color palette (l).

This is what a brush stroke looks like with a wood grain texture applied.

Color gradients are also easy to add and draw.

Add a pattern to give an extra dimension to the brush power.

- Click any of the three Style buttons at the base of the Foreground/Background Properties boxes to choose Color, Gradient or Pattern.
- Click the Texture button to add texture to the paint strokes.
- Click the Transparent button to add transparency to the brush.
- If you are happy with a particular combination in the palette, click the 'All tools' checkbox to lock it and to apply the settings to all the tools.

Working with Brush tools

TOOLS USED

Airbrush
Art Media brushes
Art Media Layers

Mixer palette
Paint Brush

Paint Shop Pro comes with a staggering array of brushes and brush tips, enabling the user to create a range of simple, or incredibly sophisticated, painting tasks. Brush tools introduce the photographer to the concept of original creativity – you can literally make something from nothing using one of PSP's brushes (in the same way that you might with a crayon and a blank sheet of paper).

Use the Tool Options palette to change the physical nature of all brushes. Use the Materials palette to choose different brush colors as well as textures and gradients in the brush action. Simply paint over the image to add texture and additional color.

Paint Shop Pro's Paint Brush can produce a staggering array of effects, textures and 'looks' simply by changing its tool set in the Options and Materials palettes. There are over 20 preset stock tips that vary greatly in each brush.

This is a very ordinary snap of a very pretty rose. There are a number of preset filter effects that I could apply to the entire photo or even to a selection. However, it is also possible to make quite radical changes merely by using a brush on the canvas. (1) Open the photo and enlarge the canvas to add a white border all round the edges. (2) Duplicate the layer. (3) Desaturate the color. Reduce it almost to black and white.

An advantage of this process is that brushes can be used to add a non-photographic influence to a picture in order to create the illusion that it's something other than a plain old photo.

Brush tools are infinitely variable in terms of size, density, opacity and hardness. Naturally the best results will only be attainable using a graphics tablet rather than a standard mouse. A graphics tablet allows you to draw, select, erase and paint with the accuracy and delicacy of a real paintbrush, pencil or crayon. OK, it's not exactly the same, but it is 100% better than a mouse.

The Paint Brush can be used to add solid or translucent colors, gradients and textures all selected directly off the Materials palette.

Use the Brush tools for retouching photos or for combining freehand artwork with a photo. Besides the Paint Brush and Airbrush tools, Paint Shop Pro has a number of other brush-based tools designed specifically for working on a photographic image for the purposes of adding impact. These are:

- Dodge tool. Lightens pixels under the brush – good for extracting detail in dark areas.
- Burn tool. Darkens the pixels under the brush. Ideal for increasing density in overexposed pictures.
- Smudge brush. Blurs and smudges the pixels under the brush action.
- Push. Makes all the pixels behave just like wet oil paint so that they can literally be pushed about the frame
- Soften. Applies a localized soft focus effect.
- Sharpen. Increases the contrast, and therefore the apparent sharpness in the pixels.

PAINT SHOP PRO X FOR PHOTOGRAPHERS

177

MANIPULATING IMAGES

The textured effect can also be applied to the edges to give the viewer the impression that this is a painting and not a digital photo! Work at a lowered opacity to produce a seamless effect. Too fast and the brush marks become heavy and tell-tale, which is not always desirable.

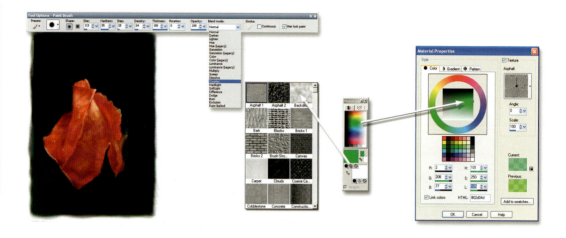

Use the Brush Options palette to change the physical nature of all brushes. Use the Materials palette to choose different brush colors as well as textures and gradients in the brush action. Simply paint over the image to add texture and additional color.

Like the Paint Brush, PSP's Airbrush also has potential for terrific creativity. Once you hit on one combination, record it as a preset for use on other images.

Using the Art Media brushes

Paint Shop Pro X has a range of Brush tools called the Art Media tools. These tools are a radical departure from the usual kind of digital brush tool in that they mimic the behavior of real-world materials like oil paint and pastels.

Altogether there are nine Art Media tools: Oil, Chalk, Pastel, Crayon, Colored Pencil, Marker, Palette Knife, Smear and Art Erasure. These tools can only be used on special Art Media layers; a new Art Media layer is automatically created for you when you start to paint with one of the Art Media tools.

Two of the Art Media brushes – Oil and Marker – are 'wet'; they simulate the wetness of their real-world counterparts. With a 'normal' Paint Shop Pro brush, if you paint by holding down the mouse button, or maintain pressure on the stylus tip, the paint just keeps on coming, but with a wet Art Media brush it runs out, just like the real thing. You have to finish the stroke and start a new one with a reloaded brush. Oil and Marker strokes stay wet, so if you paint over them with a new color the paint smears on the canvas.

Another aspect of real media that these wet brushes emulate is the ability to paint with multiple colors. A real brush might have mostly blue paint on it with a little bit of yellow, producing a smeared blue/green color, and you can simulate this effect with the Oil Brush and

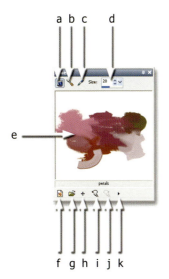

Paint Shop Pro's Mixer palette works like the real thing, allowing you to partially mix colors and apply a smeared combination with the Oil Brush or Marker tool. (a) Mixer Tube. (b) Mixer Knife. (c) Mixer Dropper. (d) Tool size. (e) Mixer area. (f) Load Mixer Page button. (g) Open Page button. (h) Navigate button. (i) and (j) Unmix and remix buttons. (k) Mixer Palette Menu button.

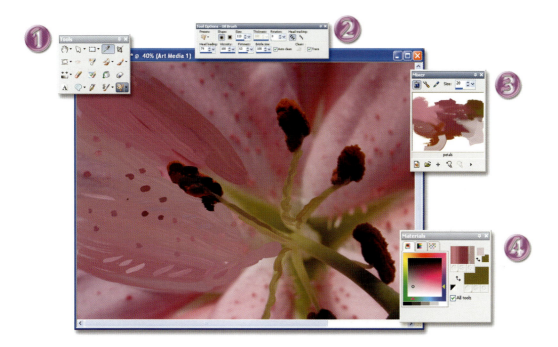

Select the Oil brush from the Art Media tools flyout (1) and use the Tool Options palette (2) to set brush parameters. Head loading determines how much paint is on the brush and how quickly it will run out. Click the Trace checkbox to automatically sample the color from underlying layers. Add color to the Mixer palette (4) using the Mixer Tube and mix the hues together with the Mixer Knife. Sampling an area of the Mixer palette with the Mixer Dropper adds the mix to the Foreground/Stroke swatch in the Materials palette – now you're ready to paint.

Marker tool. There's also a Mixer palette on which you can smear colors around and produce a messy mix of several colors to load onto your brush.

When using the Oil brush or the Palette Knife, the size of the area sampled from the Mixer palette is determined by the brush size setting in the Tool Options palette, so the bigger you brush, the more paint variation you can have. For other Art Media tools, set the sample size using the Mixer palette's Size slider, up and down arrows, or enter in a value with your keyboard.

When using the wet painting tools, painting over existing strokes causes them to smear. You can 'dry' an Art Media layer, or make it wet again at any time by choosing Layers>Dry Art Media Layer or Layers>Wet Art Media Layer.

You can save and load Mixer palette pages and switch between them by choosing Save Page and Load Page from the Mixer Palette menu.

About Deformation tools

TOOLS USED

Pick tool
Lens Correction filters
Mesh Warp

Perspective transform
Straighten tool

Altering the shape or alignment of a layer is easy using Paint Shop Pro's deformation tools. Why use the deformation tools?

- To change the alignment of a layer.
- To modify the size of the layer.
- To modify the perspective and skew of a layer.
- To significantly change the appearance of a picture.

There are four to choose from:

- Pick tool – used for relatively simple layer changes.
- Straighten tool – especially handy for straightening horizons in scans.
- Perspective Correction tool – for adding exaggerated (or corrective) perspective to objects.
- Mesh Warp – the 'big daddy' of the subset. Mesh Warp gives you the freedom to bend, distort, warp and buckle 25 sections within a layer.

The procedure is simple enough: open the document and select the layer that needs deforming. Choose the Pick tool from the Tools toolbar. Note the bounding box and 'handles'

The most obvious or immediate use for the Mesh Warp tool is fun. Choose the tool, stretch the wire frame that appears over the picture and watch Paint Shop Pro treat those pixels like so many rubberized elements!

that appear at the corners of the layer. If you hold the cursor over any of these handles, the normal four-pointed arrow Move symbol changes to a rectangle, indicating that you can scale the layer while maintaining its original proportions. If you don't want to maintain the original proportions, in other words to stretch or squeeze the layer, drag one of the center handles along any of the layer's edges.

You can further change the type of the deforming action by holding down the Shift key for a shear action or by holding the Control key to change it to Perspective Deform. The handle in the center which resembles a stroked circle moves all the contents in the bounding box. The Rotation Handle to the right of this (pre-rotation) rotates the layer. Use similar mouse actions to directly change the perspective (Perspective Correction tool) and to align the horizon (Straighten tool). Advanced users can use the Deformation tools to manipulate selected layers to create super-real perspective effects or to add extra realism such as shadows to product photos.

Lens Correction filters

Paint Shop Pro also has a range of filter effects specifically designed for correcting the detrimental effects caused by poor quality lenses. These are: Barrel, Pincushion and Fisheye Distortion Correction filters.

Not many lenses suffer unduly from this type of optical aberration any more, but note that these filters are fantastic for adding distortion to make, in some examples, quite surreal-looking results.

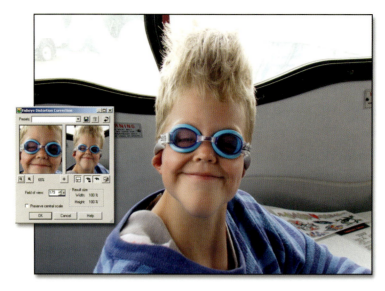

Use the Fisheye Distortion Correction filter to iron out curving vertical and horizontal lines caused by Fisheye and ultra-wide angle lense – or to apply wacky distortions to a photo or layer.

The Pincushion Lens Correction filter produces the least amount of distortion effect and it was the one that I liked the most (although I don't think my nephew necessarily agrees with me – sorry Danny!).

Applying filter effects

> **TOOLS USED**
> Filter sets

Photo-editing applications are used to improve the look of digital pictures. Most contain filter sets. These are pre-recorded visual effects that can be applied to a picture at the press of a button (OK, at the press of two buttons).

Paint Shop Pro has many filters, designed not only to improve the quality of your work but also, in some examples, to radically change the nature of the picture. For example, you can increase or decrease color, contrast, hue, sharpness and even black and white tone in a photo at the press of a button. These filters are regarded as 'standard issue' for most photo-editing

This is what the Filter Effect Browser looks like. You can make it display a thumbnail of every filter in Paint Shop Pro, or you can be a bit more specific by choosing filters from individual subsets. Double-click the window that you like the look of to apply that filter to the picture open on the desktop.

products. Paint Shop Pro also has a range of creative and esoteric filter effects that are used to change the nature of a picture from a photo into something different, like a drawing, painting or even a sketch. In fact, with a bit of patience, you can create almost any type of special effect you care to think of, such is the power of the software filter set.

> **Tip**
>
> Many criteria come into play to influence the success or failure of a filter effect. Factors include the quality, focus, color and contrast in the original snap. Don't use a filter to mask the fact that a snap is no good – because the filter effect will invariably be no good either!

Paint Shop Pro has dozens of filters. The program is also compliant to a range of plug-in type filters. These are manufactured by third parties, like Flaming Pear and Auto F/X. These are loaded into the Effects menu just as if they were original integral products.

Most of Paint Shop Pro's filters are subdivided into types under the Effects menu. These include:

- 3D Effects (6).
- Art Media Effects (6).
- Artistic Effects (15).
- Geometric Effects (8).
- Distortion Effects (13).
- Texture Effects (15).
- User Defined.

You'll also find more filters under the Adjust menu. These include:

- Add/Remove Noise (10).
- Blur (6).
- Sharpness (4).
- Softness (3).
- Red-eye Removal.

There's also a powerful filter Effects Browser. This previews all the filter effects as thumbnails so that if you've no idea what to use, you can make an educated, illustrated guess.

Each filter sub-folder contains specific effects that can be applied to any picture globally, to a layer in that document or to a specific selection. For example, Art Media filter effects include: 'Black Pencil', 'Brush Strokes', 'Charcoal', 'Colored Chalk', 'Colored Pencil' and 'Pencil'. Select

Top: Page Curl. **Middle:** Pencil. **Bottom:** Colored Foil.

Top: Balls and Bubbles. **Middle:** Halftone. **Bottom:** Soft Plastic.

Top: Aged Newspaper. **Middle:** Lights. **Bottom:** Black Pencil.

PAINT SHOP PRO X FOR PHOTOGRAPHERS

Top: Kaleidoscope. **Middle:** Lens Distortion. **Bottom:** Displacement.

> **Tip**
>
> If you hit on a filter effect that works really well, save it as a preset that you can later apply to other images with a single click. Click the Save Preset button (the disk icon) at the top of the Filter dialog box.

any of these and the dialog that appears offers further refinements to the filter action. Some are quite straightforward while others have a comprehensive range of controls.

What's the 'correct' use of a filter? I try to go for the subtle use although, in some cases, blatant can also work quite well, especially if you need to change the nature of the entire picture.

What pictures work with filters?

The simple answer to this is all pictures. You can turn sweeping landscapes into Turners, still lifes into a van Gogh and sleepy interiors into illustrations for a Guggenheim catalog. Well almost, but you get the (unfiltered) picture.

Hot filters to try

- Balls and Bubbles
- Brush Strokes
- Charcoal
- Halftone
- Trace Contour
- Soft Focus
- Digital Camera Noise Removal
- Fill Flash
- Backlighting
- Displacement Map
- Radial Blur

New to Paint Shop Pro X

- Black and White Film Effects
- One Step Purple Fringe Fix
- Object Remover
- High Pass Sharpen

Adding lighting effects

> **TOOL USED**
> Lights

Paint Shop Pro has a very powerful feature that allows you to add real studio lighting-type effects after the shot has been taken. It's a pretty cool filter-type effect that, when used with care, can add snap, pizzazz and depth to an otherwise flat or lacklustre picture.

Paint Shop Pro offers several light sources, exactly as you'd have in a real photo studio. Click on one and you'll be able to edit its behavior – widening or narrowing the spread of light has the effect of increasing or spreading the flood of light onto the picture. A narrow beam intensifies

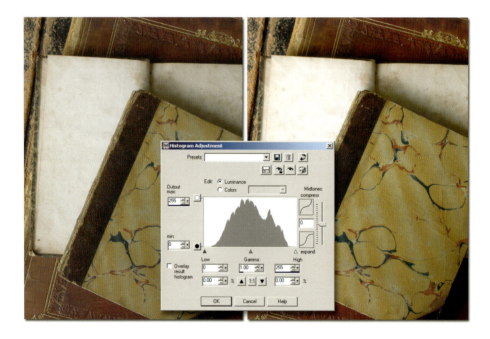

Lighting effects allow the image-maker to add lighting effect to the shot after it has been captured. This is done via a clever combination of directional contrast and brightness enhancements, simulating the effect of a floodlight or a spotlight. If you don't want one of the lights on, simply reduce its effectiveness to zero and it goes 'out'. Though you should never use this as a substitute for shooting a frame properly, the addition of a lighting effect like the ones seen here can make or break a picture that is not as strong as it possibly could be. The first step is to use the Histogram Adjustment dialog to improve the tones and contrast in the photo.

PAINT SHOP PRO X FOR PHOTOGRAPHERS

(a) To open the Lights dialog box select Effects>Illumination Effects>Lights. Click one of the five Light Source buttons to edit that specific light source. (b) Move the cross-hairs that appear in the preview window to align the lighting effect to the correct part of the subject. (c) Reduce the intensity setting to zero to switch the lamp off (it's less hassle than pulling the plug out of the wall!). (d) Smoothness, Cone size and Asymmetry control how the beam appears in the picture. Use them like the dimmer, barn doors and snoot that you get in a 'real' photo studio.

a b c d

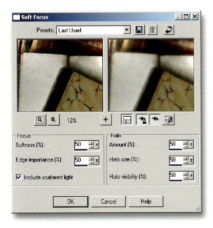

In this example I have added a Soft Focus filter effect to blow out the highlights created by the lights, giving this very pleasing look.

the concentration of added light so take care not to 'overdo' this, otherwise you'll end up adding overblown highlights that take away from the subject matter. A little, in this case, will always produce a better result. The great thing about this tool is that its five light sources are infinitely adjustable. If you only need one or two lights, switch the others off by lowering their intensities to a zero value. Take care though, because you might end up spending a lot of time moving the 'lights' around the studio floor (i.e. the canvas). Keeping it simple will produce realistic and genuine improvements to any picture.

This is the final result – a snapshot with all the flair of a professional photo studio!

STEP-BY-STEP PROJECTS

Technique: creating a panorama

TOOLS USED	
Flatten	Move tool
Layers	Opacity
Merge	Pick tool

Panoramas are a great way to stretch your creativity, both through composition and all-over picture potential. So, what exactly is a panorama and what special gear is needed to make it?

A panorama is essentially nothing more than a group of pictures joined together, seamlessly, into one wide (or high) picture. Panoramas generally begin with more than two frames but can be constructed from up to 10 or more individual photo elements. How many you use for the panorama is dependent on how much detail is required in the frame. Once the components have been shot, they are stitched together using Paint Shop Pro and then the tone is adjusted for maximum picture impact.

Tips on shooting panorama components

- Use a tripod or other stabilizing device for shooting your panoramas. It's important to keep the camera absolutely level at all times, otherwise the panorama segments won't stitch together correctly.
- Lock off the camera exposure meter (using its AE Lock feature) so that every component is exposed at exactly the same value.
- Lock off the focus (using the AF Lock function) so that each frame is focused to the same distance point.
- If your camera has a zoom lens, set it to the widest angle setting and leave it there for all the photos in the panorama.
- Overlap each panorama frame by about 20–30%. This will make it easier to align them when it comes to stitching them together.
- Remember that a panorama need not be horizontal – you can also make neat vertical panoramas.
- Because of their wide, all-encompassing nature, panoramas need to be composed very carefully to include sufficient foreground interest. But try to avoid fences, walls and other detail in the very near foreground which can cause stitching difficulties.

- It is possible to hand-hold the camera when snapping panorama components but extra care must be taken to get the level right.
- If you are hand-holding, rotate around the camera body rather than around yourself and you'll find your overlapping image edges match up more easily.
- Ensure that the camera rotation is around the nodal point of the lens, where possible. (Check the Internet for further information on estimating the nodal point for your camera model.)

STEP 1 Once you've made all your exposures, import the lot into the computer, open Paint Shop Pro and create a new, blank canvas to the desired panorama proportions ('File>New'). It doesn't matter if it is too large – it can be cropped at a later stage.

Tip

It's not always possible, but try to avoid including moving subjects near the edge of your panorama images. If they move between two overlapping shots it can make stitching them together difficult.

STEP 2 Find and open the panorama components. Copy each one and paste it into the new document. Try to keep the order of pasting the same as the order in which the elements were shot (i.e. left to right or right to left).

> **Tip**
>
> If you haven't got a tripod and are hand-holding the camera, when you take the first image in your panorama, make a note of a reference point (a lamppost, for example) a quarter of the way in from the right-hand side of the viewfinder. For the second image, turn to the right until the reference point is on the left of the viewfinder.

STEP 3 Choose the layer on which the left-hand panorama segment sits and, using the Move tool, drag it over to the left-hand side of the frame. Choose the second-to-left layer and, after reducing its opacity (in the Layers palette), move its left edge slightly over the right-hand edge of the first frame to get an exact fit. Jiggle the Opacity slider so that you can see through one layer to the layer beneath to make this process easier and then, once it's in position, return the opacity to 100%. Repeat this process for all remaining panorama components. You may find that some have been shot on a tilt, especially if the panorama camera was hand-held and not mounted on a tripod. If this is the case, use the Pick tool to straighten out the uneven horizon on that particular layer.

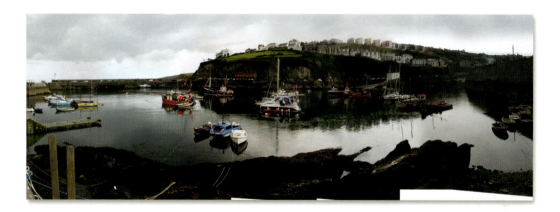

STEP 4 Once the entire set of frames (components) has been overlapped successfully and all opacities are the same, save the file as a copy (i.e. keep one file as a 'master file').

STEP 5 Check that the density and the color values for all layers are the same, otherwise you might find that, even though the exposure was 'locked off' at the shooting stage, some frames are still darker or lighter than others. Use the Color Balance and Histogram Adjustment tools to make these tone corrections if necessary. Choose the Crop tool to cut off the extreme edges of the frame if there's a noticeable mismatch with the component segments (as in the bottom of the above image).

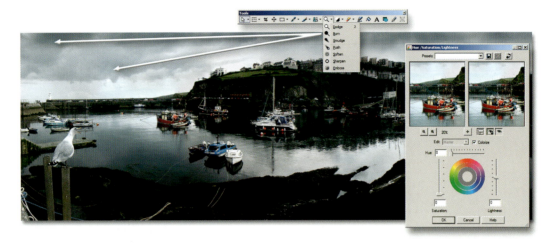

STEP 6 Flatten the layers in the copy (Layers>Merge>Merge All {Flatten}). (Note that doing this loses most of its editability.) Now you can adjust the global color and contrast values in the panorama to get the entire photo the way you really want it to look. Consider, at this stage, using one of PSP's darkroom tools to increase (or decrease) the density/color in selected parts of the scene using a brush.

Tip

If you can't get the overlapping edges of two images to match exactly, just do the best you can. You can retouch problems away later using the Clone Brush. A more advanced (and effective) technique is to use Mask layers to feather the edges of overlapping segments.

STEP 7 Save the panorama.

This is the final, cropped and color-balanced panorama.

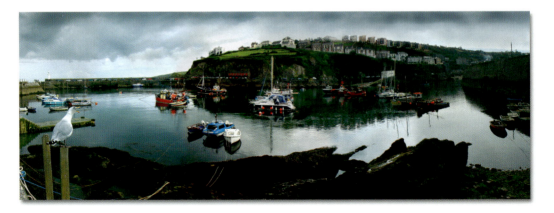

Technique: creating realistic depth effects using displacement maps

TOOLS USED	
Blend modes	Displacement map
Convert to Raster layer	Text tool

The Displacement Map effect was introduced in Paint Shop Pro 9. Displacement maps have been a feature of that other professional image-editing application (OK, Photoshop!) for some time, but even professionals are often at a loss to know what to do with this effect. This is a shame, because you can use displacement maps to create amazingly realistic 3D overlay effects.

Let's say, for example, you want to overlay some type on a heavily textured background – a brick wall, or a rocky cliff face – but you want it to look like it's been painted on, following the contours of the surface below, rather than floating on top the way a normal text layer would. Displacement maps allow you to do just that.

STEP 1 Open the base image in Paint Shop Pro and resave it as a copy (File>Save Copy As) into the folder containing Paint Shop Pro's displacement maps. If you did a standard installation on your C drive, you'll find this at E:\Program files\Corel\Corel Paint Shop Pro X\Displacement Maps.

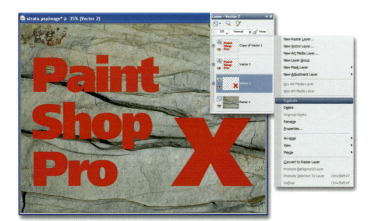

STEP 2 Add the type, the bigger and bolder the better. Here I've added two layers so that the number 'X' can be sized and positioned independently. Right-click the Type layer(s) in the Layers palette and select Duplicate from the contextual menu.

STEP 3 Select the Type layer(s) in the Layer palette and choose Convert to Raster layer from the Layers menu. If you used more than one Type layer, turn all the other layers off by clicking their Layer Visibility button (eye icon) in the Layers palette and choose Layers>Merge>Merge Visible to combine them. Double-click the merged layer and rename it 'Type' in the Layer Properties dialog box.

STEP 4 Turn the background layer back on, make sure the Type layer is selected and choose Effects>Distortion Effects>Displacement map. Click the Displacement Map button underneath the before thumbnail, make sure all is selected from the category pull-down menu and locate the copy image you saved in Step 1.

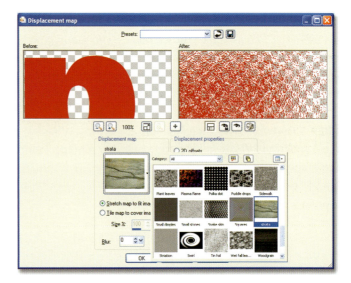

Tip

You can use the background from the current image as a displacement map if you turn off visibility for all the other layers. But make sure you have the (invisible) Type layer selected before you apply the displacement effect.

STEP 5 You should now see the type deform in the preview window. The displacement map moves pixels in the target image depending on the value of corresponding pixels in the map. There are two buttons in the Displacement Map pane that allow you to stretch or tile the map, but our map is the same image and, therefore, the same size as the target, so we don't need to bother with these.

Tip

Sometimes you can get a more realistic overlay effect by switching the layers around and placing the Background layer on top of the Type layer and choosing an appropriate Blend mode. You'll need to promote the background layer to a full layer to do this.

STEP 6 In all likelihood, the default settings won't produce a satisfactory distortion; there will either be too little or too much. There are two ways to control this. First, click the 3D Surface radio button in the Displacement Properties pane and change the intensity. The Displacement Map dialog box only shows the Type layer. If you want to see the effect overlaid on your background image click the Proof button (the eye icon). Clicking the Auto Proof button will update the proof each time you make a change, but this can be quite time-consuming, especially with larger images.

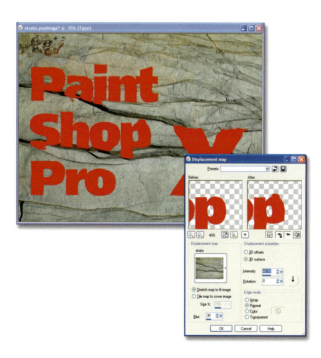

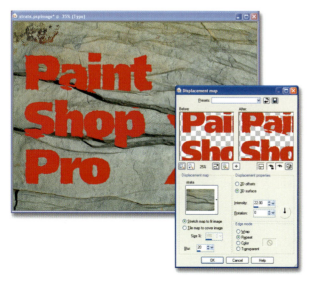

STEP 7 Generally, it's sufficient for the type to deform along the larger cracks and fissures in our background image, but ordinarily every little detail would produce unwanted distortions. The effect of the finer detail can be reduced by blurring the image. Drag the Blur slider until only the edges of the type are deformed and appear to be following the contours of the background image. Using trial-and-error, find the best combination of Blur and Intensity and, when you're happy with the result, click OK.

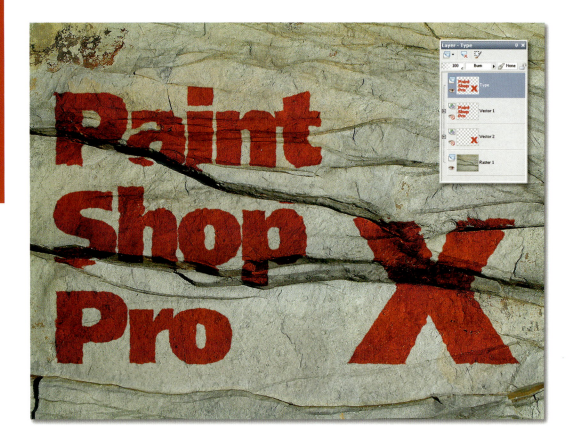

STEP 8 The type is now following the contours of the rock, but it doesn't look painted on and has an unnaturally flat look. Real paint would show through some of the rock texture and detail. You can create this effect using a Layer Blend mode; here I've set the Blend mode for the Type layer to Burn. Hard Light, Color and Multiply are also worth trying – different images require different approaches. Sometimes, reducing the layer opacity helps heighten the realism of the effect.

STEP 9 Paint Shop Pro X ships with an assortment of ready-made displacement maps, including geometric patterns and texture photos which you can use to distort images. You can also make your own – save them in the Displacement Map folder or use the File Locations button on the Displacement Map dialog box to add a folder of displacement maps. Greyscale images work best. Mid-gray pixels in the map produce least distortion; black and white pixels distort pixels in the target image the most.

STEP 10 This technique can be used to apply all kinds of images to all kinds of surfaces, You can use it for lighting effects – to make a laser beam deform as it passes over objects; to produce realistic shadow effects; and to superimpose designs onto all kinds of backgrounds from crumpled material to water.

Technique: having fun with the Picture Tube

> **TOOL USED**
> Picture Tube

For the professional photographer Paint Shop Pro's Picture Tube tool is one of the weirdest around. What does it do? The Picture Tube literally 'pours' pictures out of a tube onto the canvas.

Using graphics and photos as 'liquid paint' rather than flat color is an interesting concept,

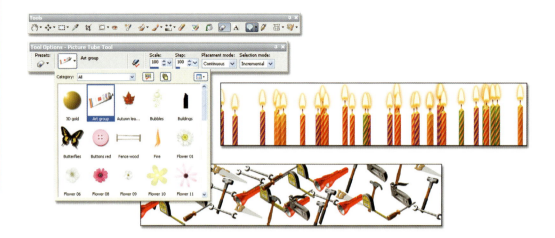

Use the Picture Tube to have fun, create borders and even to decorate artwork destined for the inkjet printer.

but it's one of those esoteric type tools that's almost impossible to find a proper use for. Unless, of course, you create your own specific Picture Tube files.

Picture Tube applications

- Creating fun effects.
- Cool edges and borders for pictures.
- Making unusual picture frame effects.
- Entertaining your kids (and yourself).
- Creating textured backgrounds.
- Adding specific, custom views to a picture (such as image grain, noise and even textures).

How to create a Picture Tube file

STEP 1 Open the pictures chosen to be in the set, ensuring that they are dust-free and clear from JPEG artifacts (use PSP's JPEG Artifact Removal filter to do this). Ensure that all pictures are a similar resolution and physical dimension.

STEP 2 Create a new document ('File>New') with a transparent background to accommodate the picture elements. For example, if you are making a four-image Picture Tube, set the fields to 800 pixels wide and 200 high. Choose 'Transparent' as the background color and then click 'OK'.

The Picture Tube icons can be different sizes and randomness. Shift-clicking creates a point-to-point straight line.

STEP 3 Open Paint Shop Pro's Rulers palette ('View>Rulers') and drag the guideline to the 200 pixel mark. Drag another to the 400 pixel mark and a third to the 600 pixel mark.

STEP 4 You should now have a document with a transparent background (a checkbox pattern indicates transparency) with colored grid lines dividing a long wide frame into four sections. Copy and paste the four pictures into this document. At this stage it's a good idea to save a copy of the file in case the resulting tube is no good. Give it a unique name and save it as a '.pspimage' (layered) file for later use.

Tip

In the Picture Tube Tool Options palette, you can control the scale of the picture tube elements, the frequency of their placement and selection modes (how they are placed from the file).

STEP 5 Merge all the layers ('Layers>Merge Visible') that Paint Shop Pro has created (don't flatten this as it will produce a default background color which is not required at this stage). Once merged, the four pictures should be sitting on a single layer that has a transparent background.

By setting the randomness to a high value and reducing the frequency you can use the tube to paint individual objects one at a time over the canvas.

STEP 6 Select 'File>Export>Picture Tube' and another dialog opens. Enter the amount of cells that you have made for the tube (in this case, four). Make a unique name for the tube and click 'OK'. To test the tube, create a new document with a white background (any size and resolution will suffice) and select the Picture Tube tool. Open its Options palette and, after pressing the Image Selection tab, scroll through the preset tube files to find your alphabetically-placed file. Select this and paint away to test the tube.

You'll soon discover whether the selections you made, the scale of the images and their colors are attractive or not. If you are not happy with the result it's simple enough to open the '.pspimage' version again, make changes, save it over the previous tube file and try again.

Further fun

While a few photo-purists might swear at the Picture Tube, there are still a heap of devotees that swear by it. So many that there are entire websites dedicated to its use, offering heaps of free tubes for fun applications. Start by visiting Corel's site for further resources and downloads at www.corel.com.

Technique: adding edge and framing effects

In what seems to me a great step forward, Paint Shop Pro gives you the power to not only add frames to any picture you import into the program, but also to add a great range of frame edges

You can use the tube to create cartoon-like effects. Download new tubes from the Corel website's community page.

Another use for the tube is to create 'edgy' backgrounds for website projects. Lower the opacity on the layer so that text can be read more clearly over the top.

to the file as well, using the Picture Frame tool.

In the past you'd have to load a specialist plug-in to create these types of effects. Paint Shop Pro now supplies these ultra-cool edges for free!

Paint Shop Pro's Picture Frame tool is fantastic, providing a great range of paint style edges (among others) that normally would take hours to create or several hundred dollars to buy (I wish I'd known about this before I spent the money!).

> **Tip**
>
> If you don't want the frame to cover part of your picture, select 'Frame outside of the image' in the Picture Frame dialog box. Paint Shop Pro will automatically increase the canvas to make space for the frame. This option is particularly useful with the larger frames.

Why use edges? Photographers live in a rectangular world so it is great that we can now change that to recreate the look of a painted or sketched edge, film, crayon, and heaps more edges. If you habitually work with the program's specialist filter effects, you'll find this new addition worth the upgrade investment alone.

Technique: how to add an edge or frame to a picture

STEP 1 Open the picture and choose 'Image>Picture Frame', and choose a frame or a picture edge from the dialog's many options. (There are not as many frames in this version as you'd get with an expensive third-party product; however, all the frames and edges here are changeable – you can flip, mirror and rotate each, making up to 60 extra choices and designs from which to choose. Not bad for a freebie.)

STEP 2 Once the frame dialog is open, choose a frame or edge that you like the look of and click OK to add it to the full-resolution picture. If you don't want the frame to obscure detail at the edges of your photo, check the 'Frame outside of the image' radio button.

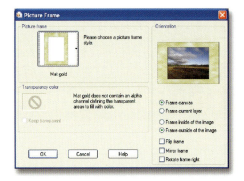

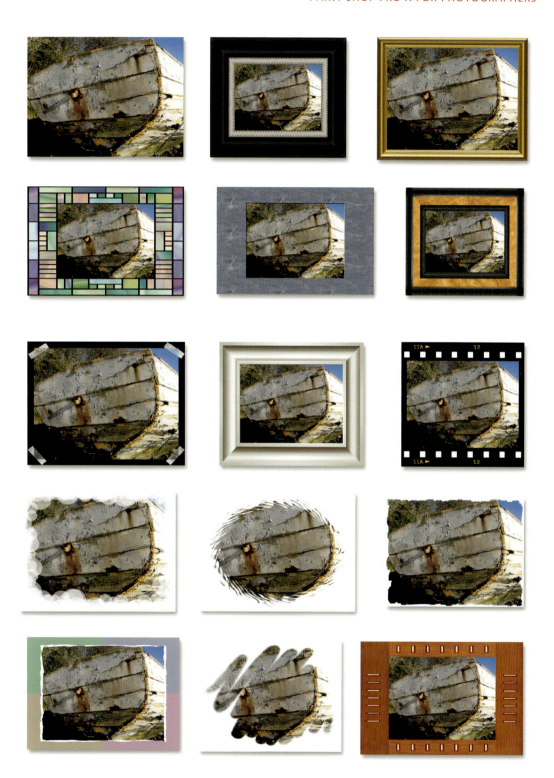

Just some of the frame styles available with Paint Shop Pro's Picture Frame feature.

STEP 3 Paint Shop Pro puts the frame on its own layer, so you can apply adjustments to the frame, leaving the photo untouched. Here, I've used the Hue/Saturation/Lightness tool to change the frame color. You could just as easily change the Layer Blend mode, transparency or apply any of the Effects filters.

Technique: using the Color Replacer tool

> **TOOL USED**
> Color Replacer tool

One of the unsung heroes of the photo-editing world, Paint Shop Pro's Color Replacer tool, allows you to select a specific color in a photo and change it to another. You can choose another color from an adjoining section of the picture or it can be selected off the Materials palette.

Fine-tune this color selection using the tolerance values in the Options palette. This increases the range of colors selected and replaced (those more or less of a similar tone). Keeping a low tolerance value permits you to click-add color a bit at a time over the colors that have been elected as 'replaceable'.

In some instances this is an awesome tool to use, being able to change colors almost at the click of the mouse, while other images are not so easy to do – which is why you have the Options palette.

Ctrl-left-clicking chooses the source color – the one you want to end up with; Ctrl-right-clicking chooses the target color – the one you want to replace.

STEP 1 Select the Color Replacer tool from the Lighten Darken brush flyout on the toolbar.

PAINT SHOP PRO X FOR PHOTOGRAPHERS

STEP 2 Ctrl-left-click within the image to select a source color. The source color is the one you want to paint with; in this case we are changing the door color from red to green, so the source color is green. Paint Shop Pro uses the Foreground swatch in the Materials palette for the source color, so if the source color doesn't appear anywhere in your image just set the foreground color in the usual way using the Frame, Rainbow or Swatch tab in the Materials palette.

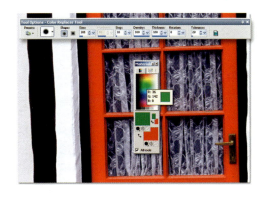

STEP 3 Ctrl-right-click within the image to select a target color. The target color is the one you want to replace; in this case it's red. Paint Shop Pro uses the Background swatch in the Materials palette for the target color; when you Ctrl-right-click with the Color Replacer tool the Background swatch changes to the color of the pixel under the cursor.

STEP 4 Left-click to replace target colors in the image with the source color (or, better still, use a graphics tablet and stylus). The amount of color that is replaced depends mainly on the Tolerance setting in the Tool Options palette. Experiment with the Tolerance setting so that only those image areas you want to paint with the source color are affected by the Color Replacer.

8

Print Preparation

TECHNIQUES COVERED AND TOOLS USED IN THIS CHAPTER

Techniques
Calibrating your monitor
Changing image resolution
Choosing an inkjet printer
Installing color profiles
Resampling
Using color management
Using templates

Tools
Print Layout
Resize

PAINT SHOP PRO X FOR PHOTOGRAPHERS

PRINT PREPARATION

This chapter is all about preparing your work for printing using desktop inkjet printers. Printing can be a frustrating business because there are many factors which affect final print quality – the quality and resolution of the digital image, the type of printer, the inks and paper used, color managment and printer settings. By following the advice provided here you'll be able to consistently produce the best results possible from your printer.

Image resolution

> **TOOL USED**
> Resize

In order to get good results when printing its important to understand a little about image resolution. If you've bought an inkjet printer recently, one of the things that may have influenced your decision is the printer resolution. Your inkjet printer may boast a resolution of 1440 dpi or even more. Similarly if you've recently bought a digital camera, somewhere on the box it will say 3 or 5, or, if you're lucky, even 8 megapixels.

Like printer and digital camera manufacturers, makers of flatbed scanners use resolution as a selling feature – the higher the better. But what do all these numbers mean and how are

At 100% magnification only a small part of this 3072 × 2048 pixel image is visible; to see the whole thing it's necessary to reduce the magnification to 31% (using Window>Fit to Window).

they related? Perhaps more importantly, how does the size of a camera's sensor affect how your photos will look when they are printed?

When it comes to digital images, cameras, scanners, printers and Paint Shop Pro all deal in the same currency – pixels. The starting point with any digital image, therefore, is its size in pixels. Canon's EOS 300D digital SLR can take pictures with a maximum resolution of 3072 × 2048 pixels, giving a total pixel count of 6 291 456, or approximately 6.3 megapixels.

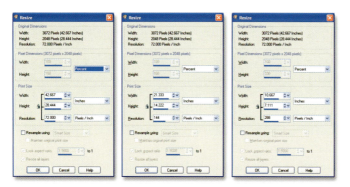

There's an inverse relationship between resolution and print output size – doubling the resolution halves the output size.

If you viewed this image in Paint Shop Pro at 100% magnification you would only be able to see a small part of it. As well as the number of pixels in an image we also need to take account of the resolution, measured in pixels per inch (ppi). The resolution of your screen is 72 ppi (some Windows screens may be 96 ppi, but the theory is the same). If you divide the pixel dimensions by the resolution you get the physical size of the image. 3072/72=42.6 and 2048/72=28.4, so the EOS 300D photo would measure approximately 42 × 28 inches on screen at 100% magnification.

Shuffling pixels

Open an image in Paint Shop Pro and select Image>Resize. The Original Dimensions pane in the Resize dialog box tells you the pixel dimensions of the photo, in this case 3072 × 2048 pixels. The Print Size pane shows the physical dimensions of the image at the specified resolution; at 72 ppi this image measures 42.6 × 28.4 inches.

Make sure the 'Resample using' box is unchecked and enter 144 in the resolution field; notice how the width and height dimensions half when you double the resolution. If you enter 288 in the resolution field the image size decreases again by a factor of 2. All you are doing here is rearranging the same information – the 6 291 456 image pixels – into a progressively smaller space.

On the screen at 72 ppi, the pixels are packed so closely together that you can't see them individually. But inkjet printing technology requires images of higher resolution to produce good quality results. Generally, your photos should have a minimum resolution of 200 ppi to print well. It's a common misconception that you should match image resolution to inkjet printer resolution, but if you print your digital camera photos at 1440 ppi or higher you're going to need a magnifying glass to see them!

36 ppi

72 ppi

144 ppi

200 ppi

300 ppi

500 ppi

Though the commercial printing process used for this book is technologically dissimilar to inkjet printing, these images nonetheless provide a good example of what you could expect to see if you output images at these resolutions to a desktop inkjet. At low resolutions pixellation is clearly visible. A good quality image is produced at 200 ppi, but at higher resolutions no improvement in picture quality is discernible. The minimum recommended resolution for the offset litho process used to print this book is 300 ppi, so you may see some improvement from the 200 ppi to the 300 ppi image above (look at the detail in the clock face), but this is unlikely to be the case with an inkjet printer. Try carrying out your own resolution tests to determine the point at which increasing the resolution produces no apparent quality improvement on your printer.

Resampling

Go back to the Resize dialog box and enter a value of 200 in the Resolution field. This gives a print size of roughly 10 × 15 inches. What if you don't want to make a print almost A3 in size? That's easy, just enter the size you want in the Width or Height box – changing one automatically changes the other to maintain the aspect ratio. Say you want to fit the photo on a 6 × 4 inch piece of photo paper, enter 4 in the width field (for this portrait-shaped photo) and the height field automatically changes to 6. Wait a minute, though, now our image resolution is 512 ppi, far higher than the 200 ppi required for inkjet printing. This doesn't really matter too much and it certainly won't affect the print quality, which will be no better and no worse than at 200 ppi. It will take longer, though, for your computer to send all that data to the printer and for the printer to process it. You can speed things up by downsampling the image – removing the extra pixels that aren't required for printing at this size.

Downsampling

Check the 'Resample using' box and select either Smart Size or Bicubic from the interpolation pull-down menu. Now enter a value of 200 in the Resolution field. This time, rather than changing the physical diemensions to accommodate all the image pixels at the new resolution, Paint Shop Pro has done something different. It has removed pixels to produce the requested resolution at the existing size (it hasn't done it yet, but it will when you press OK). Take a look at the Pixel

The photo on the left has been downsampled from an original 2560 × 1920 image to 6 × 4.5 cm at a resolution of 300 ppi – suitable for printing. Its pixel dimensions are now 717 × 538. The smaller middle photo was downsampled to 2 × 1.5 cm at 300 ppi, giving new pixel dimensions of 237 × 178. The middle photo was then upsampled to the original 6 × 4.5 cm size at 300 ppi. You can clearly see the loss of detail and sharpness caused by the interpolation, hardly surprising as only one-third of the pixels in this image are original. You can improve things marginally by Unsharp Masking, but there's no substitute for the original pixel data, so always make sure you keep originals backed up before resizing!

Dimensions pane and you'll see the new pixel dimensions are 799 × 1198. If you do the maths yourself you'll discover that this does indeed produce a 6 × 4 inch image at 200 ppi.

Removing pixels in this fashion will not affect the picture quality. This 4 × 6 inch print will be indistinguishable from one printed at 512 ppi, but you'll have it in your hand much sooner. But what if you change your mind and decide that an A3-sized print would look pretty cool after all (assuming you're lucky enough to own an A3 color inkjet printer)?

Upsampling

Open the Resize dialog box once more. (Confusingly, when you open the Resize dialog, it applies the last-used settings to the current image. To get back to the current image size select 'Percent' in the Pixel Dimensions Units pull-down menu and enter 100 in the Width field.) Make sure the 'Resample using' box is still checked and enter the original pixel width of 2048 in the Width field (the Height box will automatically increase to 3071 – only 1 pixel out!). Click OK and Paint Shop Pro will upsample the image, taking us back where we started right? Wrong!

Take a look at the new image and you'll notice it's not quite as sharp as it was to begin with. Paint Shop Pro has added new pixels in-between the existing ones to bring the image up to size. The values of these new pixels are based on those of neighboring ones using a process called 'interpolation'. Interpolated pixels are OK if you're in a fix, like you need to make a large print from a small digital file, but they are no substitute for the real thing.

So, you can take pixels out of a digital photo with no loss of quality, and this can help speed up printing, but you can't put them back without things starting to look mushy. What are the implications of this for storing and printing your digital pictures? If you follow one simple rule you won't go wrong. Always keep a full-sized original copy of your digital photos backed up on removable media (i.e. CD or DVD). Then you can downsample your images for printing, emailing, uploading to the Web or whatever, but if you need to make a full-sized print that requires the maximum image resolution you'll always have the original to fall back on.

Choosing an inkjet printer

Current inkjet printer technology makes it possible to produce color prints of comparable quality with those produced by high street photo labs. There are a number of manufacturers of inkjet printers, among them Canon, Epson, Hewlett Packard and Lexmark.

Features

There's a bewildering array of models on the market with widely varying features and choosing a specific model can be difficult, but it largely depends on what you intend to use your printer for. The kind of questions you should ask yourself are:

Epson's Stylus Photo R800 uses seven separate ink cartridges plus a gloss varnish to produce photo-realistic prints of stunning quality. It can print to a continuous roll of paper as well as single sheets and can print directly onto CDs and DVDs.

- Do I want a printer purely for printing photos, or do I need an all-round printer which can also handle text documents well?
- Will I be printing only from my PC, or will I want to plug the camera or a memory card directly into the printer?
- Am I likely to want to print directly onto CDs and DVDs?
- What about size? Am I likely to want to print larger than A4, or on a roll of paper rather than individual sheets? (Particularly useful for panorama photographers.)
- Will I be printing a lot of photos, or just running off an occassional few prints? How much will I need to spend on ink and paper?
- Is printing speed important, or am I prepared to wait a while for better quality prints?
- How much do I want to spend on a printer?

Once you've answered these questions, it's largely a case of finding a model within your budget that has the features you want.

Technology

Most inkjet printers work on a similar basis. The print head deposits tiny droplets of ink onto the paper as it passes over it on a platen that moves from left to right and prints in both directions. The paper is pulled through the machine by a motor in small steps as the image is printed line by line.

Early inkjet printers produced all of their colors from three inks – yellow, magenta and cyan – black was produced from a combination of all three, but this tended to produce muddy gray text and so in later models a separate black cartridge was added. A further development was the introduction of two additional colors to widen the total number of available colors (the range of

colors a printer or any other output device is capable of reproducing is called its 'gamut').

While earlier models often contain two cartridges – one containing all of the color inks and another for the black – the trend is moving towards individual cartridges for each ink to reduce costs and wastage. The Epson Stylus Photo R800, pictured opposite, has no fewer than eight cartridges – yellow, magenta, cyan, matte black, photo black, red, blue and a gloss optimizer which adds a glossy finish to prints.

Ink and paper

There's no getting away from the fact that 'consumables' – ink and paper – are expensive. It's possible to economize by sho pping around for bargain paper and using 'non-branded' inks in your printer produced by third parties.

Printer manufacturers advise against using anything other than their own ink products and my personal experience has been that it is difficult to get good results using anything other than the manufacturers' inks. Paper is a different matter and if you can find an inexpensive paper that produces good results in your printer then by all means use it.

One of the drawbacks of using unbranded inks and papers is that you are out on a limb when it comes to color management and this can make it difficult, if not impossible, to achieve predictable and consistent color output. See the section on color management at the end of this chapter for more detailed advice on getting consistent color results from your printer.

In the early days of inkjet printing, inks tended to deteriorate quickly, leaving photos either drastically faded or with an ugly cast. Recent technological developments have led to much more stable ink and paper compositions with claimed lifetimes in excess of 50 years. Prints made with the Epson Stylus Photo R800 have a claimed lifetime of more than 80 years. Whatever printer you use, you can extend the life of your prints by storing them in a cool, dry, dark place and framing them under glass for display.

Printing with Paint Shop Pro

TOOL USED
Print Layout tool

Having opened the picture, make sure that the quality is the best possible and choose Print Layout from the File menu. The Print Layout dialog shows the files selected for printing in the left margin. Click 'Open Template' to view your options. The default template group is Avery. This group has over 50 templates which cover most everyday options, but you can also make your own and save them in the template library ('File>Save Template').

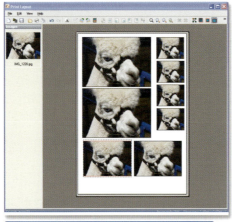

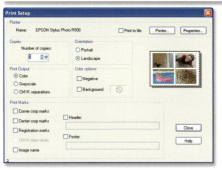
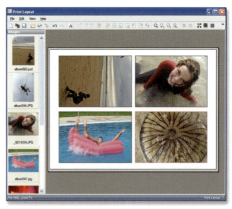

Clockwise from top left: (1) Picture layout provides an easy way to print multiple copies of the same photo, or a selection of photos on a single sheet of paper, saving you time and money. **(2)** A range of templates is available, including Avery standard sizes so you can, for example, produce one large print for your album, or framing, and several smaller versions to send to friends. **(3)** You can print multiple photos from the Browser by Shift- or Ctrl-selecting them, then right-clicking and choosing Print Layout from the context menu. The selected images appear in a strip on the left and are dropped in position on the template layout. **(4)** Click the Print Setup button to change the paper orientation and add captions (though this is better done in the Print Layout dialog box). Most of the settings here are for producing film separations for commercial printing.

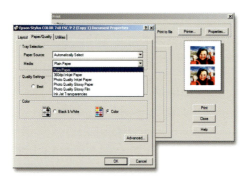

Don't forget to select the appropriate inkjet paper type. If you don't, the color may not come out as you'd hoped.

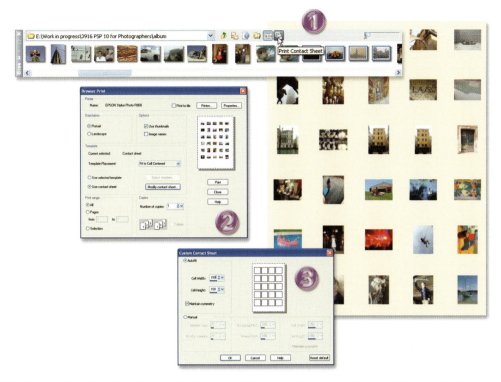

Click the Contact Sheet button in the Browser **(1)** to quickly print a sheet of thumbnails for the current folder. This opens the Browser Print dialog box **(2)**, where you can use the default template or choose another. Click the Modify Contact Sheet button to open the Custom Contact Sheet dialog box **(3)** and produce your own layout. Beware of doing this with a folder containing a large number of images as it may take a long time or worse, crash the application.

What can you use templates for?

- Creating unique contact sheets.
- Customizing for specific jobs such as cards, receipts, invitations, business cards, etc.
- For making mini-stickers.
- For creating your own business labels.
- Address labels.

Once in the Print Layout you can either run the same picture in all the template's windows or you can bring more in. Simply open up a new picture and drag that into the place in the template where you want it to appear. Paint Shop Pro replaces the original picture with the new one. There are a number of assistants built into the menu bar. These are designed to make it easier to place picture elements centered, range right, range left and so on. If you find that some of the pictures don't fit the frames supplied, use the buttons ranged along the top to resize them all at once. Options include 'Size and center' 'Fill cell with image' and 'Fit and center.

It's a handy and quick way to make multiple print selections without the need for working out the complexities of layers, layer groups and selections, as you might with other programs.

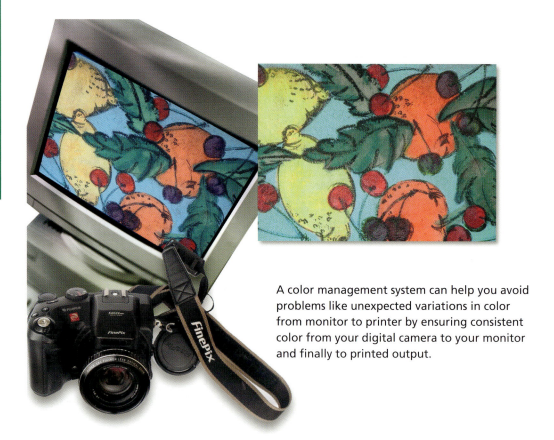

A color management system can help you avoid problems like unexpected variations in color from monitor to printer by ensuring consistent color from your digital camera to your monitor and finally to printed output.

Color management

If you've ever asked the question 'why don't my prints match what I see on the computer display' then you need to know about color management. A color management system (CMS) ensures that individual devices – digital cameras, scanners, computer monitors and printers – all treat color in the same way so that you get consistent color from one to the other.

To return to the original question, it is in fact impossible for your printer to reproduce exactly what's on your monitor as the two devices use different physical systems to produce color. The monitor transmits light using red, green and blue phosphor dots (or, in the case of an LCD panel, a fluorescent backlight passing through a colored filter) and a color print uses pigment or dye-based inks to reflect light. As we saw earlier in the chapter, color printers can use up to seven inks; even so, it is not possible for them to reproduce all the colors on your computer display. In color reproduction terms the two devices are said to have different gamuts.

It's not just different devices that vary in the way they handle color. As anyone who has visited the TV department of a high street electrical store can verify, no two TVs look the same. A picture viewed on your PC at home will quite probably look different on your work PC, and if you email it to your friends each one of them is likely to see a slightly different version, due to the individual color characteristics of their display.

Color profiles

To try and sort out this mess, an organization called the 'International Color Consortium' (ICC), which has as its members companies like Adobe, Apple, Agfa and Kodak, developed a system of profiling for color imaging devices. Each device has a profile which describes its color characteristics and which can be read and understood by imaging software. Windows has built-in support for ICC compliant color management.

Using ICC profiles a color management system can accurately convert color information from one device to another. In short, this means more accurate color from your camera to your monitor and finally out to your printer. It also means that, providing they are using color management, what everyone else sees on their monitor is the same as what you see.

Calibration

In order for color management to work successfully, it's important that your monitor is correctly calibrated. To do this, select File>Color Management>Monitor Calibration and complete the Monitor Calibration wizard. Once your monitor is calibrated, the next step is to ensure you have profiles installed for all of your devices, or at least for your monitor and printer. These should have been installed automatically when you installed the devices but it doesn't hurt to check.

To find out what profile your monitor is using right-click on the desktop and select Properties from the contextual menu. Click the Advanced button on the Settings tab and then the Color Management tab. If your monitor profile isn't listed, click the Add button and try to find it. All Windows color profiles are stored in the folder c:\Windows\system32\spool\drivers\color. If you can't find it here, check any disks that were supplied with the monitor, or the manufacturer's website.

For your printer, select Printers and Faxes from the Start menu, right-click the printer icon, select Properties from the contextual menu and click the Color Management tab. It's not always easy to identify the correct color profile from its name. Windows should automatically assign the right profile, if it's available, though you can add it manually if necessary. As with monitor profiles, if one

Monitor calibration is important for accurate color management. Let your monitor warm up for half an hour before running the wizard.

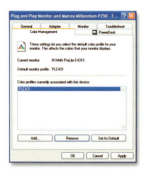 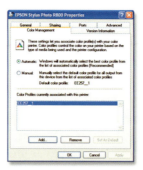

You can check the currently installed default profiles for your monitor and printer by opening the Display and Printer Properties dialog boxes.

wasn't supplied with your printer the best option is the manufacturer's website.

Printer profiles are less straightforward than monitor profiles because they are designed to work with a specific combination of inks and paper. A profile generated for photo-quality glossy paper is unlikely to produce satisfactory results with matt paper. Furthermore, there is a wide variation in different manufacturers' paper characteristics, so a profile designed, for example, for Epson Premium Glossy Photo Paper will not provide good results with another manufacturer's glossy photo paper.

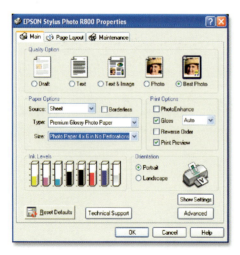 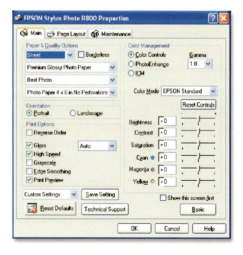

In Basic mode (left), the printer driver for the Epson Stylus Photo R800 helpfully indicates ink quantities remaining. Advanced mode (right) provides a range of color controls, but these should be avoided if you are using color management.

Color management in Paint Shop Pro X

Paint Shop Pro X has introduced new support for ICC color profiles which makes getting consistent color from your monitor to your printer that much easier. To turn on color management select File>Color Management>Color Management and check 'Enable Color Management' in the Color Management dialog box.

Select your monitor and printer profiles from the pulldown menus – unless you have several profiles installed there will be only one, the default profile for the device that you installed previously. That's nearly all you need to do.

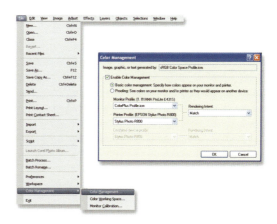

Use the Color Management dialog box to turn on color management and configure your display and printer profiles.

If you have an image open, the color profile, if it has one, will be displayed at the top, after the message 'Image, graphic, or text generated by:'. Not all images are tagged with a profile, but if it's a photo from a digital camera it will most likely have an embedded sRGB profile.

Don't worry if the image has no embedded profile, you will still be able to see how it is going to look when printed. All of the elements for a color managed workflow are in place and the color management system can correctly interpret the numbers in the profiled image and translate them for display on your monitor or printer using the profiles for those devices.

Despite all of this, for the reasons explained earlier, it's still not possible for the image displayed on your monitor to match your printer. But, Paint Shop Pro can show you on screen what an image will look like when printed on your desktop color inkjet, or any other printer for which you have a profile. This is called 'soft proofing'.

To display a soft proof on your monitor open the Color Management dialog box and check the radio button labelled 'Proofing'. To see colors on your monitor and/or printer as they would appear on another device. Select your printer in the Emulated Device Profile pull-down menu and click OK to view the proof.

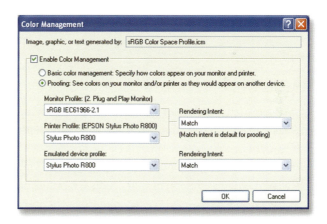

To produce a 'soft proof' – an on-screen view that accurately simulates output from your printer – check the Proofing radio button and select your printer profile from the Emulated Device Profile pull-down menu.

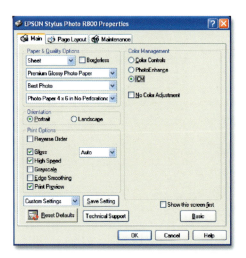

Click the ICM checkbox to enable color management using the currently installed default printer profile.

Printing using color management

How your Print dialog box looks will depend on the printer you are using and the driver software. The examples shown here use the Epson Stylus Photo R800 printer, but other printer drivers will provide similar options. Firstly, make sure your image is the correct size and resolution for printing on your chosen paper as described earlier in this chapter. Select File>Print and click the Properties button on the Print dialog box.

The stylus Photo R800 driver provides Basic and Advanced options. It also provides an extremely useful graphical representation of the ink levels. Click the Advanced button and select the paper type, size, orientation and other print options. On the right-hand side of the dialog you'll find the Color Management settings. In Color Controls mode you can alter the brightness, contrast, saturation and color balance of the print output using the slider controls. Only use these controls if you don't want to use color management. PhotoEnhance mode allows you to apply a number of effects to the printed output including monochrome and sepia toning and soft focus, canvas and parchment texture effects.

The button we are interested in is the one marked 'ICM'. Click this and the driver will use the color management system to correctly interpret and print the colors in the image. Don't check the No Color Adjustment box as this is intended for use where the conversion to the printer color space has already been made in the image-editing software.

That's all there is to it.

No profile?

If you can't get a color profile for your printer and ink/paper combination there are three options available to you. You can pay a company to produce a profile for your individual setup. The way this works is that the company supplies you with a set of images composed of color swatches which you print out and return to them. They then analyze these using sophisticated spectrophotometry equipment and produce a profile based on the results. This kind of profiling is very accurate, because it is tailor-made for your specific printer, paper and inks, as opposed to a generic profile. Epson provides a bespoke profiling service; details can be found on the Epson website at www.epson.co.uk. Two other companies that also produce printer profiles are Pixl (www.pixl.dk) and Chromix (www.chromix.com). These services aren't cheap, but if accurate color is important to you, and certainly if you are producing images for commercial use, they are well worth the cost.

The second option is to produce your own color profiles using a device such as the Spyder ColorVision or GretagMacbeth Eye-One Pro. These are spectrophotometer devices that you connect to the front of your monitor so that they can take readings and compile a profile. The Eye-One Pro can produce printer as well as monitor profiles, but the cost of these devices puts them out of reach of anyone other than professionals or amateurs for whom accurate color is very important.

The ColorVision Spyder PRO can produce profiles for printers as well as monitors – but is expensive.

If you are making prints for personal use and can't justify the cost of a profiling service or dedicated hardware you can make your own printer adjustments. As I said at the beginning of this chapter, you will never get your printer to emulate exactly what you see on your monitor (even professional setups have to content themselves with soft-proofing – getting the monitor to show what the print will look like), but you should be able to improve an existing unsatisfactory setup.

You can do this in one of two ways. Either use the printer driver's color adjustment controls to alter the color balance, or use Paint Shop Pro's Adjustment layers to make temporary adjustments prior to printing. In either case you will need to compare printed output to what is on your screen and for this you should use a test calibration image that displays a wide range of colors, including naturally occurring hues like sky, foliage and skin tones. Professionals use specially designed color targets for this, but you can easily create your own, like the one pictured here. If you haven't got time to make your own, you can download this target image from www.guide2psp.com.

Use a target such as this one to compare printed output with what's on your screen.

STEP-BY-STEP PROJECTS

Technique: printing multiple photos with Print Layout

TOOL USED
Print Layout tool

Print Layout is a straightforward layout application that you can use to make multiple prints on an inkjet printer, saving time and money. Using Print Layout you can print several copies of one photo on a single A4 sheet of paper, cut them up and send them to friends and family. You can print out multiple photos for passport or driving licence applications, or you can use Print Layout to arrange different images on the same page for quick and convenient printing. There is a range of templates which you can adapt to fit your own needs and save for future use.

STEP 1 We're going to use Print Layout to print a selection of photos onto template pages. Select File>Browse (Ctrl+B) and Ctrl-click in the browser to select the photos you want to print. It's easier to add all the pictures you want to print at this stage, so if there are any you're not sure about, select them – you can always leave them out later.

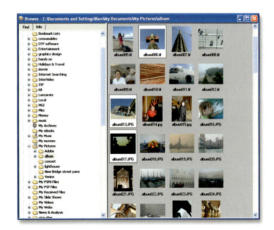

STEP 2 Select File>Print Layout. The photos you selected in the browser appear in the Images window on the left. The default Template is 21.59 × 27.94 cm. Drag the images to the layout window and size and position them.

STEP 3 If the images exceed the size of the template you will get an alert box telling you they won't fit and asking if you want to resize them. This can happen if you have not resized your image. Click OK and they will be scaled to fit the width of the default template. Drag a corner handle to make them smaller – the proportions are automatically retained so you don't need to worry about stretching or squeezing them.

STEP 4 Don't worry too much about neatly laying everything out at this stage, just get the pictures in the layout window at roughly the size you want them. If you want to get four pictures on a template, make them slightly smaller than a quarter of the page size to allow a border around them.

STEP 5 You can position the images manually, but Picture Layout has a few auto positioning features to help out. The four buttons in the center of the toolbar will position an images in any of the four corners of the page or dead center. To the left of these, you'll find the Auto Positioning button. Roughly arrange your images on the page, click the Auto Arrange button and they will be automatically sized and positioned for the best fit.

STEP 6 Manually arranging images like this is the best way to create poster layouts. Use the Text tool to add a headline at the top of the page and to put a caption under each image.

Tip

If you're printing multiple images on a page for cutting out, it helps to minimize wastage if you sort your photos into landscape and portrait format and print only one kind at a time. Don't mix landscape and portrait format photos on the same layout.

STEP 7 To choose a template layout, click the Open Template button on the toolbar or select File>Open Template. Select a category, click on one of the template thumbnails and click OK. This will replace your previous layout so, if you want to keep it, save it first using File>Save Template.

STEP 8 To add photos to the template, just drag and drop them from the Images window onto the 'cells' in the template. If the image isn't an exact fit, you can drag a corner handle to resize it and drag it around within the rectangle to change the crop, or click the Fill Cell with Image button; there are buttons to help with this on the right of the toolbar.

STEP 9 If you are making a page that contains only one image, click the Fill Template with Image button to copy the image to every cell on the template. Otherwise, drag the remaining images into position and resize them. Right-click on any of the images and select 'Apply placement to all cells' to have the positional changes you make to one image automatically applied to all of the others.

STEP 10 Add captions using the Text tool and click the Print button on the toolbar, or select File>Print to print the page.

9

Working with the Web: Optimizing and Uploading Images

TECHNIQUES COVERED AND TOOLS USED IN THIS CHAPTER

Techniques
Animating web graphics
Creating image rollovers
Creating image maps
Optimizing web images
Producing a rollover navbar
Resizing images
Slicing web images
Understanding HTML source code
Uploading files to a web server

Tools
Animation Shop
Animation Wizard
Banner Wizard
GIF Optimizer
Image Mapper
Image Resize
Image Slicer
Internet Explorer
JPEG Optimizer
Onionskin Preview
Optimization Wizard
Rollover Creator
VCR Controls
View Animation

PAINT SHOP PRO X FOR PHOTOGRAPHERS

In this chapter you'll discover how to produce pictures that others can view on the Web. Producing small files which download quickly in a viewer's browser, while at the same time maintaining image quality, is as much an art as a science. You'll also discover how to produce animated graphics for the Web and how to add your images to web pages and upload them to a web server.

How the Web displays images

We all take it for granted that websites integrate pictures and words seamlessly, but producing images for the Web requires a little knowledge of how the Web works as well as a practical grasp of digital image-making.

You're probably aware that web pages are written in HTML, which stands for Hyper Text Markup Language, and that your web browser interprets that code to display formatted text and pictures on your screen. To see what HTML looks like, in Internet Explorer select Source from the View menu. Thankfully, you don't need to be able to write or even understand HTML in order to produce web pages as there are plenty of applications that will help you do this while keeping the code at arms length.

Picture files are loaded into a browser page by HTML code which looks something like this:

You can display the HTML code for the currently displayed browser page by selecting View>Source in Internet Explorer. The source code is opened as a text file in Notepad, where you can edit and save it.

The HTML code simply tells the browser what the image is called, where to find it on the server and what size it is. Once the Browser interprets this line of code it will download the image and display it. If you want to see more HTML source code select Source from the View menu in Internet Explorer while viewing any web page.

If it's a large image, or if the PC on which the Browser is running accesses the Internet via a slow modem, it could take a while for the image to download and display, and trying to keep this delay as short as possible whilst maintaining good image quality is the main aim of web image-editing.

The first, and most often overlooked, method of reducing image file size is to reduce the size of the image itself. The resolution of nearly all display monitors is 72 ppi, so the first thing to do is open the Image Resize dialog and change the resolution to 72 ppi. If you work at a higher resolution than this, your images will simply appear bigger on the web page. Because of this, most web designers prefer to work in pixels rather than other units and, if you are doing a lot of web work, you should try to get into this habit. If you make an image 72 × 72 ppi it will be an inch square on screen.

Large images take a long time to download, so try and keep them to a minimum. Given that many people will be viewing your pages on a screen with a maximum resolution of 800 × 600

The Resize dialog box provides lots of options and it's important to pick the right ones. First, uncheck the 'Resample using' box and enter 72 pixels per inch in the Resolution field. This 3.5 megapixel image would be 58 × 75 centimeters on a web page if we didn't downsample it. Check the 'Resample using', 'Lock aspect ratio' and 'Resize all layers' boxes, and enter the 72 ppi size – 5 centimeters here. Set the view to 100% to see exactly how the image will look on the Web.

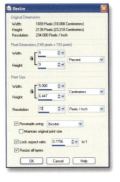

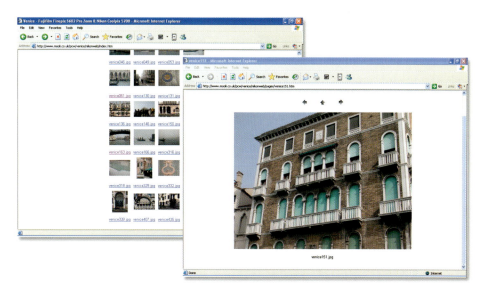

If you want to upload larger images, link them to a page of thumbnails so visitors to your site can pick which ones to view, and not be overwhelmed with lengthy image downloads.

pixels (though 1024 × 768 and 1280 × 1024 are gaining ground fast), on a page with several images and text, you will by necessity need to keep the pictures small just to fit them in.

If you want to include full or near full screen-sized images, link them to a smaller thumbnail and give your viewers the option to sit through a lengthy download if they wish. Another effective but little-used file-shrinking strategy is to aggressively crop images. Get rid of extraneous background detail and crop right in on the subject – every pixel you trim will result in even greater time-savings once the image has been compressed.

Web file formats

TOOLS USED
GIF Optimizer
Image Mapper
Image Slicer

JPEG Optimizer
Rollover Creator

Nearly all images on the Web are saved in one of two file formats – JPEG and GIF. If you own a digital camera you'll know about JPEG even if you don't know much about the Web. GIF has been around even longer than JPEG and is used pretty much exclusively for web graphics. There's a rule of thumb that says you should use JPEG for photographic images and GIF for graphics with

flat color and, like most rules of thumb, it's a good one 99% of the time but there are situations when it's best ignored. As always with web images, the objective is to produce the smallest possible file size, whilst maintaining the best possible image quality. By experimenting with both JPEG and GIF compression, you'll soon learn what works best for particular images.

If you look hard enough, you'll find some web images that are saved in the PNG format. This relative newcomer was recently introduced in an effort to combine the strengths of JPEG and GIF and eliminate some of their shortcomings. Despite some advanced features, like drop shadows and support for layers, PNG has never really taken off, though you can easily create PNG files using the PNG Optimizer from Paint Shop Pro's Web toolbar.

JPEG in depth

JPEG is actually a compression algorithm, a process which reduces the size of digital picture files, but it's come to be used to describe the file format which uses it. JPEG is a lossy compression method, which in plain English means that when you use it some loss in quality occurs and the compressed file won't look the same or as good as the original. Compression algorithms that maintain the exact same data and image quality are called 'lossless'. Although JPEG doesn't offer lossless compression, at low compression settings it comes pretty close. A new version of JPEG, called JPEG 2000, provides a lossless option as well as other advantages, but is yet to gain widespread support. You can create JPEG 2000 files in Paint Shop Pro, but you need a special plug-in to view them in Internet Explorer.

> ### Tip
> The most effective way to reduce the size of images is to crop them. A good quality, closely cropped photo is always better than a highly compressed one with lots of extraneous detail, so get into the habit of making the Crop tool your first step in web image preparation.

JPEG is pretty good at removing quite of lot of picture detail, and thereby considerably reducing file size without anyone noticing, because the algorithm is designed to remove the kind of color information that the human eye doesn't perceive that well. You can compress image files by a factor of about three and you would have to look very hard to spot any degradation in image quality.

Using the JPEG Optimizer

Most image editors, and Paint Shop Pro is no exception, leave it to you to make the decision about how much compression to use. It's up to you to decide just how much image quality you are prepared to sacrifice in return for smaller file sizes.

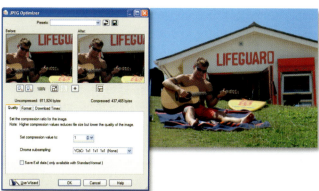

Original

The more JPEG compression you apply to an image the smaller it gets, and the worse it looks. At a setting of 1 the compressed image above right is indistinguishable from the original, but the file size is nearly halved. At a setting of 20, opposite, you can begin to see JPEG artifacts creeping in – look closely at the lettering on the hut.

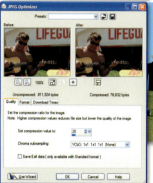

Increase the compression setting to 40 and the file size drops to a mere 25Kb – down from an original 784Kb. On a 512Kbps cable or DSL Internet connection this would take around half a second to download, but the image quality has suffered badly, with JPEG blocking visible just about everywhere you look.

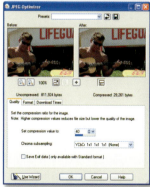

If 40 is a step too far, 80 is just ridiculous. It's interesting to note that, beyond a certain point, not only does the image quality suffer horrendously, but file size savings get correspondingly smaller. A setting of 20 slices 670Kb from this file; increasing it to 80 gains you only another 53Kb.

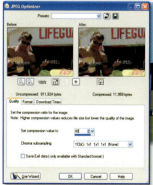

To make this decision you need to know two things. What will the image look like if you compress it using a given JPEG setting? And how long will it take to download? The answer to the first question can be found in Paint Shop Pro's JPEG Optimizer, which you launch by clicking the JPEG Optimizer button on the toolbar.

The optimizer has three tabs – Quality, Format and Download Times – and before and after preview windows. Make sure the preview is set to 100% view so you can see the image exactly as it will appear on the web page; enlarge or maximize the dialog if necessary. Enter a number between 1 and 100 in the 'Set Compression Value to' box, or use the slider. The higher the value entered here, the more compression is applied, resulting in a smaller, lower-quality image. 1 is virtually no compression; you'll start to see the preview deteriorate at around the 20 mark, and beyond 60 things will start to look very bad indeed.

> **Tip**
>
> You can increase the JPEG compressibility of images by blurring them slightly before compressing them. A small degree of blur softens the contrast in edge detail, which is where JPEG artifacts are most noticeable. Use the Gaussian Blur filter with a radius of between 0.5 and 1 before JPEG optimizing.

Bear in mind that these figures are not percentages, and if you enter the same values in a different Web Optimizer you're unlikely to get similar results. These values just represent Paint Shop Pro's maximum and minimum JPEG compression settings.

Judging picture quality

Just below the Before and After Preview windows you'll see two figures. The left-hand one under the Before window says 'Uncompressed' followed by the file size in bytes and, on the right, the compressed size is given, again in bytes. Notice that even at the lowest compression setting of 1 the size of the compressed file is only about a half to one third that of the uncompressed one. If you want the approximate file size in kilobytes, just divide by a thousand. Generally speaking, compression settings in the range of 10 to 30 will give acceptable quality images with high compression ratios, but let your eyes be your guide and as soon as the image becomes unacceptably grubby drag the slider back towards the low side.

Feel free to experiment with the various Chroma subsampling presets on the pull-down menu, though it's unlikely you'll achieve any improvement by changing this. Even the Paint Shop Pro Help file recommends leaving it on the default setting.

Use the Format tab to select either standard or progressive format; the latter preloads a low quality preview into the Browser so that the viewer has something to look at while waiting for the real thing. With standard format nothing is displayed until the entire image is downloaded.

PAINT SHOP PRO X FOR PHOTOGRAPHERS

WORKING WITH THE WEB

Compressing the original (top left) with a compression value of 20 produces a 135 Kb JPEG. By first applying the Gaussian Blur filter with a radius of 0.5, compressing with the same settings produces a file 20 Kb smaller. The resulting image is slightly softer, but perfectly acceptable.

Estimating download time

The Download Times tab provides the answer to our second question. In actual fact it provides several answers, any one of which might be true, depending on the kind of link visitors to your website are using to access the Internet. Four download times are displayed. These provide a guide to the time it will take to download the Optimized file on links operating at 56, 128, 380 and 720 Kbps (kilobits per second).

56 Kbps is the speed at which someone using a modem connects to the Internet. 128 is about right for slower ISDN links, 1 and 2 Mbps provide a rough approximation for cable and DSL broadband lines.

You'll have noticed the sudden appearance of words like 'about', 'guide', 'rough' and 'approximation' – this isn't an exact science. Some people, God help them, may still be trundling along with their old 28 Kbps modem. Others will have a 255 Kbps, 512 Kbps or even a 2 Mbps ADSL link. Furthermore, a 2 Mbps line doesn't guarantee 2 Mbps transfer rates, which could be affected if the line is shared via a network router, or if there's Internet congestion, or if the server can't cope with the level of traffic, so inevitably there is going to be a certain amount of guesswork involved.

Having said that, it's good practice to ensure that most people can access your site without

having to wait all night for the images to download, so if the JPEG Optimizer is telling you that just one of the many images that may end up on your home page will take 10 seconds to download on a 128 Kbps link, you need to think about how you are going to speed things up.

Once you're happy with the quality and size of the Optimized file, press the OK button to save the file.

GIF in depth

Whereas JPEG images are full color 24-bit files, GIFs make use of an indexed color palette to help keep file size down. Each pixel in a JPEG file needs 24 bits (or 3 bytes) of data to describe it. But the same pixel in a GIF needs only 8 bits and in some circumstances even fewer. GIF does this by referencing each pixel to a color lookup table, or palette. The palette has 256 colors. The first color is numbered 0, the next 1 and so on all the way up to 255; to describe the color of a pixel all you need is its number and, as there are only 256 possibilities, 1 byte is sufficient to describe them all.

One shortcoming of this approach is that, compared with the 16 million or so colors that a 24-bit format like JPEG can display, 256 seems a bit meagre. This is one of the reasons GIF is recommended for graphics images that often contain very few colors. Indeed some graphics contain far fewer than 256 colors and in such cases it's possible to make further file size economies by reducing the color palette to as few as four, or even two, colors. A four-color palette can be defined with 2 bits. That's 2 bits for every pixel in the image compared with 24 for JPEG – a massive saving.

> **Tip**
>
> Avoid using drop shadows on images that you intend to convert to GIF. It's impossible to render subtle gradations of tint with a limited color palette.

Although 256 colors may not sound like a lot, it's surprising how little image quality suffers when you convert even complex photos containing lots of colors into GIF format. GIF can also expand the palette of perceived colors using a process called 'dithering' in which colors are combined to produce intermediate hues.

Once the palette has been defined, GIF further reduces the file by applying a lossless compression algorithm called 'LZW'. So GIF has two methods of reducing image file size: color palette reduction and LZW compression. Typically, LZW compression reduces the file size by a factor of two, in other words halves it, so most of the work involved in reducing GIF size involves making careful choices about how the color palette is created so you can represent all the colors in your image with the smallest possible palette.

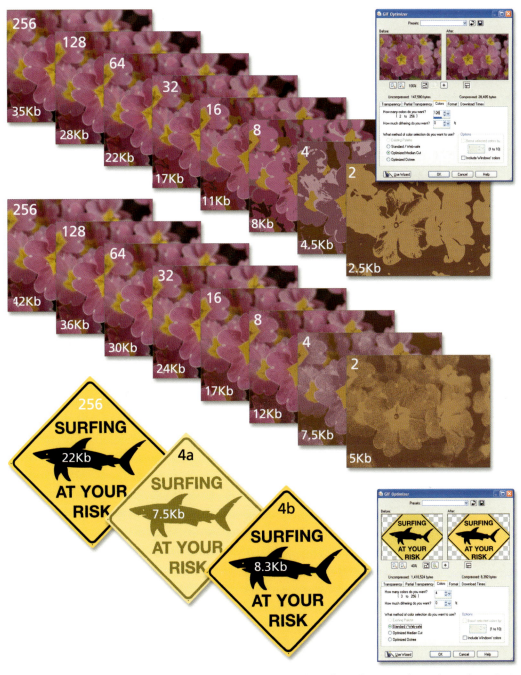

The top row shows what happens when you progressively reduce the GIF color palette from 256 to two colors. The second row shows the same process with 100% dither selected. GIF is best suited to graphic images like the bottom one. Reducing the palette to four colors produces little noticeable quality loss because there were few colors to begin with. The GIF Optimizer doesn't always select the best color palette (4b). In this case choose Image>Decrease Color Depth>X Colors, then optimize using the existing palette (4b).

Using the GIF Optimizer

To open the GIF Optimizer, click the GIF Optimizer button on the Web toolbar. Expand the window so you can see the previews at 100% and click the Colors tab. The first input field, 'How many colors do you want?', lets you specify, well, just that. The maximum and minimum values depend on the method of color selection and there are four choices here, Existing Palette, Standard/Websafe, Optimized Median Cut and Optimized Octree.

The Use Existing Palette option will be grayed out unless the image was an 8-bit indexed image to begin with, or you converted it prior to opening the GIF Optimizer. The Standard/Websafe option uses a palette of standard colors devised to provide the best viewing experience for those using Internet Explorer or Netscape on an 8-bit display. Until quite recently, optimizing images for displays that were limited in this way was quite an art, but now that 24-bit color displays are commonplace this isn't such an important consideration and you can safely ignore this setting, unless of course it provides better results than the others.

Optimized Median Cut and Optimized Octree are two different algorithms designed to derive the most representative palette of 256 colors from all of those in the unoptimized 24-bit image. If your existing image contains only a few colors use Optimized Octree and if you want to reduce the image to fewer than 16 colors use Optimized Median Cut.

For now, select Optimized Median Cut and drag the slider under the 'How many colors do you want?' box as far as it will go to the left until the box contains the value 2. This is what your image will look like if it's displayed with 1 bit per pixel, allowing two colors. Unless there were only two colors to begin with, the odds are it will look terrible. Highlight the 'How many colors do you want?' box with the mouse and enter the value 4. Things will look a little better, but not much. Double the number of colors to 8, then 16, 32, 64, 128 and finally 256, taking a look at the compressed preview each time.

Dare to dither

Assuming your original image was a color photo, it probably will have begun to look something like normal when you got to 16 or 32 colors. Even so, some of the colors may not look right and you may get 'banding' – discrete bands of color where the original showed subtle gradations – in skies for example. What's happening is that the original colors in the image are being mapped to the closest one available in the palette and it's one of the reasons GIF is a poor choice if your original contains lots of colors (but a good one if it only contains a few).

There is something you can do about banding. Enter 100 in the box marked 'How much dithering do you want?' This will considerably reduce and perhaps even eliminate the banding and posterization, but it also introduces a speckly graininess into the image which you may find no more acceptable than the banding. Another drawback is that dithered files are slightly larger than undithered ones. By dragging the dithering slider you should be able to reduce the graininess to an acceptable degree without reintroducing the banding.

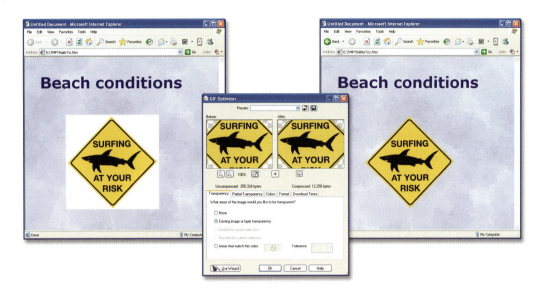

The Transparency tab of the GIF Optimizer allows you to use existing layer transparency, or specify a color from the image (usually the background). Use the Partial Transparency tab to specify a blend color for the edge pixels which is similar to the background on your web page.

Try transparency

One very useful feature of the GIF format is that it supports transparency. You can tell the Optimizer to use the existing image or layer transparency, or define a color from within the image as transparent. The advantage of including transparent areas in the GIF is that you can place irregular graphics – logos or text, for example – over different backgrounds on your web page and the background will show through. The Partial Transparency tab of the GIF Optimizer provides sophisticated controls to deal with semi-transparent pixels (for example, those around the edges of anti-aliased text), which can cause problems.

Whatever file format you choose, Optimization is a trial and error process. Every image is different, and while you can Batch Process similar images using the same settings, if you want to get the best possible quality at the smallest file size you will need to give each one individual attention, selecting the settings you think will provide the right balance between quality and download times, and then fine-tuning depending on what you can see in the Optimizer preview window.

Special Internet graphics

We've seen that lengthy download times are anathema to web designers and Paint Shop Pro's Optimizers provide some useful tools which enable us to reduce images' file sizes considerably.

HTML provides some other ways of efficiently using images to avoid the necessity for lengthy downloads and Paint Shop Pro provides specialized tools to help you take advantage of them.

Image slicing

As we've seen, large images on a web page can take a long time to download, and lengthy downloads are to be avoided at all costs. But what if you sliced a big image up into more manageable chunks? Of course, if the sliced up image contained exactly the same content as the original, it would take just as long to download the bits as the whole thing but, as we shall see, there are some big advantages to be gained by image slicing.

Let's suppose the image you want to put on your site contains a photo and some text (like the one below). By slicing it you can apply the most effective Optimization to each segment. For example, you can use the JPEG Optimizer to compress the photo and the GIF Optimizer to compress the text, which has only a few colors. Furthermore, if the image contains white areas you can leave them out altogether.

Reassembling the slices is done using an HTML table. Like a spreadsheet this is simply a grid of cells. Each slice occupies a cell in the table; there are no spaces between the cells so the slices abut one another and appear as a single image. Sometimes, entire web pages are composed of sliced images reassembled in a table in this way. Paint Shop Pro's Image Slicer allows you slice the image and apply optimization to individual slices, and takes care of image naming (this can be complicated if there are a lot of slices) and creating the HTML table.

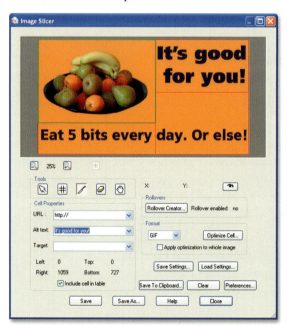

The Image Slicer lets you apply different Optimization settings to areas (or slices) of an image. In this example you'd use JPEG for the fruit bowl slice and GIF for the others. You can also specify HTML attributes like Alt tags, link URLs and target windows.

Rollovers

As the name suggests, rollovers change appearance when you roll over them with the mouse pointer. Generally (but not exclusively), rollovers are used for buttons, so that the viewer knows something will happen when they click on the button. Some websites use rollovers in a clever and sophisticated way to

Rollovers are a popular way of animating web navigation elements, seen here on the Corel website. Use the Rollover Creator dialog box to specify files for the various rollover states – Mouse over is the only one you need for most situations.

change content on one part of the page when you roll over another part.

Rollovers display different images according to their state, and their current state depends on what's happening with the mouse. You can create and edit rollovers in Paint Shop Pro's Image Slicer by pressing the Rollover Creator button. The dialog provides no fewer than six rollover states to which you can assign images – Mouse over, Mouse out, Mouse click, Mouse double click, Mouse up and Mouse down. In practice, most people get by with three – normal, mouse over and mouse click – and in fact even the last of these could be considered extraneous, as once a user has clicked on a button, they're usually linked to another page and don't see what happens to the button.

Rollovers and image slicing really come into their own when used together, usually to produce website navigation bars, the kind you commonly see with a row of buttons arrayed along the top or down the side of the home page. The entire navigation bar can be divided so that each button has it's own slice. When a user mouses over one of the buttons, only that slice needs to change, not the entire image. If it has been properly optimized, that means a file size of just a few bytes and almost instantaneous download.

Image maps

Image maps are almost the reverse of image slices; they allow you to add hotspots to an image file that, when clicked, link to other web pages. You might, for example, have a map of the world with red spots at various locations to indicate international sales offices. Using Paint Shop Pro's Image Mapper, you can cover each of the dots with an invisible hotspot, together with a URL link to the

Use image maps to assign multiple links to areas of an image. In this example an image map is used to link individual European countries to pages containing distributor details.

page on your site giving contact details for that office. The Image Mapper tools aren't restricted to regular shapes and as well as rectangular and circular hotspots you can define irregular ones.

Animation Shop

TOOLS USED

Animation Wizard
Banner Wizard
Internet Explorer
Onionskin Preview

Optimization Wizard
VCR Controls
View Animation

One way to attract the attention of visitors to your website and to provide your pages with a more dynamic feel is to add animated graphics. Used intelligently, animated graphics can work for you by attracting attention to features that might otherwise be overlooked; the trick is not to go overboard. Visiting a web page with flashing, scrolling and jumping graphics all over the place is like walking into a bar where the jukebox, TV and radio are all playing at full volume. The first

and only thing likely to be clicked is the back button or the close box, as your visitor looks for the quickest route back to relative tranquillity. So only use animated graphics for a purpose, and then sparingly.

One great trick that the GIF format can perform with very little encouragement is animation. GIF animation is frame-based and works on the same principle as film and video. Each stage in an animated sequence is displayed for a fraction of a second then the next frame is shown, then the next. When this happens in fast succession, the rapidly displayed frames give the impression of motion. Sometimes GIF animation is compared to a flick book, where the same effect is achieved by rapidly flicking through a slim paper booklet, each page of which contains an image in progressive states of motion.

Though most movies and videos use quite a high frame rate to achieve the illusion of motion (around 24 frames per second), with simple GIF animations you can get away with much lower frame rates of 4 to 8 frames per second. For this to work you need to keep the animation pretty simple; anything complicated, like fades or complex motion, will not look good. As with still images for the Web, the advantage of low frame rates is smaller files and faster download times.

There are a great many shareware applications available for creating GIF animations, but one of the best, Animation Shop, is produced by Corel. You can find out about it on the Corel website at www.corel.com. Animation shop was included free in earlier versions of Paint Shop Pro, so if you have an earlier version Animation Shop will be on the disc. You can also download a fully-functional 30-day trial version from the Corel website. Animation Shop provides everything you need to create first rate GIF animations and, better still, it works hand in hand with Paint Shop Pro. This means you can use all of Paint Shop Pro's painting, drawing and image-editing tools to create the artwork for your animation, then open the file into Animation Shop to add motion effects and save the file in animated GIF format.

GIF animation is based on the same perceptual 'trick' used in film and video – still frames displayed in quick succession provide the illusion of motion. While video uses 25 frames per second GIF animation can be effective with as few as 4 frames per second.

Layer-based animation

Paint Shop Pro layers are the key to creating effective GIF animations. When you open a pspimage file in Animation Shop you can elect to convert each layer in the image to an individual animation frame. To create your animation build it up a layer at a time starting with what will initially appear on the screen in layer one, what will appear next on layer two, and so on. Remember that at a frame rate of 4 fps (frames per second), just four layers will give you a one-second-long animation. You don't need to worry about timing at this stage, but it helps if you have a clear idea of the total length of your animation and what's going to happen at each stage.

To open layered Paint Shop Pro files in Animation Shop, you first need to save them as Animation Shop .psp images. Though an excellent application, Animation Shop hasn't been updated for some time, so it doesn't support some of PSP's newer features like Vector Shapes. When you save an Animation Shop .psp file with Vector layers you'll get an alert box telling you that the vector data will be lost. Don't worry too much about this; although it would be nice to be able to edit vector shapes in Animation Shop, if you save the file with a different name you can always go back to the original PSP vector file if you want to make any editing changes to the vector objects.

Start by producing your animated GIF in Paint Shop Pro. Create each element of the animation on a new layer – when you import the image into Animation Shop 3, each layer will become a new frame.

The View Animation window and VCR Controls show you how the animation will look when played. Animation Shop provides a whole host of special editing tools. Right-click in the animation and select Frame Properties to change the frame duration.

A bigger drawback of this file incompatibility is that, while you can move files in the opposite direction – from Animation Shop into Paint Shop Pro – obviously, once your Vector layers have been rasterized, there's no going back and any editing you do to files once they have been round tripped to Animation Shop and back will need to be done using Raster Editing tools.

To ensure Paint Shop Pro layers open to frames in Animation Shop open the General Preferences dialog (File/Preferences/General Program Preferences), click the Layered files tab and make sure the box labelled 'Keep layers as separate frames' is checked. If the box labelled 'Export frames to Paint Shop Pro as layered images' is checked, when you reopen files in Paint Shop Pro they will appear once more in layered format.

Compared to Paint Shop Pro 9, the Animation Shop workspace is a fairly spartan affair. Docked above the Main View window you'll find the toolbar, Tool palette and VCR controls.

The Animation Shop (*.psp) format doesn't support vector layers. When you reopen files in Paint Shop Pro that have been saved as Animation Shop files the vector layers will have been converted to raster layers. If you want to keep the editable vector layers save the Animation Shop file with a different filename. Set the Layered File preferences in Animation Shop to keep layers as separate frames.

Useful tools

Let's take a look at some of Animation Shop's more useful tools and commands. The first thing you'll want to do when you've opened a layered Paint Shop Pro file into Animation Shop is see what it looks like when it's played. If you don't have the patience to create your own layered file, Corel provides one that demonstrates Animations Shop's features very well. Open the Animation Shop image browser and find the Anims folder within the Animation Shop 3 folder. If you used the default installer settings it will most likely be on your C drive at Program Files/corel/Animation Shop/Anims. Open the file called 'Butterfly.mng'. '.mng' is an animation format based on the PNG still-image format. As well as animated GIFs, Animation Shop provides limited support for a number of other animation formats, including AVI, FLC and MPG.

The butterfly animation has 13 frames; if you can't see them all, maximize the View window and change the Zoom ratio in the style bar so all 13 frames can be seen at once. Underneath each frame there are two figures. On the left is the frame number preceded by an F. On the right each frame has the number 10 prefixcd by a D. This is the frame duration in 1/100ths of a second. If

> **Tip**
>
> Sketch out your animations in storyboard format before attempting to produce them in Paint Shop Pro and Animation Shop. This will give you a clear idea of what happens in every frame and what you need to include on each layer.

each of the 13 frames displays for 1/10th of a second the total time it will take this animation to play is 1.3 seconds. In fact, the animation is on a loop, which means it will play continuously; 1.3 seconds is the time it will take for the sequence to play once. To change the frame duration, right-click on the frame in the View window, select Frame Properties from the contextual menu (or press Alt-Enter) and change the value in the 'Display Time (in 1/100th sec)' box by overwriting it or dragging the slider.

With animations like this butterfly, looping works well and gives the illusion of continuous motion, but often it's just an irritation to have an animation constantly looping. To limit the number of loops right-click in the View window, select Animation Properties from the contextual menu and on the Looping tab set the animation to play just once.

To see it in action click the View Animation button at the end of the toolbar; a new Play View window will open and you can see the butterfly flapping its wings (but not getting anywhere!). You can now use the VCR Controls to pause playback, slow and fast forward and reverse, and to advance and reverse a frame at a time.

Onionskinning is a useful feature for frame-based animation that lets you compare the current frame with previous ones. In the days before computer-based animation, artists worked on transparent acetate cells. Each new frame was placed over the previous one so you could see the progression. Onionskinning emulates this by overlaying a semi-transparent view of adjacent frames on the current one. To toggle this feature click the Toggle Onionskin Preview button on the toolbar.

Onionskinning lets you see adjacent frames super-imposed on the current one. Double-click the Onion-skin Preview button to change the View settings

Double-clicking the Toggle Onionskin Preview button brings up the Onionskin Settings dialog box, where you can set the opacity of onionskinned frames and select the number of overlay frames per side (i.e. before and after the current frame).

If you plan to create animations from scratch in Animation Shop, you will find the first two buttons on the toolbar a useful aid. These buttons initiate wizards; the first is the Animation Wizard and the second one is the Banner Wizard. The Banner

Wizard is more useful if you are literally starting from scratch with no raw materials. If you have a layered Paint Shop Pro file or a series of images which you want to combine into an animation use the Animation Wizard.

The Animation Wizard

The Animation Wizard takes you step-by-step through the process of creating an animated graphic and is an excellent way to learn the steps involved, even if you plan to create your animations manually in future. The first step is to define the size of your animation; even more than with still images you need to keep things small to avoid lengthy download times, so make it no larger than 200 × 200. Click the next button and choose whether you want a transparent or colored background. If the animation is going over a patterned background, or other detail, make it transparent, otherwise set the canvas color to the same color as your web page background.

The next page in the wizard determines what will happen with imported images that are not the same size as the animation frame. You can choose to put them in the top left corner, center them, or scale them to fit, but for best results try and ensure that the size of your imported images and the animation frame size match. Next, set the animation either to loop indefinitely or a specific number of times, and specify the frame duration. Finally, add the images you want to be loaded as frames into the list; you can change the order using the Move Up and Move Down buttons. Click the Finish button and Animation Shop creates the file to your specification.

The Banner Wizard

The Banner Wizard is for creating standard-sized text-based animated banner adverts of the kind seen all over the Web, but can be used to create any kind of text animation. To launch it click the Banner Wizard button on the toolbar. Select a background option and choose one of the standard banner sizes from the pull-down menu, or input a custom size and click the Next button.

Next, set the frame duration and loop parameters then, in the Text panel, type in what you want to say. Click the Set Font button to select a suitable typeface and size. As your text may not be on screen for long, and will probably be moving, try and pick something bold and easy to read. The next stage provides the opportunity to select the text color or, much more interestingly, fill the animated text with an image. Finally, select one of the available transitions from the pull-down menu. These include marquee (which scrolls the text through the banner from right to left) flag (which waves it around like a flag in the wind) and wheel (which rotates the text on a circular path). Most of these effects are customizable to a small degree and you can get an idea of how the finished animation will look in the Preview window.

When you're happy with how everything looks, click the Finish window and the banner frames will appear in the View window. Click the View Animation button on the toolbar to see how everything looks. Don't worry if it's not quite what you expected, you can fine-tune frame timing, cut, copy, paste and reorder frames and apply further transitions using Animation

Use the Banner Wizard to create animated graphics in seven easy steps. Just select the background, size and duration, then enter the text and select one of the available styles. You can specify an image for the background, text, or both, but try to keep it readable.

Shop's tools. Treat the wizards as a means of creating a first draft which you can then fine-tune to perfection.

Output

Use the Optimization Wizard (File/Optimization Wizard) to create a file for insertion into your web page. For the best compatibility leave the default settings of Animated GIF file and Create new animation from the optimized animation. This will ensure that everyone will be able to view your animation and that you can go back to the original should you decide to reoptimize using different settings.

PAINT SHOP PRO X FOR PHOTOGRAPHERS

Adjust the Quality slider to select one of the standard quality settings or click the Customize button and create your own color palette and select dithering and other Optimization options. Next you're provided with a side-by-side preview of the existing and Optimized animations. If for some reason you're not happy with how things have turned out, press the Back button to return and try different Optimization settings. If you're having difficulty getting things to look the way you want, go back and read the 'Gif in depth' section that starts on page 240.

When you're happy with how everything looks, click the Next button to get feedback on the size and estimated download time for the new optimized GIF. Finally, click the Finish button and the new GIF animation will appear in the View window. All you need to do now is save it (File>Save). Choose CompuServe Graphics Interchange (*.GIF) in the Save as Type pull-down menu.

STEP-BY-STEP PROJECTS

Technique: creating a rollover navbar

STEP 1 As we saw earlier, rollovers are a useful way of signalling active links on a website and Paint Shop Pro's Web toolbar provides all the tools you need to create them. Using layers simplifies the process because you can put the original graphic elements on one layer and the changed elements – that will appear when the viewer mouses over the graphic – on another.

The first step is to create the graphics. For this navbar, we've used the Preset Shapes tool to create a series of flower graphics. After drawing the first flower, select it with the Pick tool and press Ctrl+C to copy it. Then select Edit/Paste/Paste as new vector selection to place a copy of the flower on the same Vector layer as the existing one; you can click the plus sign to the left of the

layer to expand it and see the individual vector objects.

Just press Ctrl+G to paste further copies of the flower object into the layer. When you have as many as you need (don't let your navbar get too long and complicated) select them all by Shift-clicking with the Pick tool and use the Object Alignment and Distribution buttons on the Tool

Options palette to align them vertically and space them equally horizontally. When that's done add a text label underneath each one to describe its destination.

STEP 2 Now it's beginning to look like a navbar, but we need to produce the rollovers. The orange flowers are going to turn green when you mouse over them (and back to orange when you mouse out), so we need to create a new layer with green flowers. Right-click the orange flowers layer, select Duplicate from the contextual menu and double-click the newly created layer. In the Layer Properties dialog change the layer name to green flowers and click OK. Now turn off the orange flowers layer by clicking the Visibility toggle (the eye icon to the right of the description in the Layers palette) and Shift-click or drag with the Pick tool to select all of the flowers on the green flowers layer. Double-click within the bounding box to bring up the Vector Property dialog and change the fill color to green.

STEP 3 On the Web toolbar click the Image Slicer button; you'll see the navbar displayed in the Preview window at the top. The next job is to optimize the GIF nav buttons that you're about to produce using the Image Slicer and Rollover controls. Select GIF from the Format pull-down menu, check the 'Apply optimization to whole image' box and click the Optimize Cell button. Using what you've learned earlier in this chapter optimize the color palette

to achieve the best balance between image quality and download times. For this GIF navbar a 16-color palette provides good image quality with a file size of just over 2Kb for the entire navbar.

STEP 4 Select the Slice tool (the one that looks like a knife) and create an individual slice for each button. Position the tool equidistant between two buttons, drag a short distance up or down until a vertical line appears, then release the mouse button to create a vertical slice. When all the slices are created select the first one using the Arrow tool. In the Cell Properties panel enter the URL of the page that this button links to. You can enter either the entire URL, e.g. http://www.mysite.com/news.htm, or a relative link to the page. For example, if all of your website pages are in the same folder all you need enter here is 'news.htm'. Anything you put in the Alt text box will display in a small box next to the graphic, so put a description of where the link goes in here for those using browsers that can't display graphics. You can use the Target box to have the linked page open in a window other than the current one, or for advanced handling of sites that use frames.

STEP 5 Click the Save As button to save all of the slices to a folder on your hard disk. The name you enter in the Filename field will be given to the web page that's created, and one file will be produced for each slice, with the original document filename, together with a row and column suffix. The five slices created here are called 'navbar_1x1.GIF', 'navbar_1x2.GIF', 'navbar_1x3.GIF', and so on. Before you close the Image Slicer you need to save the position of the slices so you can use them again for the main buttons. Click the Save Settings button and save the settings in the same folder as everything else with the filename 'slices.jsd'. It's important you do this because Paint Shop Pro doesn't automatically keep the slice positions and next time you open the Image Slicer the position of the slices will be lost. The slices for the main menu and rollover graphics have to be in exactly the same positions, as any difference will show up as movement when you mouse over – we only want the color to change, everything else must remain exactly as it was.

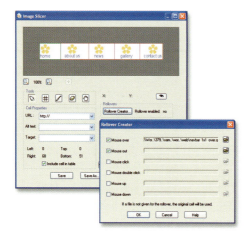

STEP 6 In Windows Explorer, find the folder you saved the web page and rollover images to and rename all of the GIFs, adding the suffix '_over' to each one. For example, rename the first file 'navbar1x1_over.GIF'.

STEP 7 Go back to Paint Shop Pro, turn off the green flowers layer visibility and turn on the orange flowers layer visibility, then click the Image Slicer button on the Web toolbar to reopen the Image Slicer dialog. Click the Load Settings button and select the 'slices.jsd' file to reload your original slice settings. Select the first slice with the Pan tool and click the Rollover Creator button.

Each of the fields in the Rollover Creator dialog allows you to specify the image you want to appear when that particular event occurs; we are only interested in the first two – 'Mouse over' and 'Mouse out'. Check the Mouse over box, click the Browse button to its right and navigate to the folder where you saved the web page and image files in Step 5. Select the 'navbar_1x1_over.GIF' image and click the Open button, which will return you to the Rollover Creator, where you can see the path to the file you just selected in the Mouse over field.

Next, check the Mouse out box. There's no need to enter a filename here because, as it says at the bottom of the dialog box, 'If a file is not given for the rollover, the original will be used', which is exactly what we want. Click OK to close the Rollover Creator.

STEP 8 Now that you have a working rollover for the first button you can preview it in your default browser by clicking the Preview button (the eye icon). If you are using Internet Explorer 6 and Windows XP with the SP2 service pack you may get a message saying 'Internet Explorer has restricted the file from showing active content'. If this happens click the message and select 'allow blocked content' from the pop-up menu. Position the cursor over the first button and the flower will change color from orange to green; move the cursor off the button and it will change back to orange. Don't try clicking on the button, as the links won't work at this stage.

STEP 9 Create the remaining rollovers by assigning the rollover images created in Steps 5 and 6 to each of the remaining slices. When you've done them all click the Save button. Use the same filename (navbar.htm), as you want to overwrite the original web page file with the new one. Don't worry about overwriting the rollover images you created earlier, as you renamed them. A

check of the folder contents will reveal the new navbar.htm web page and 10 graphics images – five for the initial web buttons and five rollover images. Double-click on the navbar.htm file to view it in Internet Explorer and check everything is working properly.

To use the navbar on your site you will need to use an HTML editing application to add the code to your pages, although it is possible to create entire pages in Paint Shop Pro and use the Image Slicer to optimize and tabularize them.

Technique: uploading web files to a web server

Most Internet Service Providers allocate server space which you can use to host your own website. You will need to check your documentation to find out how to access this; you'll need a host name and password. Files are uploaded to the web server using a protocol called 'File Transfer Protocol' or 'FTP' and you'll need FTP client software to upload your web pages and images.

There are a number of shareware and inexpensive FTP clients which you can download from the web – WS_FTP, FileZilla and CuteFTP being just a few.

FTP client software is simple to use. Once logged on, the application displays local and remote files in two windows and you simply select the local files for uploading and the remote folder you want to transfer them to.

Another simple way to upload files via FTP is to use Internet Explorer.

STEP 1 If you have a firewall you will need to configure Internet Explorer's Passive FTP feature. Open Internet Explorer and select Internet Options from the Tools menu. Click the Advanced tab and check the box marked 'Use Passive FTP,' then click OK.

STEP 2 In the address bar type the host URL – this will be something like ftp://myserver.com/ – and press Enter. The Log On dialog box will appear and you will now need to enter your user name and password in the appropriate fields. Some sites which are configured for public access, such as shareware software download servers, allow anonymous access which doesn't require a user name and password. If

you are logging onto one of these servers click the Log on anonymously checkbox, enter your email address in the password field and click OK.

STEP 3 Now you are logged on and can see the contents of the remote server. You can drag and drop files to and from any other open windows in exactly the same way as with local files.

10

Corel Photo Album 6: Organizing Your Pictures

TECHNIQUES COVERED AND TOOLS USED IN THIS CHAPTER

Techniques
Assigning keywords to photos
Backing up photos using Photo Safe
Batch Processing
Creating a Web Gallery
Creating keywords
Creating panoramas
Finding photos
Printing multiple photos with
 Print Layout
Producing a video CD

Tools
Back up
Batch
Calendar
Camera
Create tab
Crop
Enhance tab
Jump to Paint Shop Pro
Panorama
Quick CD
Quick Email
Quick Print
Quick Fix
Quick Show
Record
Red Eye
Screen Saver
Share tab
Sort
Video CD
Web Gallery

PAINT SHOP PRO X FOR PHOTOGRAPHERS

If there's one thing you can be sure of with a digital camera it's that you will take more photos than you did with a film-based one. A lot more. And why not? You don't have to pay for film and if you take six shots, or 12, rather than one or two, there's a much better chance that one of them will be very much better than the rest.

The trouble is, all of these images soon start to mount up and before you know it finding the one image that you want, from the digital mountain you've accumulated over months and years, is like trying to find a needle in, well, a very big box of needles.

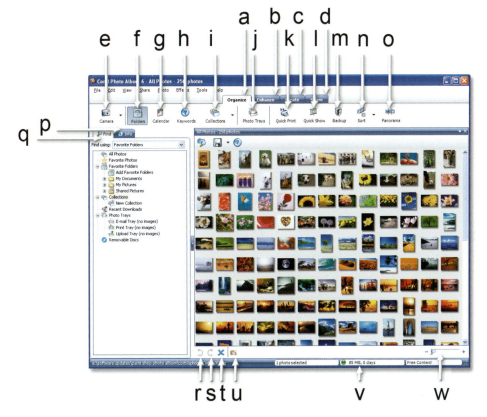

The Corel Photo Album 6 workspace is organized on four tabs: Organize (a), Enhance (b), Create (c) and Share (d). Each tab has its own set of buttons providing tools for that activity. The Organize tab buttons are: Camera (e) for viewing and downloading photos from your digital camera. Folders (f) which switches to All Folders or Favourite Folders view. Calendar (g) sorts photos by date. Keywords (h) provides a keyword search. Collections (i) keeps photos in organized groups without the need to duplicate them. Photo Trays (j) organizes photos for emailing, printing and uploading. Quick Print (k) does exactly what it says. Quick Show (l) plays a slide show of a folder or selected thumbnails. Backup (m) is for archiving images. Sort (n) organizes images in name, date or other specified order and Panorama (o) lets you stitch together multiple images into one. Alternate between the Info (p) and Find (q) tabs to find images and display their metadata info. Rotate images left (r) and right (s) and delete (t) photos using these buttons. Jump to Paint Shop Pro (u) to edit. The Photo Safe archive reminder (v) tells you how long since you last backed up your photos and the Zoom Slider (v) is used to change the size of the thumbnail previews.

What Corel Photo Album 6 does

Paint Shop Pro file browser provides good access to pictures and can even sort them, but that's as far as it goes. Corel Photo Album 6 SE, which is included free with Paint Shop Pro X, provides tools for viewing, organizing, cataloguing, sorting, finding and even editing photos. Using Album you can add titles, descriptions and keywords to your photos which can later be used as the basis for searching. This makes the otherwise time-consuming task of, say, finding all the photos you've ever taken in Paris, or of your mother, or of your mother in Paris, very quick and easy.

You can use Corel Photo Album 6 to create slide shows, send picture emails, create photo-based projects like greetings cards and invitations, produce and publish a web photo gallery and to create a video CD so others can view your pictures on TV using their DVD player. Perhaps most importantly, Album allows you to archive your photos to CD or DVD so that, should the worst happen, you always have copies of the originals safely backed up.

Finding your way around

The Corel Photo Album 6 workspace is organized into four tabs – Organize, Enhance, Create and Share. The Organize tab is where most of what Album is used for takes place. Here you can view pictures in folders stored on your hard drive or on removable disks, view, scan in or download images from a connected digital camera, sort images according to the date they were taken and other criteria, and archive your photos to disk.

To show as many thumbnails as possible, drag the Zoom slider to the extreme left and click the Show/Hide Panel button to hide the Find/Info panels.

On the left of the screen you will find two tabbed panels labelled 'Find' and 'Info'. If it's not already at the front, click the Find tab and select all folders from the 'Find Using' pull-down menu. You'll now be able to see all of the disks, folders and files on your computer's hard drive organized hierarchically in Windows Explorer style. A plus symbol next to an item means that you can expand it by clicking on it to reveal sub-folders. Using the All Folders view you can find a folder anywhere on your PC and click it to display the images it contains in the large thumbnail window.

If you keep a lot of things on hard disk besides pictures it can be hard work navigating through the folder hierarchy to find your digital images. To make the task easier choose Favorite Folders from the 'Find Using' pull-down menu. By default this view contains your My Documents folder, My Pictures folder, Shared Pictures folder, Removable disks and Photo Safe Archives. To add any folder to this list go back to the All Folders view, find the folder you want to add, right-click it and select 'Add to Favorite Folders' from the contextual menu.

When you select a folder that contains image files, they are displayed in thumbnail view to the right of the Find panel. You can adjust the size of the thumbnails using the zoom slider at the bottom of the window. At it's largest setting you'll only see two very large thumbnail images, and at the other extreme you can fit more than 15 thumbnails in a row, though you can't see them very well at this tiny size. Somewhere in the middle provides a good compromise. Double-click on a thumbnail to open it in the Enhance tab and click the Close button to close it and go back to the Organize tab.

Across the top of the Organize tab there's a strip of buttons which provide quick access to most of the Organize tab's tools and features.

Camera

Use this button to view and download images from your digital camera. If you are running Windows XP, Album will automatically detect the camera when it is plugged into a USB or Firewire port. For other operating systems you may first need to configure Album using the connection option on the Camera menu.

Folders

This button switches to the Favorite Folders view.

Calendar

This is a special mode of the Find tab which organizes pictures according to the date they were taken and allows you to locate them using a calendar display. For more about how Calendar view works see page 269.

Keywords

Keywords is another mode of the Find tab which you use to search for images based on keywords which you can assign to images. The available keywords are displayed in a category-based list in the Find tab. To find out how to assign keywords and search for photos that include them see page 267.

Collections

Collections provide a way for you to organise your pictures into logical groups without having to keep lots of copies. For example you might want the same photo, of your children on holiday in Collections called 'Family' 'Kids' and 'Holiday'. Each collection displays the image thumbnail which is linked to the original file.

Photo Trays

Photo Trays provide a quick and easy way to email, print and upload a selection of images to an online photo printing service . You just click the image thumbnails to add them to a tray, then click the Quick Email, Quick Print, or Upload button.

Quick Print

The Quick Print button opens a dialog box which you can use to quickly make an inkjet print from selected images in one of several layouts. It's not as versatile as print layout, but it's quick and easy to use.

Quick Show

Quick Show enables you to produce and play a slide show of a folder of images. If no images are selected the slide show includes all images in the currently displayed folder. Alternatively, Shift-click or Ctrl-click to select a range of images, then click the Quick Show button.

Click the Quick Show button for an immediate slide show.

Backup

Backup opens the PhotoSafe dialog box which allows you to back up images to a CD or DVD. You can choose to back up everything, or only those photos that haven't been saved to disc in a prior backup operation.

Sort

Like the Camera button, this one has a menu attached. You can use it to sort the images in the Thumbnail window by name, date modified, date taken, size, type, or folder. But if you want to organize your photos by date the Calendar view (see page 269) is a better option.

Panorama

This button launches a utility which combines several side-by-side photos into a single wide-angle panoramic image. Its use is described in detail on page 272.

Rotating images

Having downloaded images from your digital camera, one of the first tasks is to rotate the portrait-orientated images – taken with the camera turned through 90 degrees – so they open and display the right way up, not turned on their side. Album provides two buttons at the bottom of the screen for this purpose. The one on the left rotates anti-clockwise and the one on the right clockwise.

The fastest way to do this is to Ctrl-click to select all of the images that need rotating in a particular direction, then press the appropriate rotation button. If you've taken some photos with the camera turned one way, and some with it turned the other, first select and rotate all the anti-clockwise ones, then do the clockwise ones.

Delete

Next to the rotate buttons is a blue cross; click this button to delete images both from the Thumbnail view and from your hard disk.

Jump to Paint Shop Pro

The Palette icon next to the Delete button launches Paint Shop Pro. If image thumbnails are selected when you press this button then the selected images are opened in Paint Shop Pro. Use it when you need more powerful editing tools than those available in Album.

Info

Use the Info tab to display EXIF data providing, among other things, date and camera exposure settings for an image.

Album's Info tab displays the same kind of information as the Info tab of Paint Shop Pro's File Browser with one very important difference. In Paint Shop Pro, the File information and EXIF data are for information only (the exception being the new IPTC Data fields in Paint Shop Pro X which allow you to add information such as the photographer's name and a caption). In Corel Photo Album 6 you can add to and edit the data.

The topmost field contains the filename. To overwrite it, simply highlight the existing name and overwrite it.

Underneath the filename there is a field entitled 'Photo Title'. In here you can enter a more lengthy description than the filename limitation allows, for example 'Temple of the Sagrada Familia'. The next field, Photo Description, can contain still more detailed information such as 'One of the towers of the Nativity façade of Anton Gaudi's famous cathedral in Barcelona'.

The remaining image information and EXIF data tell you, among other things, when the photo was taken, what camera was used and the exposure settings. Not all images will display this data. Unedited JPEG files from digital cameras will, but editing these files in some picture editors (not Paint Shop Pro!) can cause the data to be lost. Scanned images and digital camera photos saved in file formats other than JPEG will also lack EXIF data.

You can use title and description text as the basis for searching folders of images. We'll take a look at searching later; first let's look at another way of adding information to your photos.

Keywords

Most people are familiar with the concept of keyword searching; certainly, anyone who has used Google will appreciate the value of being able to search a database for records on the basis of either single or multiple keywords. Album's search tools work in much the same way. Keywords and other information about pictures organized with Album are stored in a database. By searching the database you can find all of the records containing the keywords in your query, and the corresponding images.

Creating keywords

To start using keywords click on the Find tab and select Keywords from the 'Find using' pull-down menu. Check the radio button labelled 'Asign keywords to photos', click Add/Edit Keywords and the default keyword list will be displayed. As in the Folders view, keywords can be expanded if they have a plus symbol next to them to reveal sub-keywords. Expand the Occasion keyword by clicking its plus symbol and you'll see it has three sub-keywords – Birthday, Vacation and Wedding. There's a Photographer keyword that will have your name as a sub-keyword if you entered it when you installed Corel Photo Album 6. If this is the case, your name will also appear as a sub-keyword of the People keyword.

Press the Add/Edit Keywords button to open the Edit Keywords dialog and add more keywords to the list or edit existing ones.

Generally, it makes life easier if you think of the main keywords as categories. To add keywords to the list or to change existing keywords press the Add/Edit Keywords button. If you want to add a new category, first select the Keywords item at the top of the list, then click the Add button and a new keyword entry will appear at the bottom of the list ready for you to type in your new category. To add sub-keywords, highlight the category keyword you want to add the sub-keyword to, then click the Add button and a new (sub-) keyword entry appears indented under the category. You can assign sub-sub-keywords. The Subject keyword has a sub-keyword called 'People' and this has several further sub-keywords such as 'Parents', 'Grandparents' and 'Kids'.

To rename a keyword highlight it and press the Rename button, or use the delete button at the bottom of the Edit Keyword window to remove a keyword from the list. You can't delete a category keyword that has sub-keywords assigned. First delete the sub-keywords, then you will be able to delete the category keyword. If you attempt to delete a keyword that has been assigned to photos, Album will display an alert box warning you of this and asking if you want to go ahead. If you click OK the keyword will be deleted and will no longer be assigned to those images. When you're done creating new keywords click the Done button to close the Edit Keywords dialog box.

Assigning keywords to photos

The first step in assigning keywords to your photos is to select those images you want to assign a particular keyword to. This would be a time-consuming and tedious process if you did one photo at a time; in practice it's usually possible to assign the same keyword to multiple images. For example, if you've just returned from a holiday in Paris, the first thing you'd want to do is assign the location sub-keyword 'Paris' to every image. You might then want to make a selection of those images with yourself in and assign your name sub-keyword from the People category.

Click the magnifying glass icon next to a keyword to display images to which that keyword has been assigned.

Assigning keywords to images is simple. First navigate to the folder containing your photos, then select Keywords from the 'Find using' pull-down menu and check the 'Assign keywords to photos' radio button. Select the image thumbnails you want to assign a particular keyword to. To select all of them click in the background of the Thumbnail window and press Ctrl+A. Use click-drag, Shift-click and Ctrl-click to select a range of images. Now simply check the boxes for the keywords you want to assign to these photos. If you assign a sub-keyword its parent keywords are automatically assigned.

Finding photos

When you've finished assigning all the keywords you want to a folder of photos, click the 'Find photos using keywords' radio button. The keyword list changes slightly; there are no checkboxes next to the keywords, instead a number appears in brackets after some of them indicating the number of images that keyword is assigned to.

To view the images that have a particular keyword assigned, click the Magnifying Glass icon next to that keyword. You can click more than one keyword to display photos with other keywords assigned. Clicking 'Paris' and 'Mother' will find all the photos of Paris and all the photos of your mother, not just all the photos of your mother in Paris, though these will be included. This doesn't really matter. Not because if you were going to Paris, your mother is the last person you'd consider taking, but because Album has a more powerful tool for finding photos.

Searching

Selecting Search from the 'Find Using' pull-down menu provides two ways of searching for photos. Search by folder and photo info allows you to search the image title and description fields we talked about earlier, as well as other criteria including folder title and description, the date the image was taken or modified, file size, image size and image type.

What makes Search so powerful is that you can specify several search criteria at once and choose to match all of them (Boolean AND) or any of them (Boolean OR). Again, if you've used a web search engine you'll understand the difference. Going back to our mother in Paris scenario, matching all search criteria would turn up only those photos that contained both mother and Paris keywords. You would use this to find photos of your mother in Paris. Matching any search criteria would find these photos too, but it would also find photos with only Paris and photos with only your mother.

As well as searching by folder and photo info you can also search by keyword. Click the Keywords radio button in the Search By panel to display the keywords list below. A quick way to expand all of the categories is to right-click in the list and select Expand All from the contextual menu. Click the keywords you want to include in your search – the magnifying glass turns blue for selected keywords – and choose either 'Match all', or 'Match any of the selected keywords' from the pull-down menu. Incidentally, if you need more room to display the results of your search you can close the Find panel by clicking the slim button with a triangle on the divider between the Find panel and the Thumbnail window. To reopen it, just click the button again.

Calendar

There's one other way to find photos that is both quick and convenient if you have a fairly good idea of when they were taken. Selecting Calendar in the 'Find using' pull-down menu of the Find panel displays a date list in chronological order with the most recent at the top and the oldest at the bottom. The range of dates represents the oldest and most recent picture files Album has found on your PC. Album will only be aware of files in folders that you have opened, or on discs that have been catalogued.

The dates are listed by month; alongside each is a number which tells you how many images were taken in that month; if you click the month to highlight it, all of that month's pictures are displayed in the Thumbnail window. At the bottom of the Find panel there's a calendar and the page changes to display the current month in view. Dates on which photos were taken are emboldened and if you click on a date, only the images taken on that day are displayed.

Archiving photos

Click the Backup button to archive your photos to a CD or DVD. Album keeps track of photos that you've already archived so you don't waste disk space copying images that have already been archived. However, if you want to resave previously archived photos click the All Photos radio button. You can change the disc label to something more recognizable than the default date-based number, but there is a limit of 14 characters. If you want to make more than one copy enter the number you want in the Copy field. When you are ready to begin archiving press the Burn button.

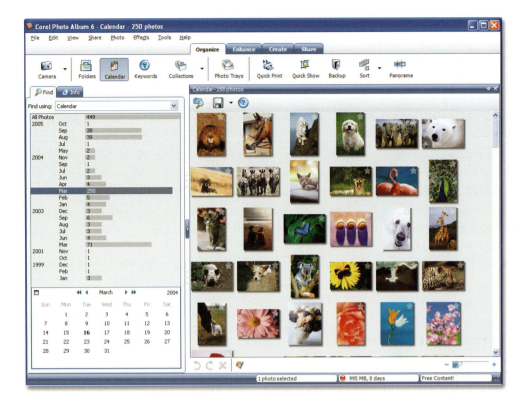

Find Using Calendar displays all your photos in chronological order. Just click the month to view all the photos you took in, say, September 2003. You can even view photos taken on a particular day by clicking the date on the calendar page at the bottom.

When you archive your pictures, Album automatically creates a backup copy of the database that contains keyword data and other information about your photos (but not the photos themselves). You can carry out manual database housekeeping tasks including backup, restore and exporting the database file to use on another computer from the Database sub-menu of the Tools menu.

Panoramas

The last button on the Organize tab is a feature introduced in version 5 of Corel Photo Album. Panorama allows you to stitch together several photos into one wide-angle panoramic view. To take panoramic photos you should ideally mount the camera on a tripod; if you are hand-holding, try to keep the camera as level as possible and overlap each shot by about a third. For more advice on taking panoramic photos see page 193.

Before clicking the Panorama button first select your images. The Panorama window opens

below the Thumbnail window; if you can't see all of the images dock the Find panel and if necessary close the Thumbnail window. Drag and drop the photos in the Panorama window so that they appear in the correct order. If you drop one photo on top of another the bottom one will be deleted. If you do this inadvertently, or you forgot to include an image, you can drag another copy in from the Thumbnail view.

When the pictures are in the correct order click the Settings button at the top left of the Panorama window and choose either Cylindrical or Perspective projection. Choose

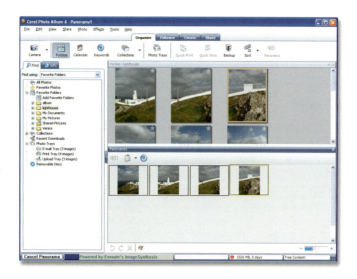

First select your images, then arrange them in order in the Panorama window. When you've decided on the type of panorama you want and specified the size, click the Panorama button.

Cylindrical projection if you are stitching more than about six images to produce a panorama with a wide field of view of 120 degrees or more. For fewer images with a narrower field of view the perspective projection gives a more realistic result.

Next, choose the Blend type. If you didn't use a tripod choose Sharp Blend mode, which is better at dealing with mismatches in the overlapping area of your images caused by not

keeping the camera level and parallax errors introduced when the camera was rotated. If this isn't a problem use Smooth Blend, which makes a better job of smoothing out exposure inconsistencies.

The last thing to do is specify the size of your panorama. There are four options: small, medium, large and very large. The final sizes depend on the size of the original images and how many of them there are. As a guide, the small setting will produce an image roughly 300 pixels deep and suitable for uploading to a web page. Using the very large setting on a panorama

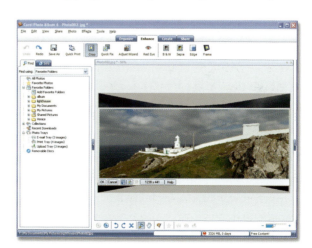

When the panorama is created a Crop window is automatically placed over it to trim the ragged edges. Press Cancel if you don't want to crop the image.

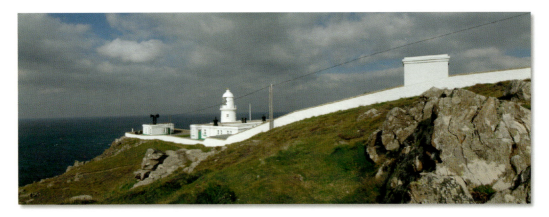

With the right photos Corel Photo Album 6's Panorama feature can produce stunning results with no more effort on your part than arranging the pictures in order and pressing the button. This panorama was created from four images (see page 271) and has had no retouching other than the addition of the drop shadow. If you experience problems creating very wide-angle panoramas, try reducing the number of images used.

created from seven images each 2128 × 2832 pixels produced a new image 2860 × 1099 pixels in size with an uncompressed file size of just over 9Mb and a JPEG saved with the best quality setting of 1Mb.

Pressing the Panorama button in the Panorama window (don't confuse it with the one on the Organize tab which looks the same, but is grayed out when the Panorama window is open) begins the process of creating the panorama, which will take a few minutes. You can do other things in Album while waiting. When the panorama is done it appears with a Crop window around it to help you trim the irregular edges. If you haven't managed to keep the camera level you may need to crop quite severely. Click OK to accept the crop, then click the Save As button on the Organize tab to save the image.

Printing with Print Layout

Corel Photo Album 6 offers two ways to print photos – Quick Print and Print Layout – both of which allow you to arrange and print several pictures on on sheet of photo paper. Given the cost of paper and ink this is no bad thing. While Quick Print is fast, and extremely easy to use, it automatically arranges photos on the page and you can't save the layout for printing later. Print Layout provides more flexibility and allows you to arrange photos on several pages which you can then save.

Print Layout uses a step-by-step wizard approach and one of the best things about it is that you still have access to the Find tab and all of Album's powerful search tools, so if you can find it, you can print it. It also lets you rotate and pan and zoom images within the frame, effectively providing a basic on-the-page cropping tool.

Enhance

The Enhance tab provides a range of tools for editing and improving your photos. We won't go into them in too much detail, and we'll even ignore some altogether because, quite honestly, you can do most of this stuff much more effectively in Paint Shop Pro. When you click the Enhance tab it opens the currently selected image in the Thumbnail window. If you want to work on another image, select it from the Thumbnail window to the right of the Main Image window.

Crop

The Crop button puts an adjustable frame around the image which you can resize to specify the crop area. There's a selection of presets including APS photo sizes and a button that flips the crop selection from landscape to portrait. That's about it.

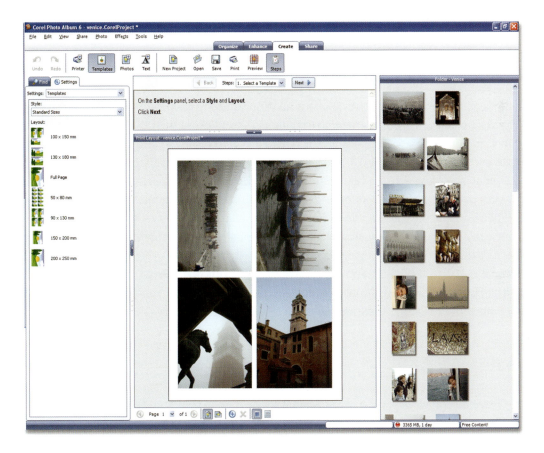

Print Layout uses a template-based wizard to help you arrange multiple photos for printing on a single sheet.

Quick Fix

The Quick Fix button makes a one-step adjustment to brightness, contrast and color balance. It's OK, but like most of the Enhance tools it just makes you want to open Paint Shop Pro! That's easily done – click the Jump to Paint Shop Pro button at the bottom of the screen.

Adjust

The Adjust wizard provides a 4-step process for improving color, exposure, vividness and sharpness.

Red Eye

Does what it says on the button – removes red-eye. This tool works in a very similar fashion to Paint Shop Pro's Red Eye tool – you just click on the offending red pupils to make them a more neutral hue.

Adding audio to photos

To add an audio file to a photo select Tools>audio>Add audio to photo and select the audio file in the browser window. To record an audio annotation select Record from the Audio sub-menu of the Tools menu and use the buttons on the record dialog to record a voice annotation. You can edit the recording by selecting Edit from the Audio sub-menu of the Tools menu. A waveform of the audio recording appears below the image. Click-drag to select parts of the waveform and right-click to edit it using the command available on the contextual menu.

When you add or record audio to an image a small icon appears on the thumbnail in the Organize tab and if you double-click it, the audio file will play. It's a shame, but you can't have these audio annotations play during slide shows created with Album.

The B & W and Sepia buttons are single-step filters with no controls that turn your image into a black and white or sepia-toned photo. Edge provides a range of soft-edged vignette effects and Frame provides five picture-frame effects.

Create

The Create tab provides several wizard-based projects that help you produce something of practical value using your images. The projects are: Album Page, Greeting Card, CD Label, E-Card, Calendar, Collage, Certificates and Magazine. You can also launch Print Layout from here. As a quick way to produce a greetings card, or a CD label, the projects are quite useful and they also contain a good range of templates.

Share

In some ways this is the best part of Corel Photo Album 6, where you get to share your pictures with everyone else. It's also got lots of features which, alongside its organizational capabilities, make Album a very worthwhile addition to Paint Shop Pro. As with the other tabs, the functions of the Share tab are accessed from a row of buttons along the top.

Choose from a range of wizard-based step-by-step photo projects in the Create tab.

Quick Email

Quick Email automatically resamples and compresses images and attaches them to an email message ready for sending. It even adds a subject line; all you have to do is key the recipient's address into the To field, or get it from your address book. Quick Email downsamples photos to 640 × 480 pixels and JPEG compresses them to around 50Kb in size. If you want to attach more than one photo to a message you just Ctrl-click or Shift-click to multiple select in the Thumbnail window. If you want to send the original files without resizing and compressing, select Email from the pull-down menu.

Quick Print and Quick Show

Both of these buttons appear on the Organize tab and behave in exactly the same way when selected from the Share tab.

Quick CD

This button simply allows you to copy selected images to a recordable CD or DVD.

Order prints

This button links to an online digital photo-sharing and printing service where you can upload your photos for selected guests to view and order high-quality prints delivered by post.

Screen Saver

This button creates a slide show from the current folder of photos and configures it as your Windows screen saver. To adjust the screen saver settings, such as the time for which each image is displayed and the transition style, right-click in the Windows desktop, select Properties from the contextual menu and click the Settings button on the Screen Saver tab.

Wallpaper

Assigns a photo to use as your Windows desktop wallpaper. If the image isn't screen-sized, you can automatically resize, or tile it. To reset your wallpaper right-click in the Windows desktop, select Properties from the contextual menu and click the Desktop tab.

Corel Photo Album 6 Full Version

The version of Photo Album 6 included with Paint Shop Pro X is called 'Standard Edition'. You can buy the full version from the Corel website which, in addition to the basic features included in the Standard Edition, has a number of aditional 'power features' and extra useful content like scrapbook templates. To give you an idea of what you can do with the full version of Photo Album 6 we'll take a look at some of the features it has to offer. Batch Processing, Video CD and finally a step-by-step project which demonstrates how to create a web photo gallery.

Batch Processing

Another of Albums's time and effort savers, Batch Processing allows you to automatically carry out the same operation on any number of images. Typically, Batch Processing is used to rename a folder of digital camera photos, adding a sequential number to each file, so the anonymous letter and number combinations used by your camera become something more meaningful, like paris001, paris002, etc.

Batch processing can also be used for other repetitive tasks. On the pull-down menu that appears when you click the Batch button you will find: Quick fix, Rename, Resize, Save as, Convert to black and white, Convert to sepia and Crop to 4 × 6.

Renaming

To batch rename a folder of images first locate the folder using the Favorite Folders mode in the Find panel. If you don't select any of the images before applying a batch command, every image in the folder is processed. Select Rename from the Batch pull-down menu. The default new

filename is the name of the folder; overwrite this if you want to use a different name. The number 1 in the 'Append filename with count from' box is the start number which will be appended to the filename. Two leading zeros are automatically added so that the images appear in the expected order when you sort by filename. For example, if you specify the filename holiday, the first image img001.jpg will be renamed holiday001.jpg. If it wasn't for the leading zeros holiday10.jpg would appear in a filename-sorted list before holiday2.jpg.

If you have added new images to a folder that has already been renamed, set the Append filename with count from number accordingly. For example, if the folder already contains images up to 'holiday076.jpg' start the count from 77.

Resizing

Select Resize from the Batch pull-down menu to open the Batch Resize dialog box. Use the dimensions pull-down to choose a percentage reduction (or enlargement, but bear in mind the quality will suffer if you upsample) or a specific maximum pixel height or width. As with some of the other Batch operations you can elect to overwrite the original files, save the resized images to the same folder with new filenames, or to save them to a different folder. The last of these is the safest option. It's never a good idea to Batch Process originals – make a copy folder first. Of course, if you make a habit of archiving your images to disk any problems can easily be rectified.

Save as

This Batch Process is really a file conversion routine. It takes a folder of photos and converts them to the file type you specify. If converting to JPEG, Flashpix, or other lossy formats, specify the compression setting by choosing one of the four options in the Quality pull-down menu.

Other Batch commands

Convert to black and white, Convert to Sepia and Crop to 4 × 6 do pretty much what you'd expect. All three of them are single-step undo-able processes and an alert box warning you of this asks if you want to proceed. Once you've clicked yes, there is no going back – so copy the folder first and make sure you've archived.

Video CD

Video CD, or VCD, is actually a format for recording movies to a recordable CD. It was developed in the days before affordable DVD writers and recordable DVD disks were available. Nowadays, most domestic DVD players can play VCDs, so they provide an easy method of sharing your photos

with friends and family in the form of slide shows which they can watch on their TVs.

Creating a VCD is simple. Click the Video CD button to open the VCD Layout window. The Layout window is divided into two sections: the top half displays the slide shows on the VCD and the bottom half shows the contents of the selected slide show. The VCD Layout window opens with one slide show consisting of current folder displayed or thumbnail selections made when you clicked the Video CD button.

If you want to add more slide shows you can click the Add Slide Show button in the VCD layout screen, or click the Close VCD Layout button and make a new selection of images using the Find tab. The next time you press the Video CD button the new image selections will be added as a new slide show.

You can add to and take away slides from individual slide shows and remove entire slide shows if you change your mind at this stage. You can also insert a title slide at the beginning, or anywhere else during a slide show. Select the slide you want the title to appear in front of, then click the Insert Title Screen button, check the 'Insert before first selected image' radio button and add up to three lines of text. You can't format the text, it's one size fits all, but you can add a background image to the title slide. As you add slide shows, keep an eye on the space required readout at the top of the Slide Shows window to ensure that you don't exceed the capacity of your recordable CD.

The VCD Menu button opens the VCD Settings dialog box where you can select a background for the menu screen and add a menu soundtrack. To add a soundtrack to the slide show itself, select Slide show settings from the pull-down menu on the Slide Show button. In the Slide Show Settings dialog box you can choose a backing audio track for the slide show and set the slide show length to match the length of the audio track. Alternatively, you can enter a fixed duration for each slide, but you'll need to make some careful calculations if you don't want your music to end part way through the show.

To burn your CD click the Create VCD button and select Create VCD settings from the menu. Select your CD writer from the Select Burner menu (if you only have one installed it will appear here), enter the number of copies if you want more than one and choose the video format NTSC for North America and Japan, and PAL for most European countries. As well as the VCD slide show you can include a PC compatible slide show and the original images. Select the latter if you

Select folders of images for inclusion in a VCD slide show which can be played on a domestic DVD player.

want people to be able to produce good quality prints on their own printer – they won't be able to do this from the slide show images.

STEP-BY-STEP PROJECTS

Technique: creating a web gallery

The Web Gallery feature in the full version of Corel Photo Album 6 provides one of the simplest ways of getting your photos onto the Web for everyone to see. Whether you want to upload a few photos of your car to increase the chances of a sale, or make available every one of the 500 photos you took on a weekend break, with Web Gallery your pictures can go global in just a few minutes.

You will of course need an account with an Internet Service Provider that allocates web space on a hosting server and some means of uploading the images to your site. (See Chapter 9 for more details on how to do this.)

STEP 1 In Corel Photo Album 6, click the Share tab and use the Find panel in Favorite Folder mode to locate the images you want to put in the web photo gallery. Click the Web Gallery button. There will be a short delay while Album generates the thumbnails and displays JPEGs for the gallery from the original image files.

STEP 2 Album displays the gallery in the Main Browser window which works just like a web browser (though you can't use it to access web pages on the Internet). To the left is a selection of template layouts. The Basic – Full Image per Page template displays each image on its own page with navigation buttons for going forward and back through the gallery. This isn't the best layout design, because viewers can only see one image at a time and have to wait until each full-sized display image is downloaded to their browser before they can view it.

STEP 3 Select the Basic – Thumbnail template and you'll see the layout change in the browser window almost immediately. In this layout each of the small thumbnail images links to a larger display image, giving viewers the opportunity to look at lots of pictures at once and decide which ones they want to see in more detail. Click on any of the thumbnail images to view the full-sized display image.

STEP 4 Underneath the full-sized image there are three navigation buttons – Forward and Back to view the previous and next full-sized images in the gallery, and a Home button to go back to the thumbnail index page. On the Home page, visited links have a pink outline around them.

STEP 5 Click the Settings button and change the maximum image width value from 480 to 600. Change the Maximum thumbnail width to 80; the height values will change proportionally as you do this. Leave the Include Audio box checked so that viewers will be able to play any audio annotations belonging to an image and leave the Include Movie Files box unchecked unless you've taken movies with your digital camera that you want to include in the gallery (bear in mind they will be large files and will take a while to download). Click OK and wait while Album generates the new thumbnails and display images.

STEP 6 The smaller thumbnails will download more quickly and you can fit more on a page without the need to scroll. Conversely, the larger display images will take a little longer to download, but bigger looks better. Depending on how many images you have and the likely connection speed of visitors to your site, you need to make a decision about whether speed of operation or quality is more important.

STEP 7 Album can't tell you how long a page will take to download at a given connection speed, but it can show you exactly what the quality of the images will be like. Click the Settings button again and set the JPEG quality level to Low (Highest Compression) using the pull-down menu. Click OK and wait for the new images to be generated. You'll see a marked deterioration in the quality of both the thumbnails and the full-sized display images.

STEP 8 The medium-quality compression setting is best for most circumstances. Remember, if you use one of the thumbnail-based templates, visitors to your site need only wait to download images they choose to view. Even using a dial-up modem link, the thumbnail images will load pretty quickly. Try the Heritage Slideshow template which advances the photos automatically, or the Side by Side template which uses frames to display the thumbnails and selected full-sized image on the same page. All of these templates use the image title and description from the Info panel to title and caption the images, so make sure you have completed these before you start as they can't be edited.

STEP 9 When you're happy with the gallery layout, click the Save button. The pull-down menu provides two options – 'Save to drive' and 'Publish to website'. Select Save to drive if you want to preview the site using Internet Explorer or another web browser, or if you want to upload it yourself using your own FTP client software. Select Publish to web to launch the Web Publishing wizard and click the Next button.

STEP 10 Click 'New' to add a web server to the list and enter the log on details for your web server which you can obtain from your ISP; click the Next button and on the next screen click 'Publish'. If you entered your web server details incorrectly the wizard, not very helpfully, tells you that it can't find the servers and closes. If this happens just select 'Publish to web' from the Save pull-down menu again. The server details you entered last time will have been saved and you can amend them to the correct details by pressing the Edit button.

You can save the completed web gallery to disk for later upload to your web server. This also allows you to check it through locally in your web browser.

Appendix 1

Jargon Buster

se the jargon buster to increase your understanding about the digital techniques discussed in this book.

ADJUSTMENT LAYER A special layer that permits users to change a wide range of things in the picture (tone, etc.) without affecting the rest of the layer data. Ideal for experimentation, as you can have as many Adjustment layers as you have the time for and they never change the integrity of the original image data.

BATCH (PROCESSING) Technique for applying the same photo-editing action to more than one file at a time.

BIT The smallest unit of computer information.

BIT DEPTH The number of bits used to represent each pixel in a digital image.

BITMAP Term describing a digital image made from pixels laid in a grid pattern.

BLEND MODE Blend modes alter the way pixels react with each other. Especially useful for creating effects between layers in a picture. Many tool actions can also be heavily influenced by changing their respective Blend modes before applying them to the canvas.

BROWSER The bit of software that allows you to check what's on your computer (or removable disk) by displaying tiny thumbnail photos rather than confusing lists of unmemorable file names.

BURN (TOOL) Brush-driven technique for increasing the local density in a picture.

CANVAS The entire picture area. Enlarge the canvas of a picture and you add pixels to its overall dimensions, although the picture itself never changes size.

CCD Charge-coupled device – the digital sensor (the 'film' equivalent) found in a scanner or digital camera. CCDs are made up of light-gathering pixels. The more pixels in the CCD, the higher its resolution.

CLONE (TOOL) Cloning is used simply to copy and paste pixels from one part of a digital image to another so that it can be repaired, retouched or replaced.

COLORIZE Effect that changes the color image to monochrome and then adds a single color tint. Similar to a duotone.

COLOR SPACE Term describing the way certain technologies display colors. The print color space is not as good as the display color space, for example, as the latter can display a wider range of tones.

CONTRAST A measure of the tonal values in a picture between black and white. The fewer the tones, the higher the contrast.

CROPPING (TOOL) The Crop tool is used to remove or cut pixels from a digital image. Cropping reduces the total file size.

CURVES Sophisticated tool for adjusting image contrast and brightness.

DEFORMATION (TOOL) Technique used for distorting, rotating, turning and bending objects on a layer.

DIALOG (WINDOW) A generic term describing the window that displays certain controls or options within the photo-editing program.

DODGE (TOOL) Brush-driven technique for reducing the local density in a picture.

DOTS PER INCH (DPI) System of measuring the pixel spread in an image. The higher the dpi value, the clearer the detail in the photo.

DRIVER Small software program that controls scanners, printers and other third-party plug-in devices.

FILE FORMAT The form in which a computer, scanner or camera saves digital data. Each file format has slightly different characteristics. For example, '.jpg' files are ideal for storing many pictures in a small space as they can be compressed, while '.tif ' files are there for preserving the best possible image quality.

FILTER A preset software action that applies a certain effect to a digital file, layer or selection. Most filter effects can be adjusted through their respective dialogs. Examples include Soft Focus, Brush Strokes, Sharpening and more.

FLAT (CONTRAST) Term used to describe a photo with low contrast levels.

FLATTEN (LAYER) Command used to 'squash' all layers into one document so that it can be resaved in another, non-layered, format, like JPEG.

GAMMA (ADJUSTMENT) Term given to the brightness values in the image.

GIF (FILE) A special file format used for saving and displaying graphics on the Internet.

HISTOGRAM A graphic representation of the tones captured in a scan or digital photo. Represented as a mountain range where the darkest tones lie to the left-hand side of the range and the highlights to the right.

HUE Another word for color (values).

INTERPOLATION The process of changing (up or down) image resolution by resampling and then adding or removing pixels.

JPEG (FILE) A type of file used to save and store scanned images. JPEG files can be compressed (squashed) so that you can get more pictures onto a disk drive. Once opened again they revert to the original proportions. Too much compression introduces errors or ugly 'artifacts'.

LAYER A second (or more) level within a single digital picture. Layers add editability to a file. Text, multiple images, masks and special effects can be applied to separate layers and these in turn can be edited for greater creative control. Layered documents must be saved in the '.pspimage' file format. But they can be flattened (layers are squashed together) so that they can be reconverted into any other picture file format like TIFF or JPEG.

LAYER MASK Used to hold back parts of an underlying layer to create a blended or merged effect. Layer masks are simple black and white layers that can be edited using any of Paint Shop Pro's paint or drawing tools.

LEVELS Sophisticated tool for applying changes to image contrast and brightness.

MOIRE The odd, checkerboard pattern displayed when you scan a commercially printed document like a magazine page. Use a softening filter to remove or to soften this detrimental effect.

NOISE Ugly speckling apparent in underexposed digital camera images. Setting your camera to a high ISO rating also introduces excessive noise. Paint Shop Pro ships with a number of filters designed to minimize this problem.

OPACITY Density or translucency of an image or layer. All tools and layers have opacity settings (default at 100). This value can be lowered for more subtle effects.

PALETTE A dialog window that relates to a specific photo-editing tool. Palettes give access to a wide range of controls that permit you to fine-tune that feature. Palettes can be docked or floating.

PLATEN The glass scanning bed on a desktop scanner.

PLUG-IN A piece of specialist software that operates from within a host software program such as Paint Shop Pro.

PNG A slightly newer file format for displaying photographic data on the Internet. While PNG files are not supported by all web browsers, the format does exhibit superior features over the more widely used JPEG format.

POSTERIZATION Drastically reduces the amount of colors used in a picture – typically to less than 10 colors. Produces an Andy Warhol-type visual.

PRINT RESOLUTION Typically this is about 300 dpi for inkjets, although equally good quality is attainable from resolutions of 200 dpi and sometimes even lower. Commercial print devices like Fuji Frontier labs require slightly different settings. Check with the manufacturer.

RASTER Same as **Bitmap.**

RESAMPLING See **Interpolation**.

RESOLUTION Typically a measurement of the number of pixels in a digital image. The more pixels there are, the more detail is visible and therefore the higher the resolution the image.

RGB (RED, GREEN AND BLUE) The primary colors used to display images on a computer monitor. All scanners and digital cameras create RGB images unless otherwise programmed (some scanners can be set to produce CMYK files).

SATURATION Term used to describe the intensity of color. A fully desaturated picture, though still technically a color image, appears black and white.

SCRIPTING Technique for recording certain Paint Shop Pro actions (rather like using a video recorder). Can then be replayed on other files for Batch Processing techniques.

SELECTION A term used when isolating part of a digital photo for the purposes of additional editing or the addition of special effects. Selections can be made automatically, freehand or geometrically. Selections protect everything outside of the selection marquee.

SHARPENING A software technique used to apply the effect of making an image crisper by applying specific contrast adjustments. Too much sharpening causes an ugly, brittle texture to the file.

SOLARIZATION Similar effect to film solarization – highlights turn to shadows and shadows to highlights. Particularly effective in color photography.

THUMBNAIL This is a small representation of the original picture file. Thumbnails are displayed in the File Browser.

TIFF A file type typically used to save and store high resolution digital scans or camera files. Unlike JPEG files, TIFF files are not lossy. This means that, though they can be compressed slightly (up to 30%), they do not suffer from image degradation or artifacts.

TOOLBAR Generic term for the part of a software program that displays certain functions.

Accessed through the mouse cursor or through keyboard shortcuts. Toolbars can be docked or left 'floating'.

TWAIN This is the bit of software that allows you to operate a scanner through a plug-in in a host program such as Photoshop Elements, LE, Photoshop, or Paint Shop Pro.

VECTOR IMAGE Different to bitmap. A vector is a mathematical equation presenting data on screen. Advantages include infinite scalability and small file size. Text is from vector data, although not all effects can be applied to this data. It must first be converted to a bitmap state.

WARP (TOOL) Effect used for bending and distorting the pixels in a digital file.

WEB RESOLUTION Typically this is 72 dpi for display on the Internet.

Appendix 2

Keyboard Shortcuts

Keyboard shortcuts are probably the last thing on your mind when learning a photo-editing program – there are too many other considerations to take on board. However, learn a few of these shortcut keystrokes and you'll not only increase the speed at which you can perform basic actions with Paint Shop Pro, but you'll also have more time to do other things – such as experiment more with your photos.

General

Open a file	Ctrl+O
Save a file	Ctrl+S
Delete	Ctrl+Del
Undo previous keystroke	Ctrl+Z
Repeat previous keystroke	Ctrl+Y
Repeat New File	Ctrl+Shift+Z
Cut	Ctrl+X
Load New Workspace	Shift+Alt+L
Save Workspace	Shift+Alt+S
Delete Workspace	Shift+Alt+D
Start Screen Capture	Shift+C
Print	Ctrl+P
Copy	Ctrl+C

Paste

As a New Image	Ctrl+V
As a New Layer	Ctrl+L
As a New Selection	Ctrl+E
As Transparent Selection	Ctrl+Shift+E
Into Selection	Ctrl+Shift+L
As New Vector Selection	Ctrl+G

View

View: Full Screen Edit	Shift+A
View: Full Screen Preview	Ctrl+Shift+A
View: Rulers	Ctrl+Alt+R
View: Grid	Ctrl+Alt+G
View: Brush Variance Palette	F11

View: Histogram	F7
View: Layers	F8
View: Learning Center	F10
View: Materials	F6
View: Overview	F9
View: History	F3
View: Tool Options	F4
View: Magnifier window	Ctrl+Alt+M

Image

Flip Image	Ctrl+I
Mirror Image	Ctrl+M
Free Rotate Image	Ctrl+R
Resize Image	Shift+S
Image Information	Shift+I
Load palette	Shift+O
Set Palette Transparency	Ctrl+Shift+V
Decrease Color Depth>2 color palette	Ctrl+Shift+1
Decrease Color Depth>16 color palette	Ctrl+Shift+2
Decrease Color Depth>256 color palette	Ctrl+Shift+3
Decrease Color Depth>32k Colors	Ctrl+Shift+4
Decrease Color Depth>64k Colors	Ctrl+Shift+5
Decrease Color Depth>x Colors	Ctrl+Shift+6
Increase Color Depth>16 color palette	Ctrl+Shift+8
Increase Color Depth>256 color palette	Ctrl+Shift+9
Increase Color Depth>RGB - 8 bits/channel	Ctrl+Shift+0

Adjust

Adjust Color Balance>Red/Green/Blue	Shift+U
Adjust Brightness and Contrast>Brightness/Contrast	Shift+B
Adjust Brightness and Contrast>Equalize	Shift+E
Adjust Brightness and Contrast>Gamma Correction	Shift+G
Adjust Brightness and Contrast>Highlight/Midtone/Shadow	Shift+M
Adjust Brightness and Contrast>Histogram Adjustment	Ctrl+Shift+H
Adjust Brightness and Contrast>Histogram Stretch	Shift+T
Adjust Hue and Saturation>Colorize	Shift+L
Adjust Hue and Saturation>Hue/Saturation/Lightness	Shift+H

Layers

New Mask Layer>Hide All	Shift+Y
Select All	Ctrl+A
Select None (Deselect)	Ctrl+D
Make Selection>From Mask	Ctrl+Shift+S
Make Selection>From Vector Object	Ctrl+Shift+B
Invert Selection	Ctrl+Shift+I
Hide (Selection) Marquee	Ctrl+Shift+M
New Window	Shift+W
Duplicate (Window)	Shift+D
Fit to Image	Ctrl+W

Index

3D effects, text 151–2
16-bit support 19

Add Noise filter 72–4
Adding audio to photos 274
Adjust
 keyboard shortcuts 291
 wizard 274
Adjustment layers 284
 black and white pictures 84–5
 combining images 129–31
Advanced layout tools 127–8
Aged Newspaper filter 187
Airbrush tool 178
Alignment, text 148
Alpha channels 109–10
Animation Shop 246–52
 Banner Wizard 251–2
 GIF format 248
 layer-based animation 248–9
 onionskinning 250
 .psp format 249
 tips 250
 VCR Controls 248, 250
 wizard 251
Anti-aliasing, text 150
Archiving photos 269–70
Arrange tool 127–8
Art Media brushes 178–80
Artificial point of focus project 111–12
Artistic Effects submenu 5
Audio, adding to photos 274

Background Eraser tool 114
Backlighting
 filter 55
 manipulation 54
Backup 265
Balls and Bubbles filter 186
Banner Wizard 251–2
Batch processing 91, 276–7, 284

Bezier curves 158, 159
Bitmap 284
Bits 284
Black Pencil filter 187
Black and white conversion filters 19
Black and White Film filter 82
Black and white pictures 79–85
Blacks and whites pixel histogram 40
Blemish removal from scans 67–70
Blend modes
 combining pictures 126
 depth effects 197–201
 jargon buster 284
 layers 131–3
Blend Range tool 86–7
Blurring images 238
Bounding box, text 149
Brightness 38, 49–50
Browser
 advanced features 15–17
 definition 284
 Filter effects 184
 location 4
 palette 14–15, 20
 printing 221
Brush tool
 images 174–80
 mask layers 134
Bubbles filter 186
Burn tool 284
 brush tools 176
 damaged photos 93
 retouching 78

Calendar mode 263, 269, 270
Calendar project 164–8
Calibration 223–4
Camera button 263
Canvas 284
CCD (charge-coupled device) 284
Channel Mixer 44–5

black and white pictures 82
Chisel tool 151–4
Clarify filter 50, 56, 77
Clone brush tool 74–7
Clone tool 284
CMS see color management...
Collections 264
Color Balance 19
 black and white pictures 84
 One Step Photo Fix 40–1
 overlay effects 86–7
 panoramas 195
 picture manipulation 42–4
Color Controls 11-14
Color gradients 174
Color management 19-20, 222–7
 calibration 223–4
 color profiles 223, 227
 Epson Stylus Photo R800 226
 ICC profiles 225–6
 no profile 226–7
 soft proofing 225
 system 222
Color overlay effects 86–7
Color Picker 172
Color Replacer tool 208–9
Color spaces 284
 combining pictures 124
Color test targets 227
Colored filters 81
Colored Foil filter 185
Colorize 85, 284
ColorVision Spyder PRO 227
Combining layers 135–6
Combining pictures 122–6
Compression see GIF format; JPEG format
Contact sheets 221
Contrast 49–50, 284
Controlling change 101–16
Convert to Raster Layer tool 197–201
Convert text to curves tool 151–4

Corel Photo Album 6 6, 259–82
 Create tab 274, 275
 Enhance tab 273–4
 finding photos 263–4, 268–9
 Folders button 263
 full version 276
 Info tab 266
 Share tab 25
 step-by-step projects 275, 279–82
 tabs 262
 Web Gallery creation 279–82
 workspace 261, 262–6
Create tab 274, 275
Crop button 273
Cropping pictures 31–2
Cropping tool 236, 284
Curves
 jargon buster 284
 Pen tool 158
 tonal adjustment 50–1
Cutout tool 151–4

Darkroom, digital 20–1
Date 17
DCNR (Digital Camera Noise Removal) Filter 71–2
Deformation tools 180–2, 284
Deleting images 265
Depth effects 197–201
Desktop inkjet printers 213–30
Despeckle filter 70
Dialog window, definition 284
Digital Camera Noise Removal (DCNR) 71–2
Digital darkroom 20–1
Digital files, sharpness 59
Digital image making 1–32
Digital noise 70–4
Displacement filter 188
Displacement maps depth effects 197–201
Dithering 241, 242–3
Dodge tool 285

brush tools 176
damaged photos 93
retouching 78
Dots per inch 285
Downloading
images 239–40
time estimates 239–40
Downsampling 216–17
Drivers 224, 285
Drop shadows 240
text 151–2
Duotone 83
DVD recording 275

Edge effects 206–8
Edge Preserving Smooth Filter 69–70
Edit selection mode 105
Editing, local 5–6
Effects Browser, filter 184
Effects toolbar 8
Enhance tab 273–4
Epson Stylus Photo R800
color management 226
features 218
printer drivers 224
EXIF data 16, 266
Exposure problems 49
Eye size, Warp tools 88

Fade Correction 44, 77
File formats 235–43, 285
File Open Pre-Processing 20
Fill Flash
filter 54–5
manipulation 54
Filters
definition 285
images 183–90
text 153
Finding photos 263–4, 268–9
Fisheye distortion correction 182

Flash memory card 23
Flat (contrast) 285
Flatten (layer) 285
Flatten tool 193–6
Flood Fill tool
adjustment layers 129–30
coloring effects 93–5
Focus 41
Folders button 263
Fonts 149
Frame effects 206–8
Frame mode 171
Free pictures 25–6
Freehand selection tool
artificial point of focus 111
controlling change 103–5

Gamma (adjustment) 285
Geometric selection tools 105–7
GIF format
jargon buster 285
web file format 240–2, 253
see also Animation Shop
GIF Optimizer 241–2
Global editing 5–6
Global Positioning System (GPS) satellites 16
Graphics 243–6
see also images
Graphics tablets 23, 111
Greetings cards 160–2
Greyscale 80

Halftone filters 186
Hand coloring black and white photos 95–9
Hard Light blend mode 62
High Pass Sharpen filter
new feature 19
step-by-step project 58, 61–3
Highlight/Midtone/Shadow tool 51
Histograms, pixels 38–9
Histogram adjustment

advanced features 10–11
damaged pictures 77
exposure 51
lights 190
overexposed sky 114
panoramas 195
Histogram Equalize 52
Histogram Stretch 52
Histograms 285
History palette 89–90
HTML (Hyper Text Markup Language) 233–4
Hue 285
Hue maps 11, 48
Hue/Saturation/Lightness 46–8
adjustment layer 129–30
black and white pictures 82, 84–5

ICC see International Color Consortium
Illustration, vectors 158–9
Image Information button 15–16
Image maps 245–6
Images
blurring 238
compression 235–9
digital 1–32
downloading 239–40
drop shadows 240
keyboard shortcuts 291
manipulation 169–209
multiple photos 228–30
quality 233
resizing 213–14, 234–5
resolution 213–15
slicing 12, 244
straightening 27–9
uploading to web 231–58
web display 233–5
see also graphics
Info tab 266
Infra-red conversion filters 19
Ink 218, 219

Inkjet papers 21
Inkjet printers 213–30
choosing 217–19
Epson Stylus Photo R800 218, 224, 226
features 217–18
technology 218–19
Inner bevel tool 151–4, 162–3
Interactive Learning Centre 18
International Color Consortium (ICC) profiles 225
Internet 243–6
see also web...
Interpolation 285
IPTC metadata support 20

Jargon busting 283–7
JPEG format
compression effects 237
definition 236, 285
tips 238
web working 235–8, 240
JPEG Lossless Rotation 17
JPEG Optimizer 12, 236–8, 240

Kaleidoscope filter 188
Keyboard shortcuts 289–92
Keywords 264, 266–8

Large image uploading 234–5
layer-based animation 248–9
Lasso tool 103
Layer masks 117–40, 285
Layers 12–14
adjustment layer 284
blend modes 131–3
combining 135–6
definition 285
features 122
keyboard shortcuts 292
opacity 127–8
palette 20, 121

panoramas 193–6
shadow formation 140–5
Layout
　advanced 127–8
　multiple photos 228–30
　printing 219–21, 228–30
　tips 230
Learning Center 4, 26–7
Lens Correction filters 180–2
Lens Distortion filter 188
Levels 52, 285
Lighting effects 190–2
Lights filter 187
Line drawing 173
Local editing 5–6

Magic Wand tool 103–5, 107–9, 113
Magnification see resizing images
Magnifying glass icon 268
Main menu 5
Makeover tools 18
Manipulation
　images 169–209
　pictures 33–64, 65–99
Marquee selection tool 103–4
Masks
　controlling change 110
　layers 117–40
　Pen tool 158
Materials palette 171–4
Median filter 69–70
Memory card 21
Menu bar 4
Merge tool
　advanced layout 127–8
　panoramas 193–6
Mesh Warp 180–2
Midtone tool 51
Mixer palette 179
Moire patterns 285
Monitors 22, 223, 224

Montage 137–9
Move tool
　layers 125
　panoramas 193–6
Multi-picture document 124–6
Multiple photo printing 228–30, 273

Navbars, rollovers 253–7
No profile color management 226–7
Noise
　definition 285–6
　digital 70–4

Object cutout project 115–16
Object remover 18
Oil brush, tool 179–80
One-Step noise fix 19
One-Step Photo Fix 11, 35
One-Step purple fringe fix 18–19
Onionskinning 250
Opacity
　definition 286
　layers 127–8
　panoramas 193–6
Optimization, web working 252–3
Order prints button 275
Organizing photos/pictures 259–82
Overexposed sky project 112–14

Page Curl filter 185
Paint brush tool 175–8
Paint Shop Photo Album 5 272
Palette 10, 265, 286
　layers 121
Panorama button 265, 270–2
Panoramas project 193–6
Paper (printing) 21, 219

Pasting
　keyboard shortcuts 290
　multi-picture document 126

text inside an image 162–3
Path tool for adding text 153–4
Pen tool 14
 shape creation 157–9
 text 154
 vector illustration 156
Pencil filter 185
Pepper filter see Salt and Pepper filter
Perspective correction 29–30
Perspective transform tool 180–2
Photo Album 5 (Paint Shop) 272
Photo Album 6 (Corel) 259–82
Photo toolbar 7–8
Photo trays 264
Photomontage project 137–9
Photos
 archiving 269–70
 finding 268–9
 keywords 266–8
 organizing 259–82
 repairing damage 91–3
Pick Tool
 deformation tools 180–2
 new features 20
 panoramas 193–6
 text 151–4
Pictures, manipulation 33–64, 65–99
Picture Tube 12, 201–4, 205
Pictures
 combining layers 122–6
 creation 24–5
 cropping 31–2
 free 25–6
 organizing 259–82
 quality 238–9
Pincushion lens correction 182
Pixels 13, 214–15
 histogram 38–9
Platen 286
Plug-ins 286
PNG format 286

Poster layouts 229
Posterization 286
Preset Shape tool 14
 vectors 155–7
Print Layout 219–21, 228–30
 multiple photos 273
 printing 272
Print resolution 286
Printers 22
Printing 211–30
 Browsers 221
 drivers 224
 layout 219–21
 Print Layout 272
 step-by-step project 228–30
 tools 219–21
Profiles, monitors 224
psp format 249
Push brush tools 93, 176

Quick CD button 275
Quick email 275
Quick Fix button 274
Quick Print button 264, 275
Quick Show button 264, 275
Quickscripts 90–1

Rainbow mode 171
RAM (random access memory) 22
Raster see bitmap
Rectangular Marquee selection tool 106
Red-Eye tool 18, 274
Red/Green/Blue tool 45–6
Renaming folders/images 276–7
Repairing damaged photos 91–3
Resampling 214, 216–17, 234
 see also interpolation
Resizing 213–14, 234–5, 236, 277
Resolution
 definition 286
 images 213–15

output examples 215
Retouching 74–7
RGB definition 286
Rollovers 244–5, 253–7
Rotating images 265
Rulers 127–8

Salt and Pepper filter 69–70
Saturation 40, 286
Save as 277
Saving masks 136
Scanning, creating pictures 24–5
Scanning, blemish and scratch removal 67–70
Scratch removal
 damaged photos 91–3
 scans 67–70
 tool 77
Screen saver 276
Screens see monitors
Scripting 8–9, 89–91, 286
Searching files 268–9
Selection tool
 adjustment layer 129–30
 controlling change 101–16
 jargon buster 286
 mask layers 133–4
 text 155
Selection from Vector Object tool 162–3
Sepia filter, black and white pictures 81
Shadows 51, 140–5
Shapes
 adding text 154
 layers 126
Share tab 275–6
Sharpen tool 93, 176
Sharpening, definition 286
Sharpness, images 56–60
Sky, overexposure 112–14
Slicing images 12, 244
Smart Photo fix 18, 35–7

Smooth Selection dialog 114
Smudge tool 93, 176
Snap to Guides tool 127–8
Soft focus effects 59–60
Soft plastic filter 186
Soft proofing 225
Soften tool 93, 176
Softening images 238
Solarization 286
Sorting pictures 265
Special text effects 151–5
Speed of downloading 239–40
Stack, layers 122
Standard toolbar 6
Step-by-step projects
 combining images 137–44
 controlling change 111–16
 High Pass Sharpen filter 61–3
 manipulating images 193–209
 Photo Album 6 275, 279–82
 picture manipulation 91–9
 printing 228–30
 text 160–8
 web working 253–7
Straighten tool 180–2
Style palette 173
Swatch mode 172
Symmetric Shape Tool
 advanced features 13
 vectors 156, 159

Tablet, graphics 23
Technology, inkjet printers 218–19
Templates 221
Test targets for color 227
Text
 adding to photo 152
 advanced features 13
 shapes 154–5
 special effects 141–5
 vector graphics 145–68

Text pasting inside an image 162–3
Text and photos calendar project 164–8
Text tool
 depth effects 197–201
 pasting text inside an image 162–3
 special effects 151–4
Threshold 52–3
Thumbnails 221, 235
 definition 286
 Photo Album 6 262, 265
TIFF format 286
Time 17
Tinting 82–5
Tips
 Animation Shop 250
 JPEG format 238
 layout 230
 resizing 236
Tonal adjustments
 histograms 39
 tools 53
Tonal appearance 126
Tonal controls 10–11
Tool presets 7
Toolbars 4–5
 definition 287
Tools toolbar 6
Transparency 243
Tritone 83
TWAIN definition 287

Unsharp Mask filter 41, 56–7
Uploading
 images to web 231–58
 large images 234–5
 to web server 257–8
Upsampling 217
USB connection 23

VCD see Video CD
VCR Controls 248, 250

VDU see monitors
Vector graphics 13–14
 text 145–68
Vector
basics 155-8
illustration 158–9
images 287
layers 126
shapes 158
Video CD (VCD) 277–9
View shortcuts 290–1
View Grid 127–8
View Guides 127–8
View menu 127–8
Vosonic XS Drive Super 21

Wallpaper 276
Warp tools 88–9, 287
Water lily 119
Web Gallery creation 279–82
Web servers, uploading to 257–8
Web toolbar 9
Web working 231–58
 file formats 235–43
 file output 252–3
 image display 233–5
 GIF format 240–2, 253
 JPEG format 235–8, 240
 Optimization Wizard 252–3
 resolution 287
 navbars 253–7
 rollovers 244–5, 253-7
 step-by-step projects 253–7
 web display 233–5
 see also Internet
Website projects 205
Whites and blacks 40
Workspace, Photo Album 6 261, 262–6

Zoom tool 67–8